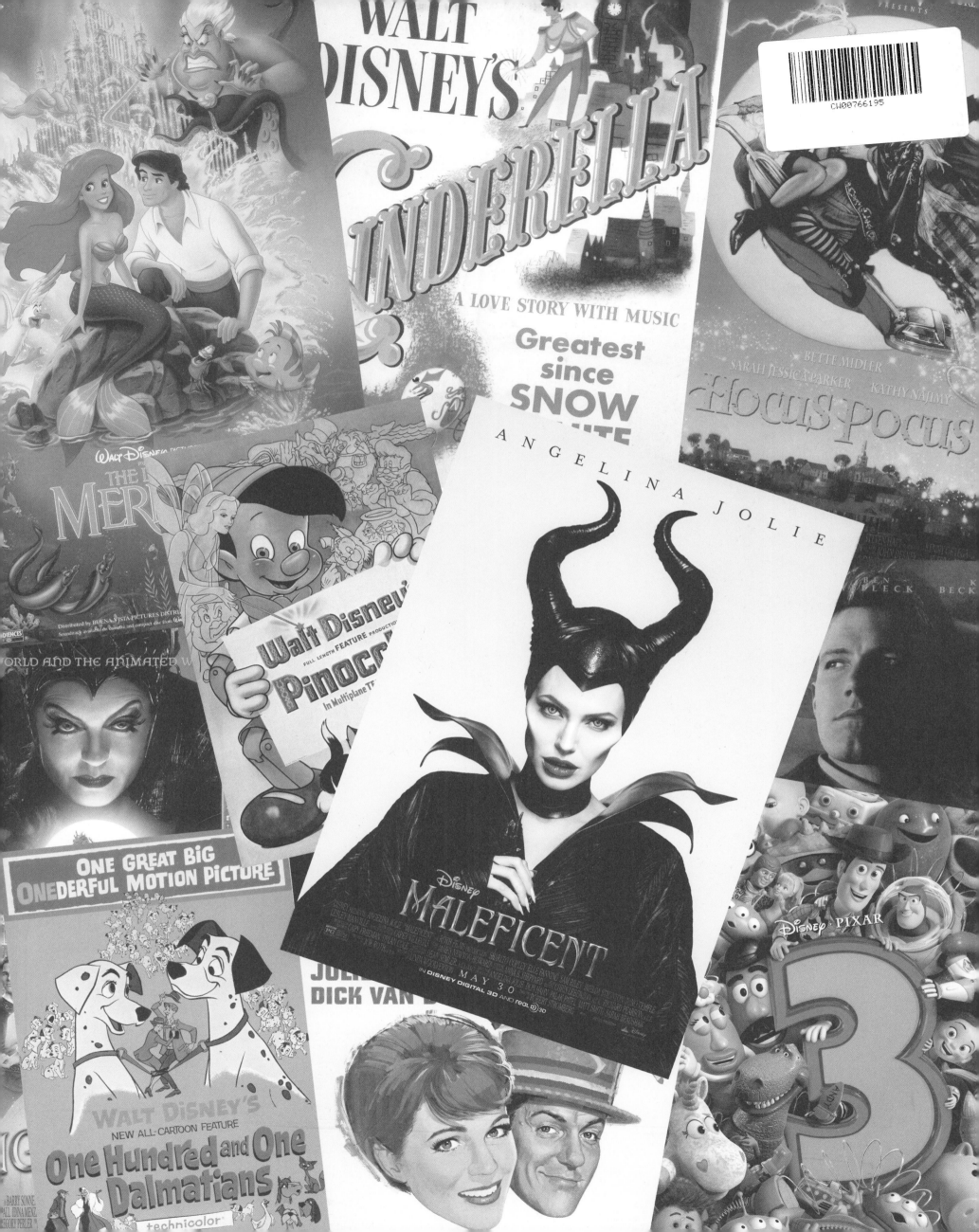

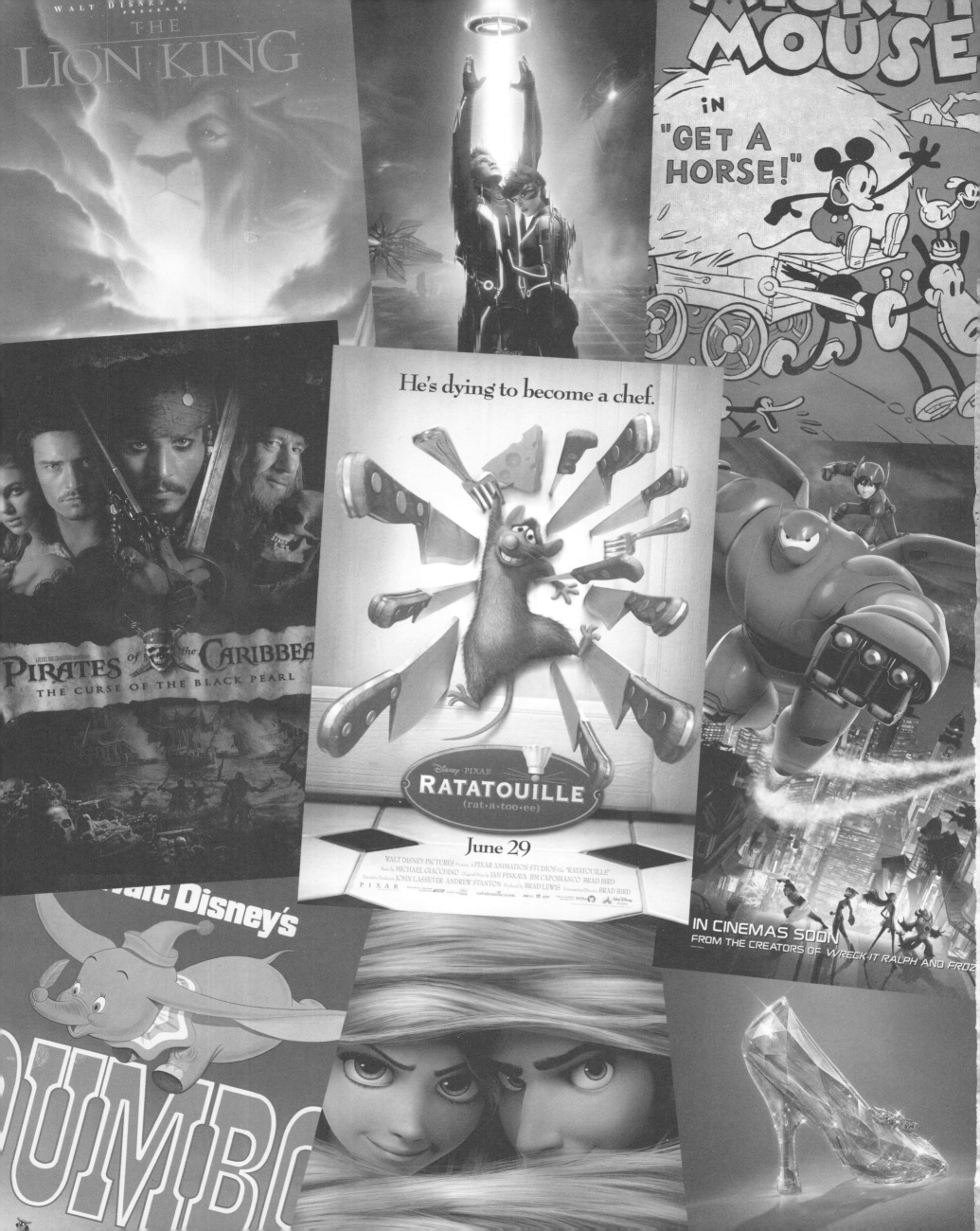

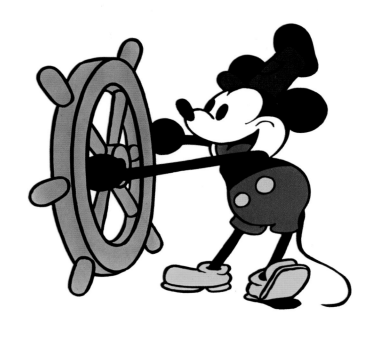

FROM THE CREATORS OF "TANGLED" AND "WRECK-IT RALPH"

Disney
FROZEN

IN CINEMAS SOON IN 3D
www.disney.com/frozen

FROZEN, 2013

Disney
MOVIE POSTERS

FROM **STEAMBOAT WILLIE**

TO **INSIDE OUT**

KEVIN LUPERCHIO

A
WELCOME
ENTERPRISES
BOOK

EDITIONS

LOS ANGELES • NEW YORK

For information address Disney Editions,
125 West End Avenue, New York, New York 10023.

Editorial Director: Wendy Lefkon
Executive Editor: Laura Hopper

Produced by Welcome Enterprises, Inc.
6 West 18th Street, New York, NY 10011
www.welcomeenterprisesinc.com

Project Director and Designer: H. Clark Wakabayashi

Printed in China
FAC-005376-16032

First Edition, September 2015
3 5 7 9 10 8 6 4 2

ISBN 978-1-4231-9901-4

The Official Disney Fan Club

D23.com

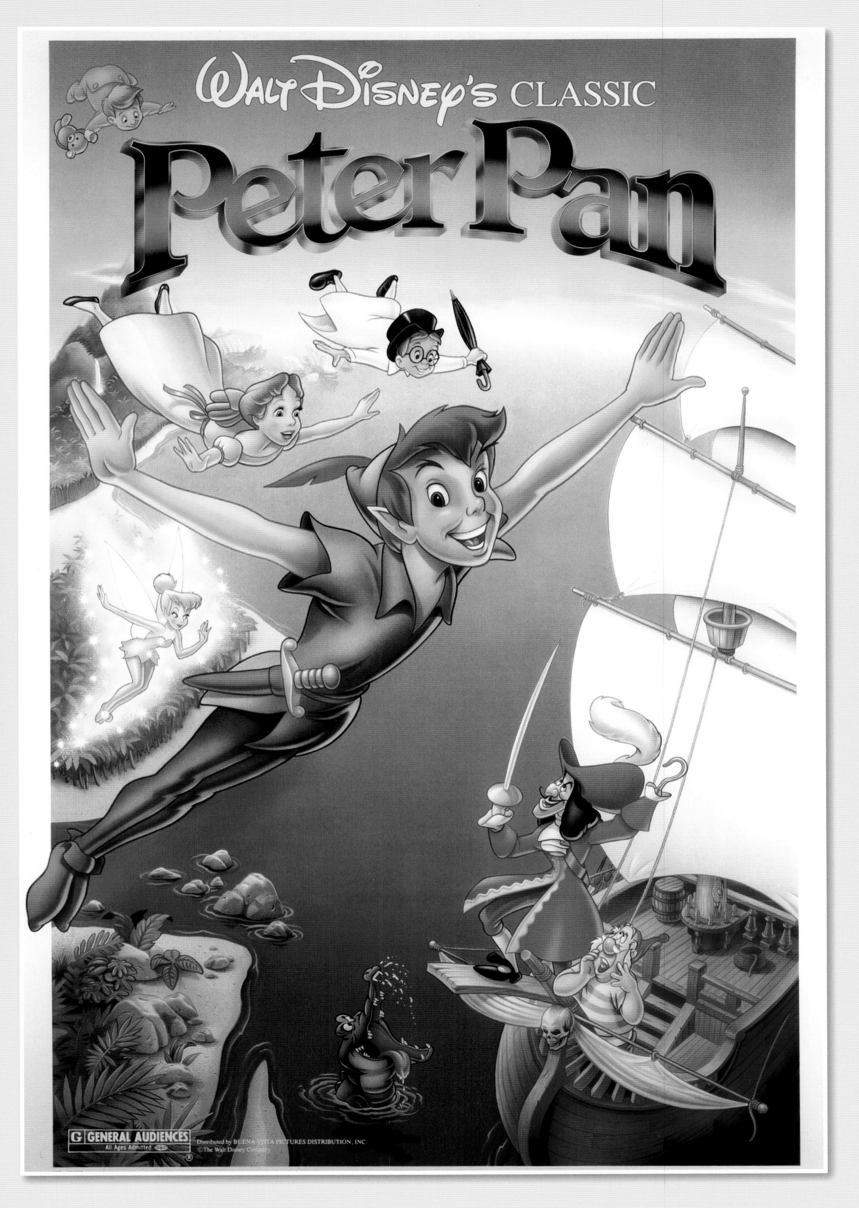

PETER PAN, 1989 (rerelease)

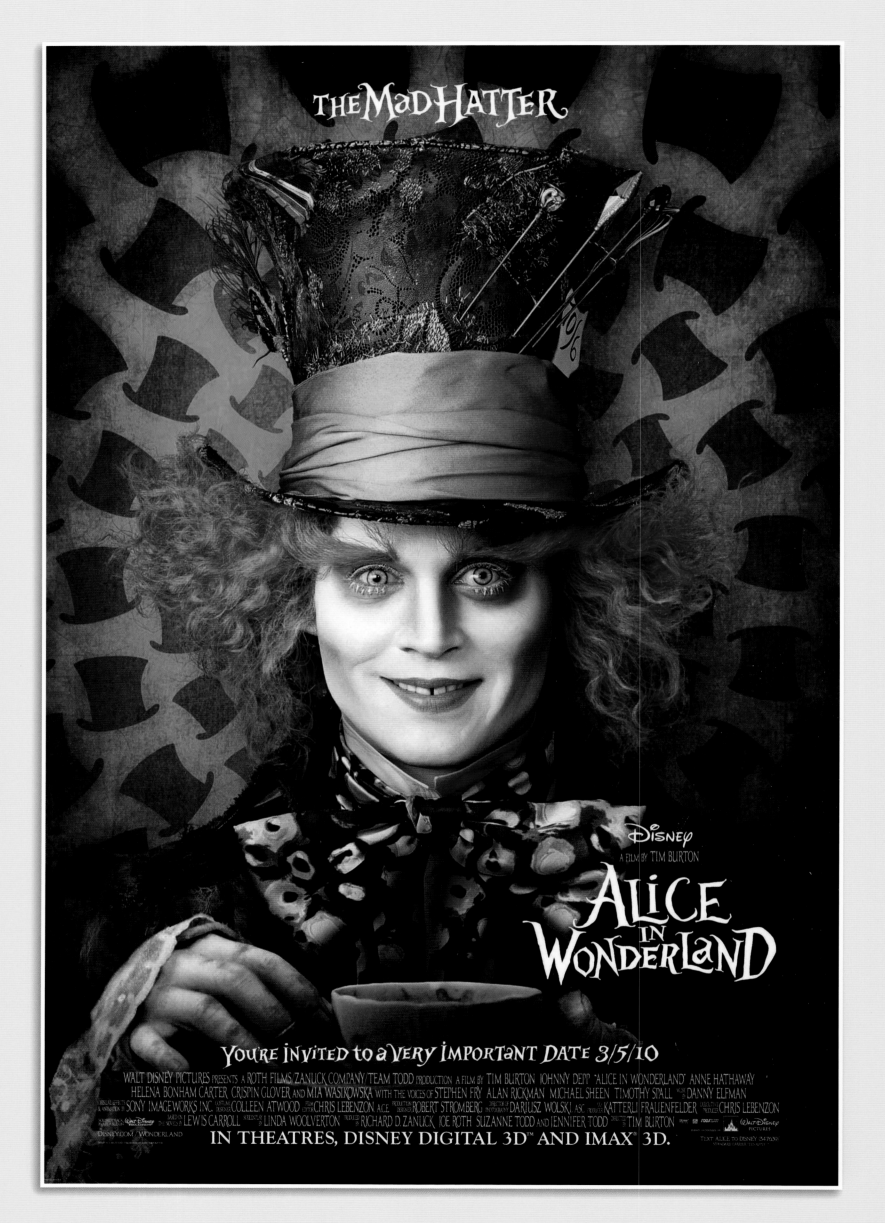

ALICE IN WONDERLAND, 2010

CONTENTS

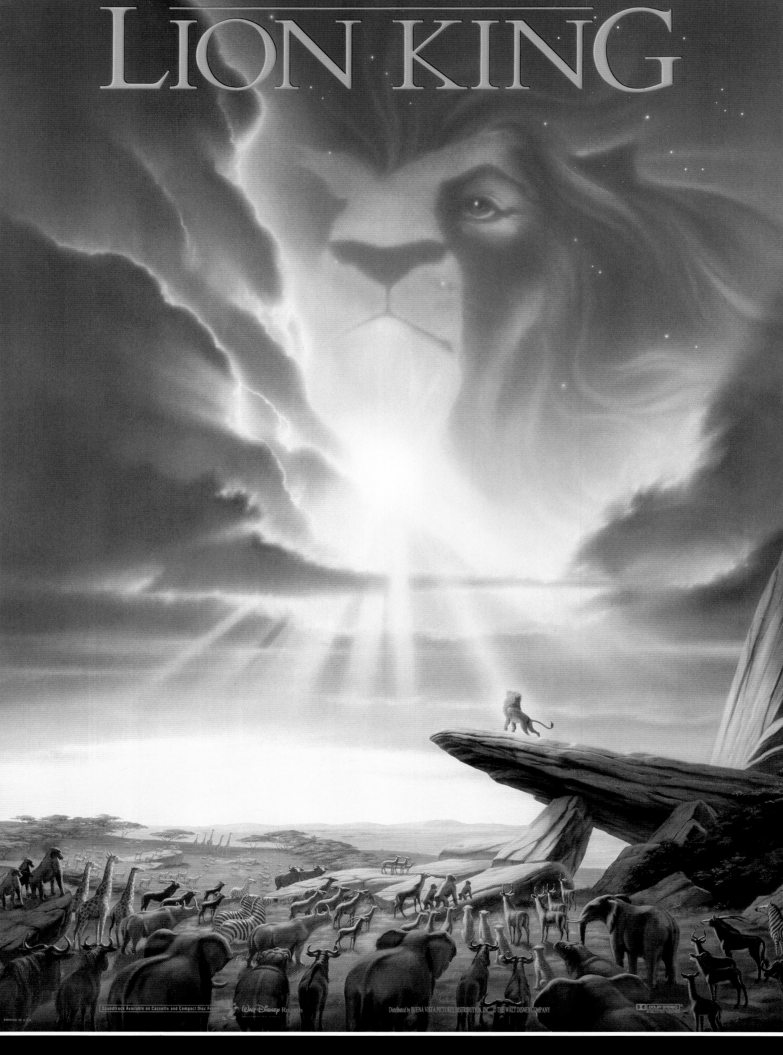

THE LION KING, 1994 (marketed to adults)

THE ART OF MOVIE POSTERS

IN the days before television and the Internet, audiences' first exposure to new movies came by way of the glass-encased posters lining the walls of the neighborhood theater. Those posters needed to be bold and dynamic enough to draw the eye while also capturing something of the essence of the movies they promoted.

From the earliest days of his studio, Walt Disney recognized the value and power of the movie poster. Every one of the short films the fledgling Disney Brothers Cartoon Studio produced, from the first Alice Comedies to the Oswald the Lucky Rabbit series to those starring Mickey Mouse and his friends, boasted its own promotional poster. When Disney turned his attention to feature-length films, beginning with *Snow White and the Seven Dwarfs* in 1937, some of the same animators who worked on the movies also designed the posters. Either Walt assigned an artist to create the posters, or several different artists submitted sketches for his review.

In the early days, "Walt *was* the marketing department," affirms John Sabel. As executive vice president of Motion Picture Creative Print Marketing at the Walt Disney Studios, Sabel has developed many animated and live-action poster campaigns during his seventeen-year tenure, including those for the Pirates of the Caribbean movies, *Maleficent*, and *Brave*.

The success of the early Disney films, helped in no small part by their posters, led to enormous growth for the studio and the creation of a separate marketing department (which remained very much under the watchful eye of Walt until his death in 1966). Today, teams of ten people or more—including

art directors, photographers, animators, letterers, and retouchers—might work on a single poster, though "rarely does a movie get just one poster anymore," comments Steve Nuchols, vice president of Creative Print Marketing at the Walt Disney Studios.

Now there are the simple, often purposefully mysterious teasers released up to a year before a movie's premiere. There might also be separate IMAX and 3-D posters, international art, and several versions of the final poster highlighting different characters or, in some cases, appealing to different demographics. While brainstorming the poster campaign for the 2001 release of *Pearl Harbor*, Nuchols and Sabel pioneered a new concept in movie posters. A *triptych* is made of three separate posters that can be placed together to create one complete scene. The triptych has gone on to become something of a staple in movie marketing; Disney featured it most recently in the campaign for 2013's *Oz the Great and Powerful,* and other studios have used it as well.

The technology behind movie posters has also changed a great deal, reflecting the evolution from hand-drawn to computer-based animation in the movies themselves. Prior to the late 1980s, most posters were, literally and physically, works of art. They were sketched on paper and then typically painted or airbrushed onto cold-press illustration boards. For live action, photographs of the films' stars might be taped onto a matte-painted background and then photocopied. The development of programs such as Photoshop allowed this work to be done on the computer— and with much greater efficiency.

Despite the growth of Disney's

marketing department and the many technological advancements of the past quarter century, the fundamental mission in developing a poster hasn't changed at all: to find one image that distills the central idea of the movie. The search for that iconic image starts with the very first sketch, according to Jonny Kwan. Now a creative director at the Walt Disney Studios, Kwan began working as a freelance artist with Disney back in the late 1980s and has designed posters for *The Lion King*, *Cars*, and *Frozen*, among other films. He said the inspiration for initial sketches may come from a rough idea conceived by the project team leader, a synopsis of the story, or even the title of the movie.

Several artists work up different design concepts for a poster campaign while another group works on potential logos. As such, finished posters may feature the work of several different people. This was the case, Kwan said, with the poster for *The Lion King*; one artist created the animals below the cliff, and another artist drew the lion face superimposed on the sky. Designs may also undergo significant changes as they work their way up the chain of command for approval.

Ninety years after the Disney Brothers Cartoon Studio released its first short, movie posters still play a central role in promoting new movies. These posters are now released—sometimes leaked—online long before they reach the glass cases of local theaters. They're discussed and dissected in online forums and on blogs; they're taped to walls or even framed by die-hard fans. As the selections in this book illustrate, the posters of Disney movies have developed lives quite independent from the movies they were designed to promote.

10

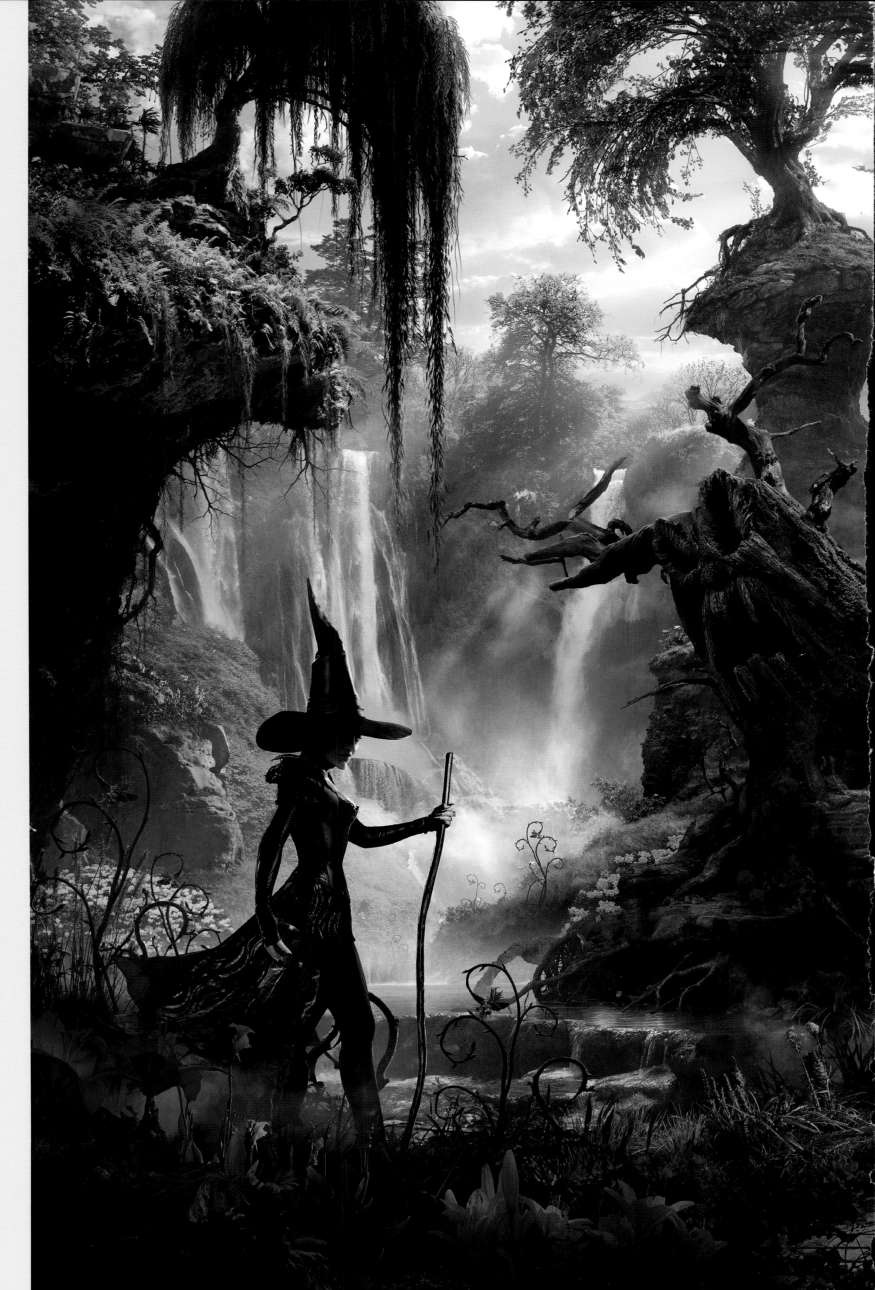

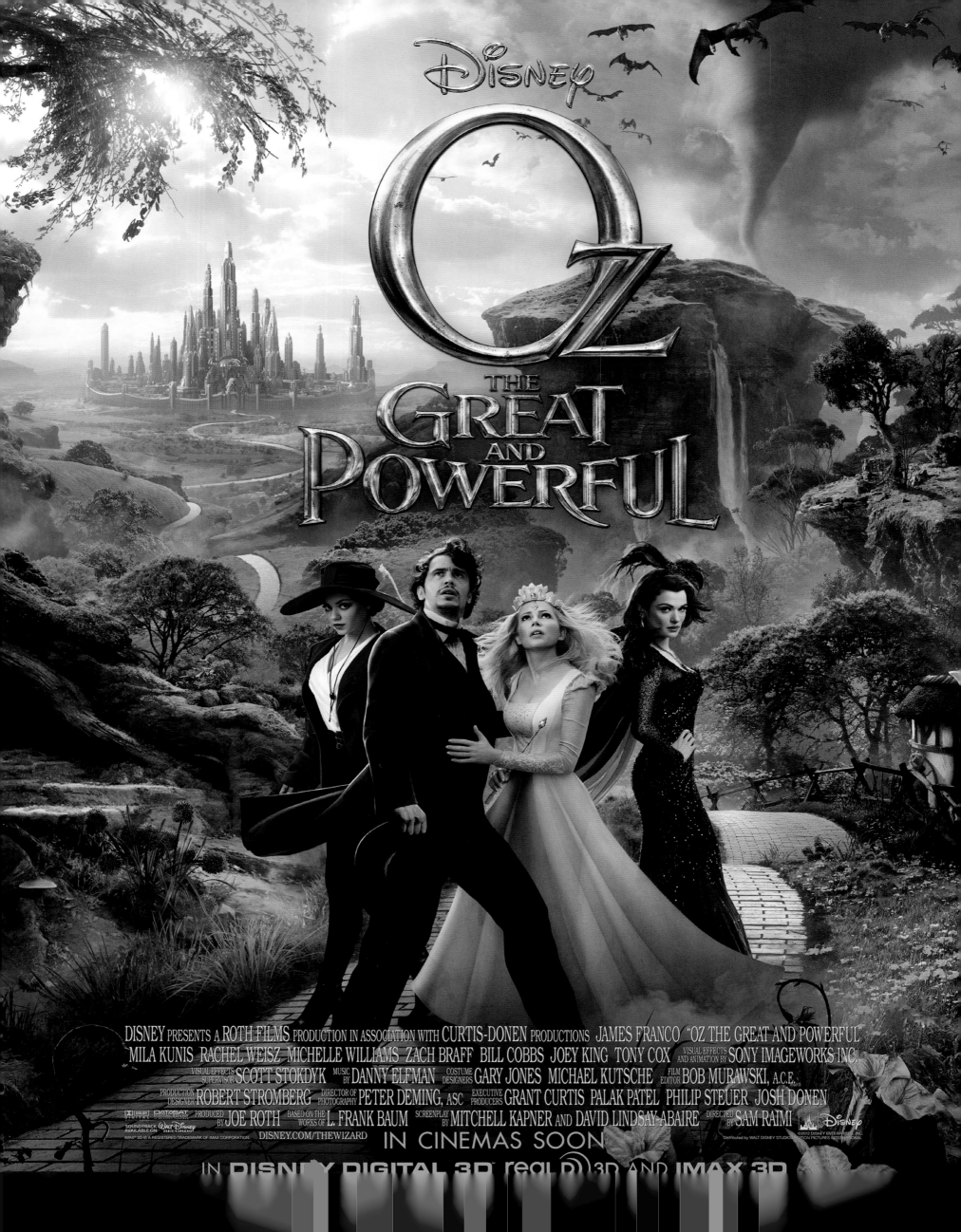

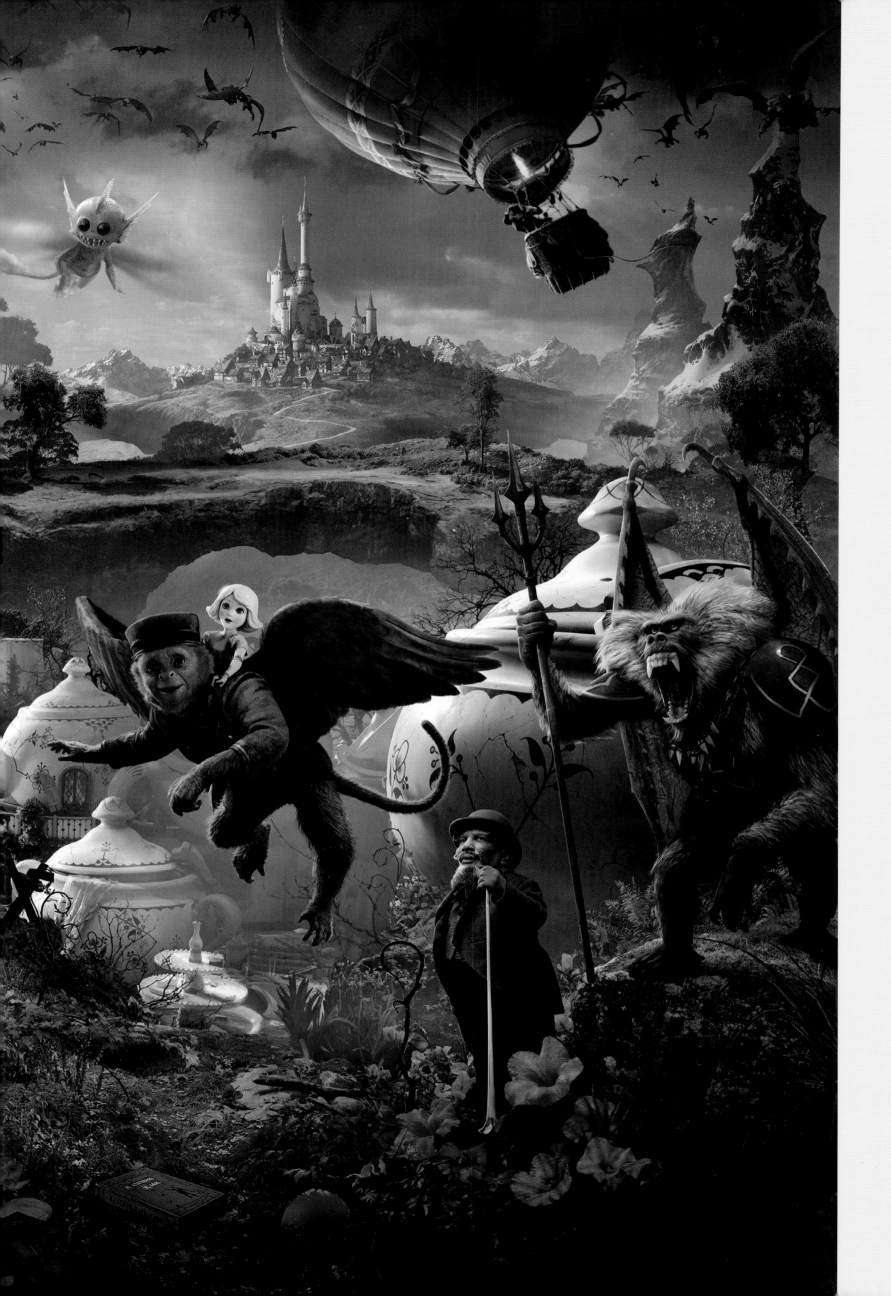

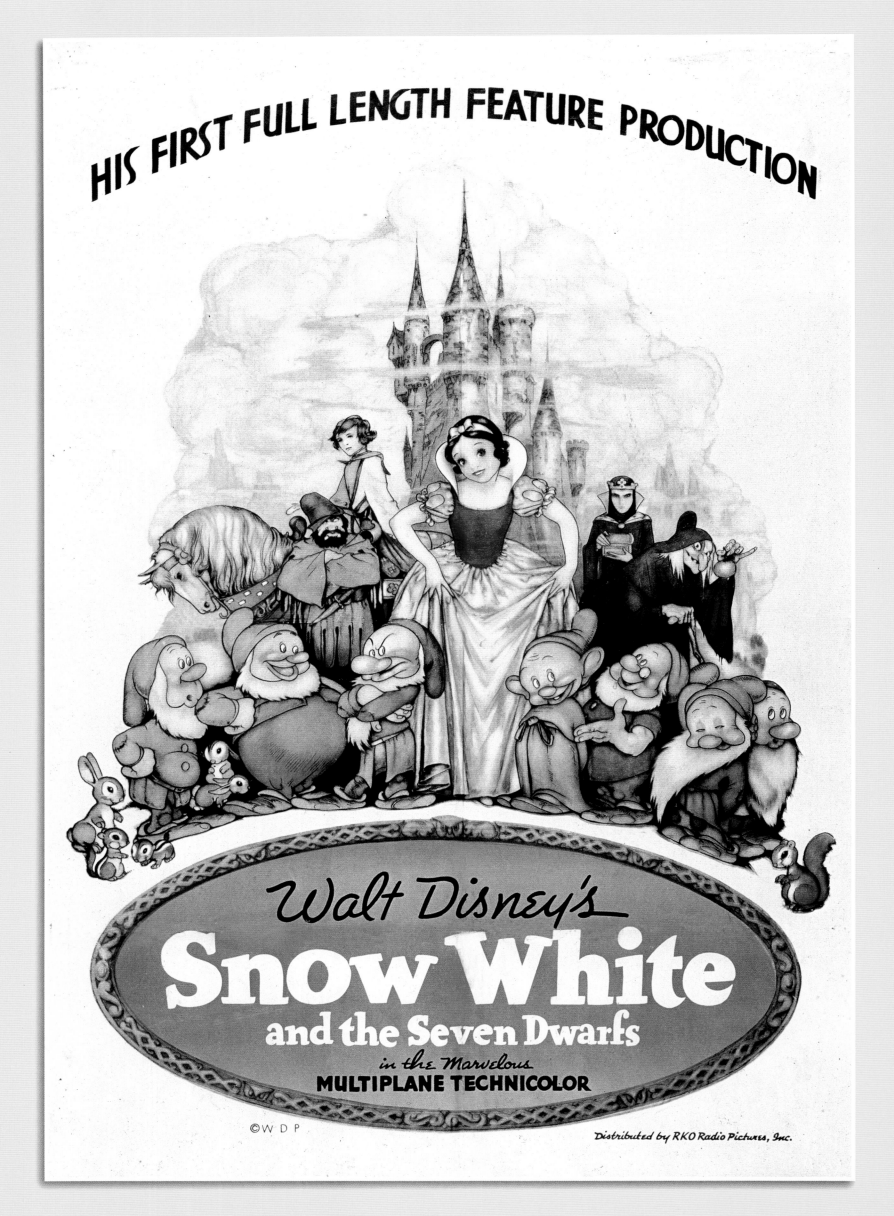

SNOW WHITE AND THE SEVEN DWARFS, 1937

MALEFICENT, 2014

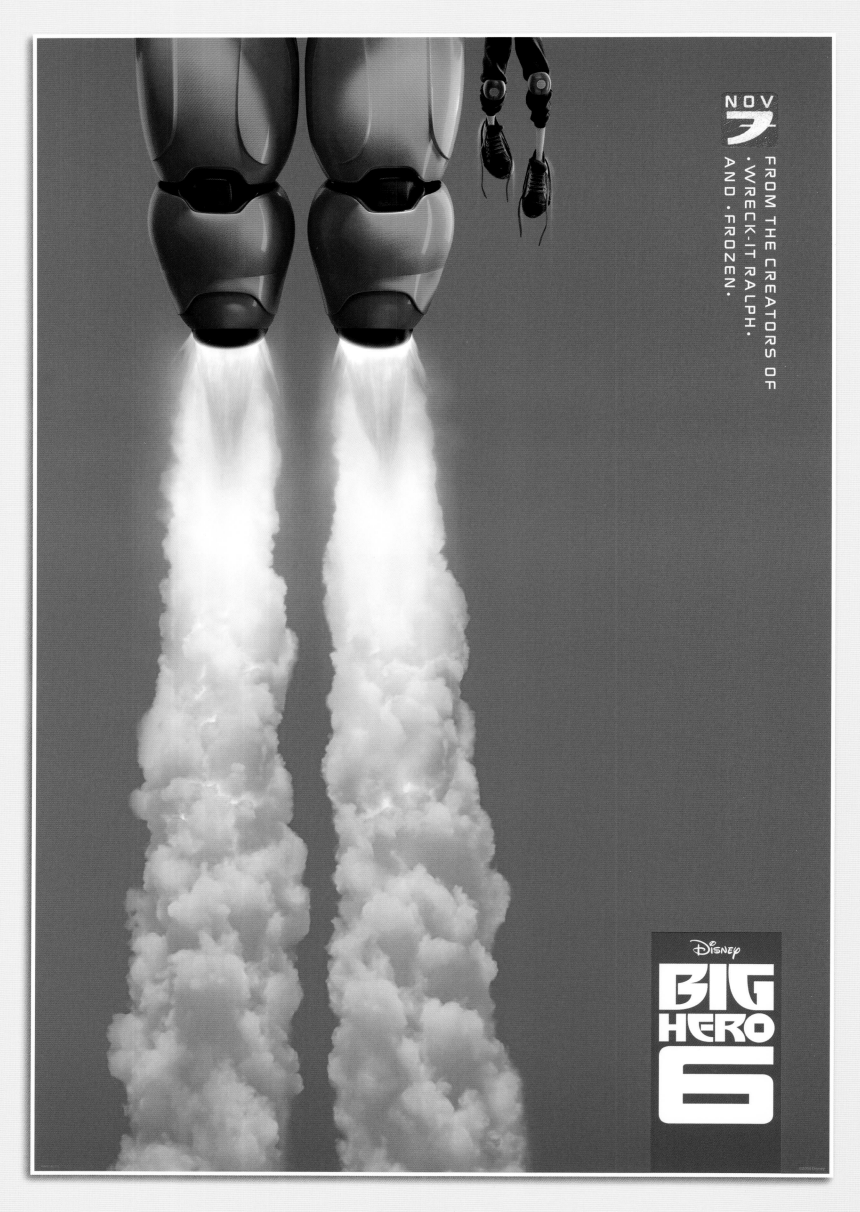

BIG HERO 6, 2014 (teaser poster)

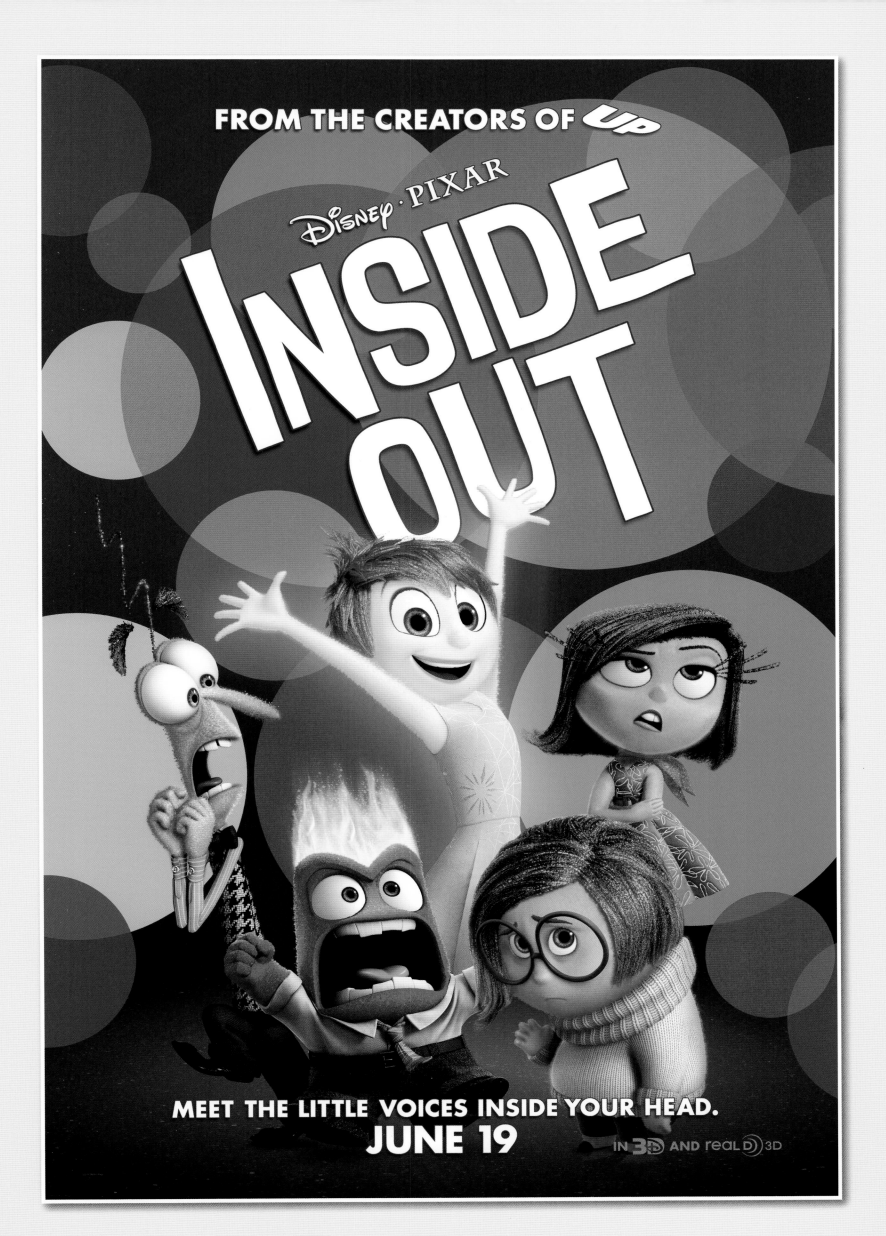

INSIDE OUT, 2015

STEAMBOAT WILLIE, 1970s (rerelease poster for *The Mouse Factory* TV series)

THE SHORTS

"Hot dogs! Hot dogs!"

— Mickey Mouse, *The Karnival Kid*, 1929 (the first words Mickey uttered on film)

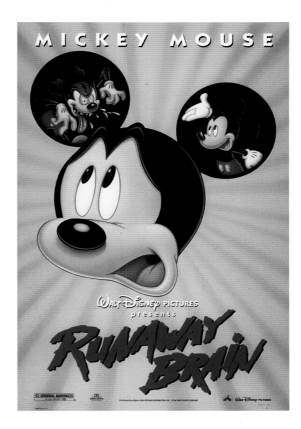

RUNAWAY BRAIN, 1995

WITH a jaunty whistle and some enviable dance moves, Mickey Mouse introduced himself to the American public in the animated short *Steamboat Willie* in 1928. But despite his now universal appeal, Mickey wasn't the first Disney star— or even the second.

Alice, a brave young girl played originally by Virginia Davis, starred in *Alice's Day at Sea*, the first short in the Alice Comedies series released by the Disney Brothers Cartoon Studio on March 1, 1924. The silent short, like the dozens to follow, was a combination of live-action and animated scenes drawn by Walt Disney himself. In each, Alice and her silly sidekick, an animated cat named Julius, embarked on a variety of adventures, including being kidnapped by pirates.

Walt's next breakout star was Oswald the Lucky Rabbit, who made his debut in the silent animated short *Trolley Troubles* in 1927. Oswald, like so many of the classic characters to follow, was clever, fun-loving, and more than a little bit mischievous. He starred in more than twenty shorts in less than a year.

And then came The Mouse.

Of course, Mickey wasn't the only Disney mainstay to debut in *Steamboat Willie*—audiences also got their first peek at Minnie Mouse. And if that wasn't enough, the short was the first Disney film to feature synchronized sound. Wide-eyed audiences heard everything from boat whistles and squawking birds to the tinkling sounds of a goat eating sheet music. Several months later, in *The Karnival Kid*, they heard something even better: Mickey's first words, as voiced by Walt Disney himself.

Over the following years, audiences were introduced to several now-famous members of Mickey's inner circle, often through the very popular Silly Symphony series of shorts, for which Walt earned his first Academy Award. Characters such as Pluto and Donald Duck earned their own series based on the success of their Silly Symphony appearances; Donald in particular was beloved by fans and, for a time, his popularity threatened to eclipse that of Mickey.

Production of animated shorts began to scale back in the 1950s as Disney shifted its focus to full-length movies. In recent years, however, they have made a comeback as opening acts for these features, beginning with *Tummy Trouble* (released with *Honey, I Shrunk the Kids*) in 1989. These new shorts sometimes introduce new characters or further the stories of existing characters, as with 2012's *Tangled Ever After* (released with *Beauty and the Beast* 3-D).

Others pay tribute to the Disney shorts of old by giving classic characters a modern polish. In 1995's *Runaway Brain*, Mickey Mouse's fondness for video games gets him in trouble with Minnie on their anniversary, while in 2007's *How to Hook Up Your Home Theater*, Goofy's characteristic clumsiness only worsens when he is faced with the challenges of modern technology.

The award-winning *Get a Horse!*, released with *Frozen* in 2013, takes this homage one step further by seamlessly melding old-fashioned black-and-white animation, state-of-the-art CGI computer techniques, and even archival recordings of Walt Disney himself as Mickey Mouse. The result is both a classic Mickey adventure (with a cameo by Oswald!) and an inventive journey through Disney shorts, past and present.

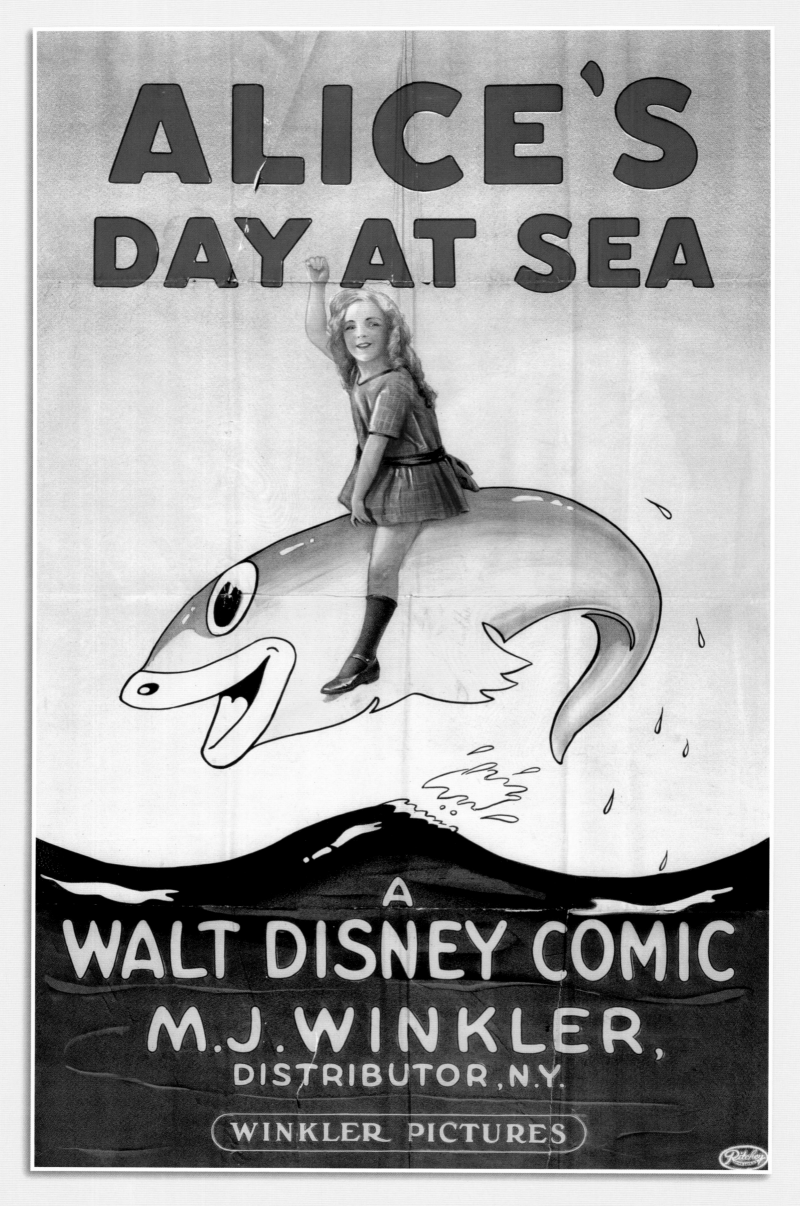

ALICE'S DAY AT SEA, 1924

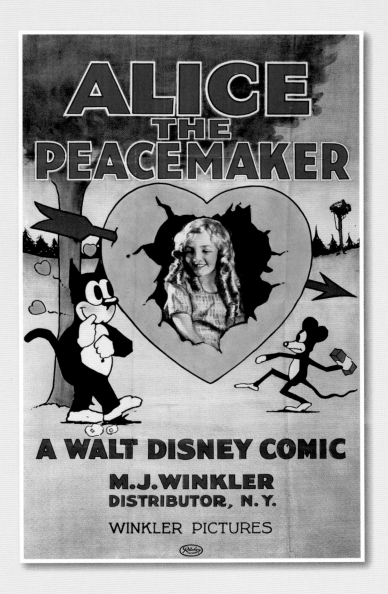

ALICE THE PEACEMAKER, 1924

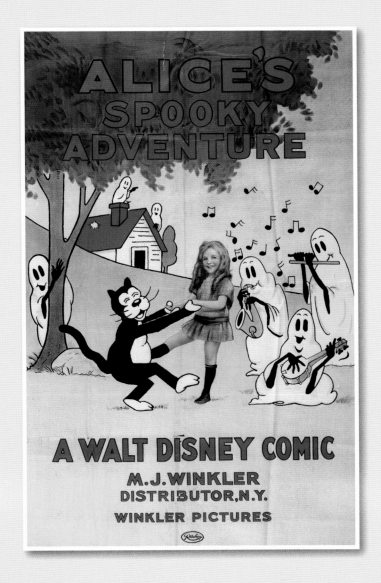

ALICE'S SPOOKY ADVENTURE, 1924

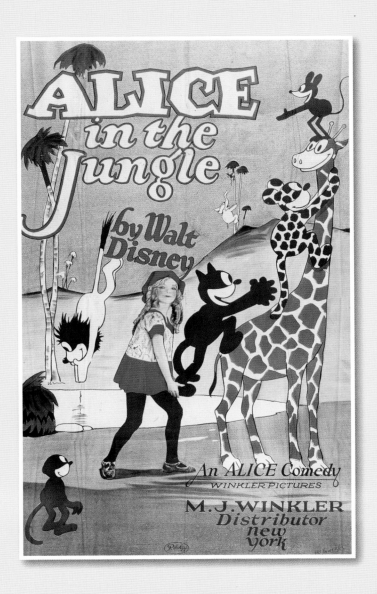

ALICE IN THE JUNGLE, 1925

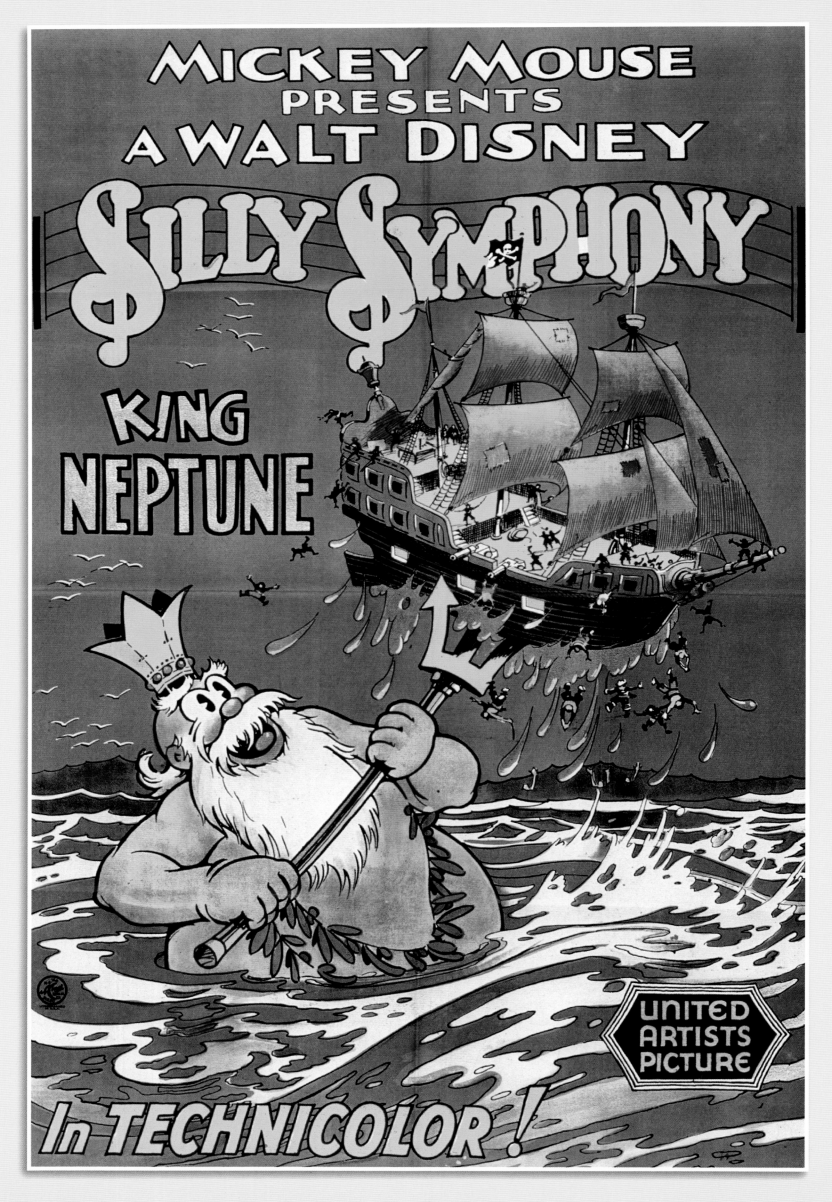

KING NEPTUNE, 1932

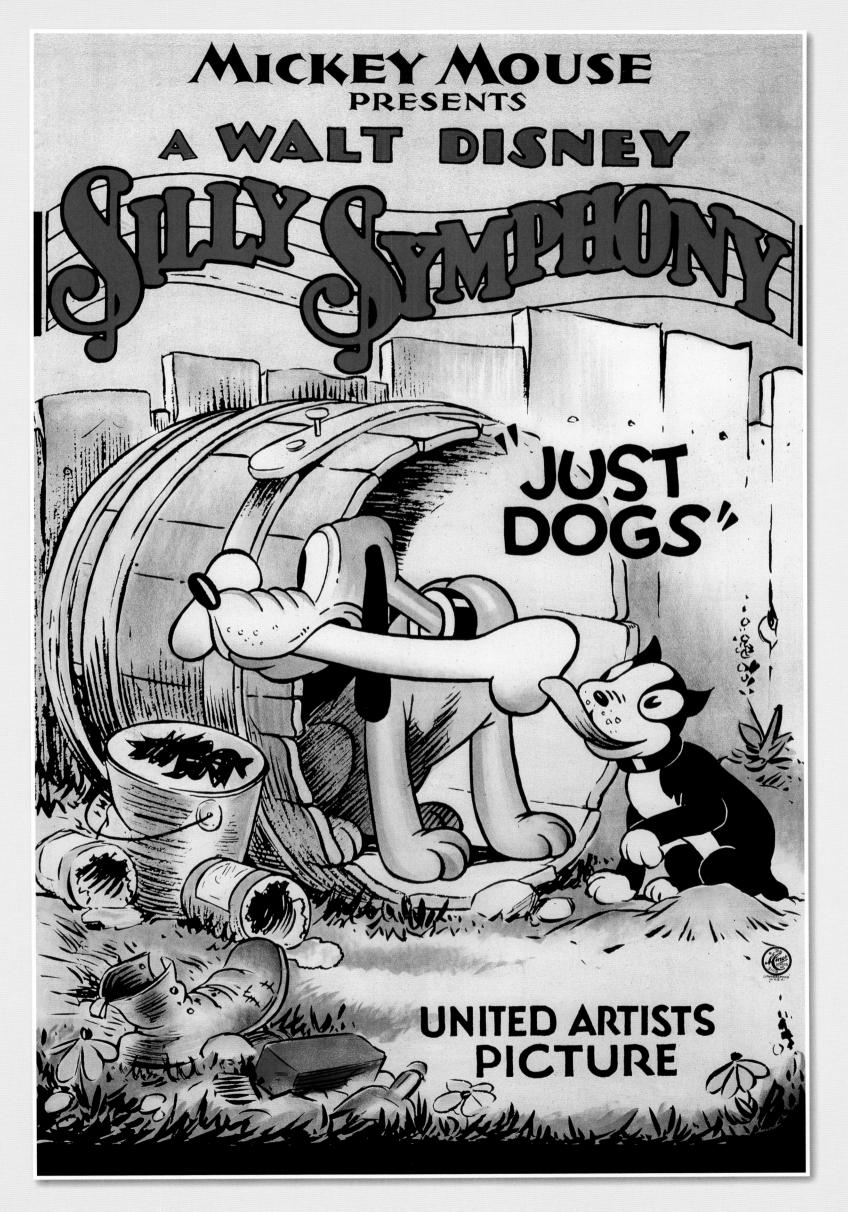

JUST DOGS, 1932

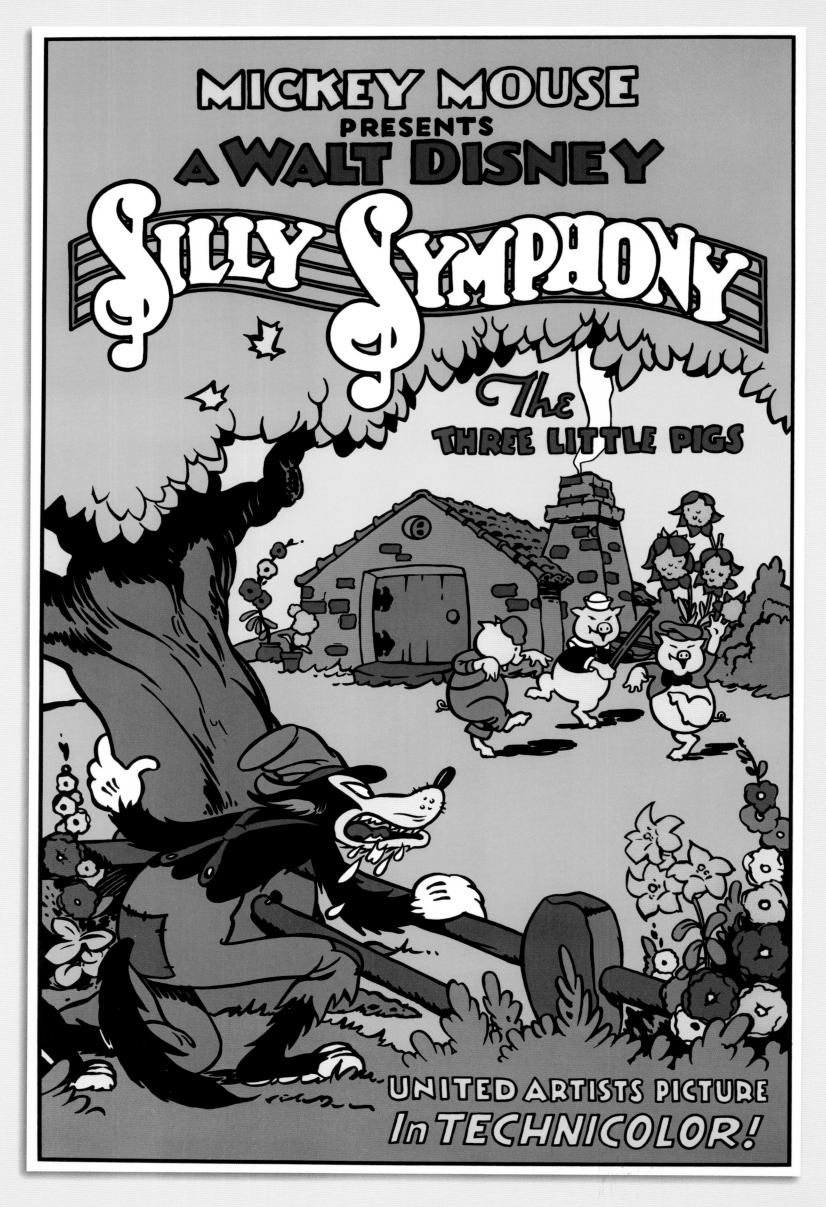

THE THREE LITTLE PIGS, 1933

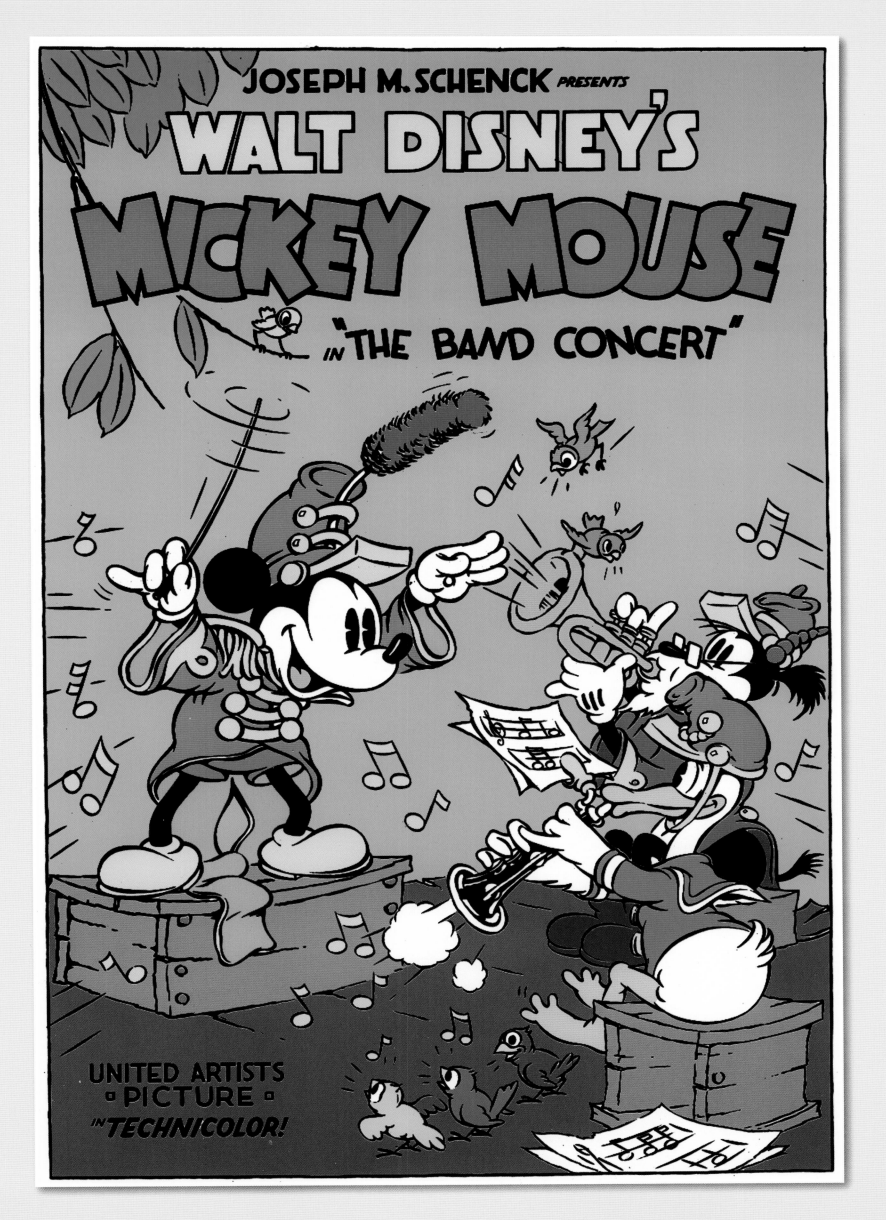

THE BAND CONCERT, 1935

ALPINE CLIMBERS, 1936

MAGICIAN MICKEY, 1937

DON DONALD, 1937

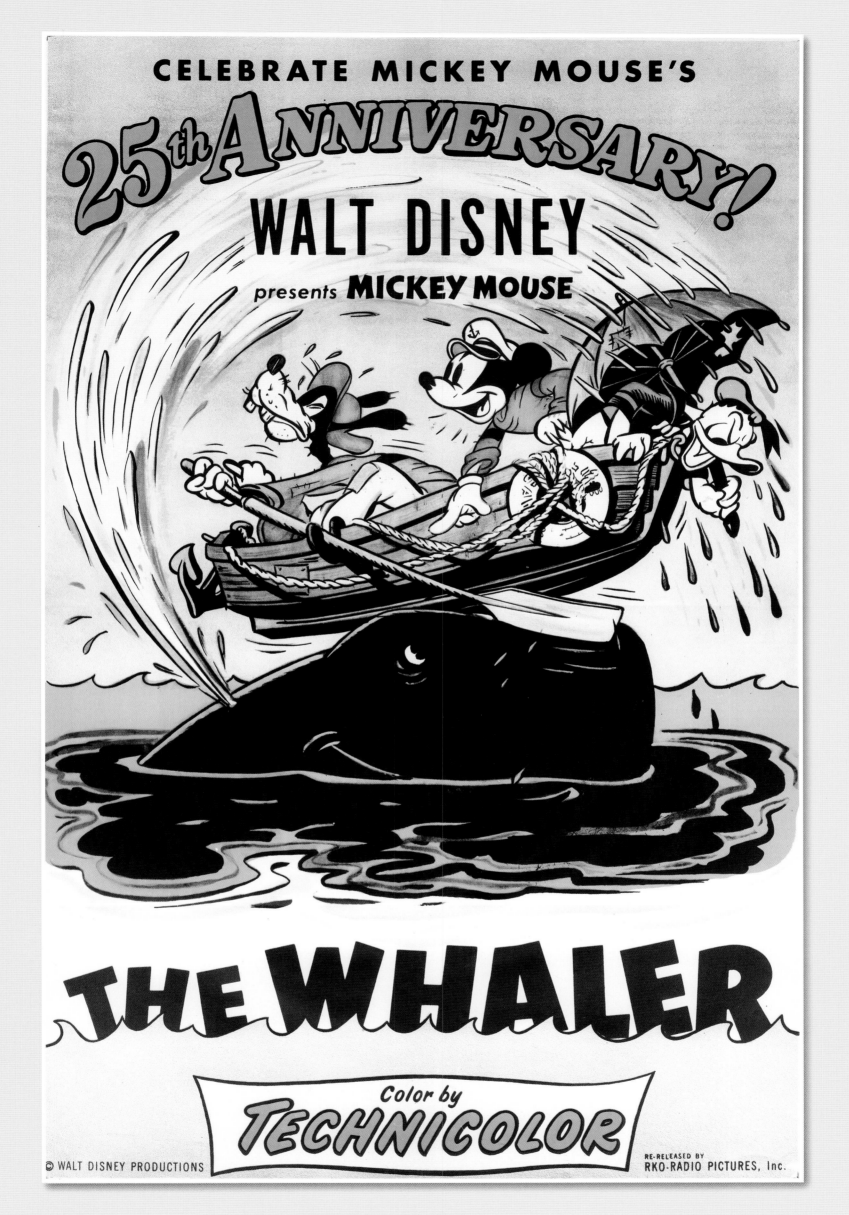

THE WHALER, 1938

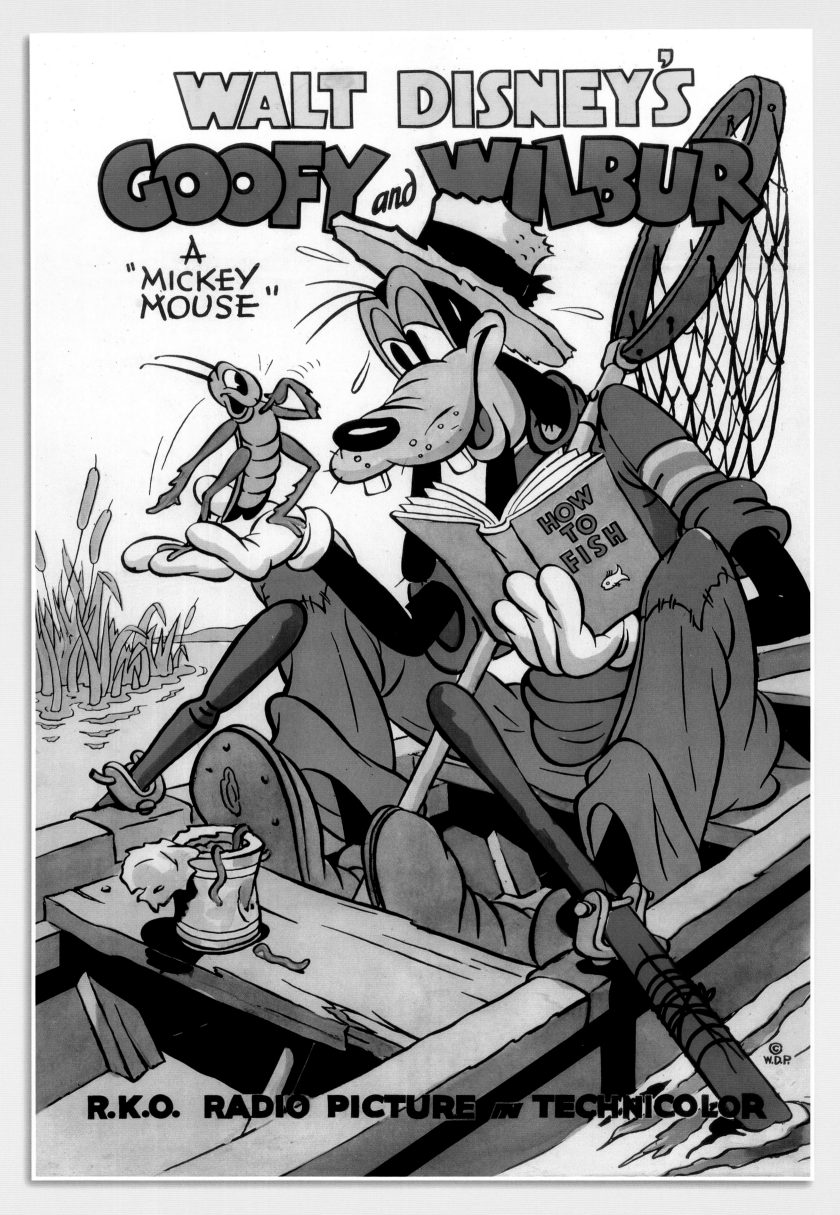

GOOFY AND WILBUR, 1939

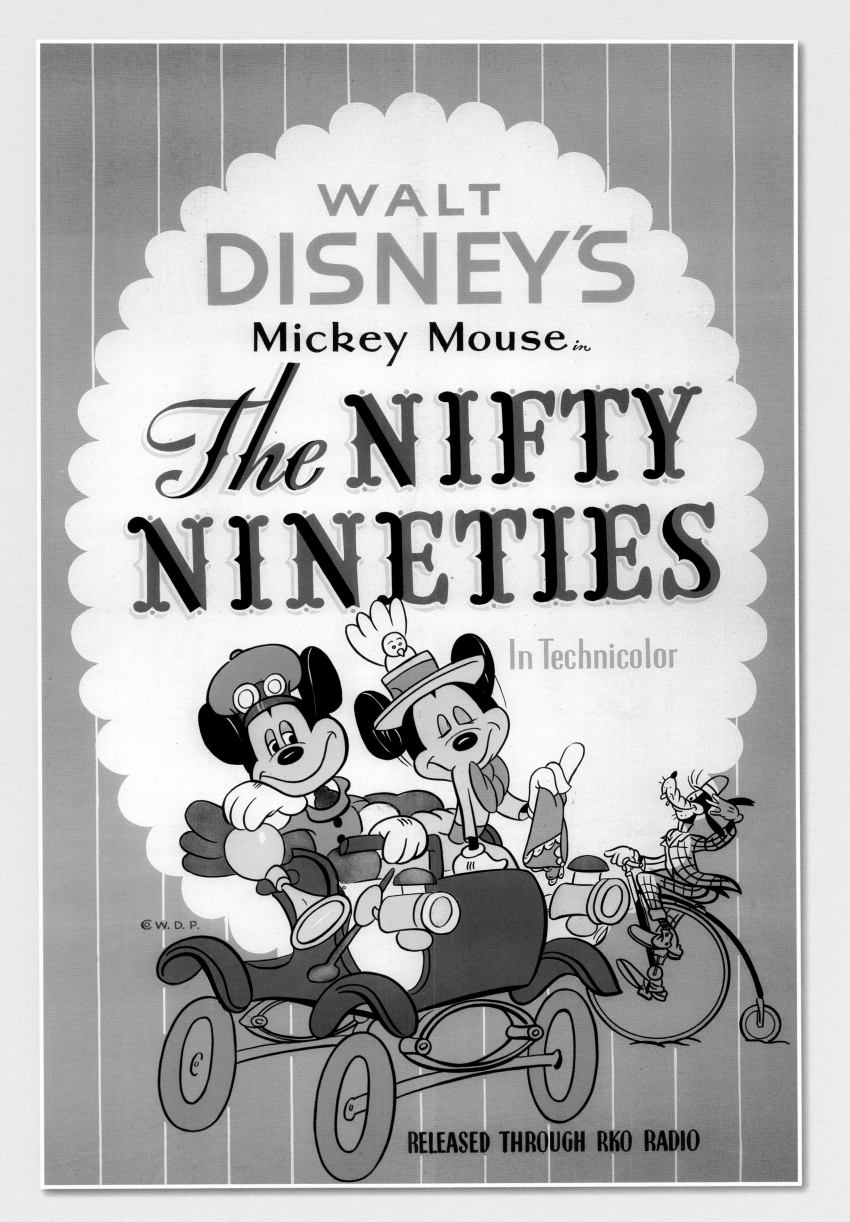

THE NIFTY NINETIES, 1941

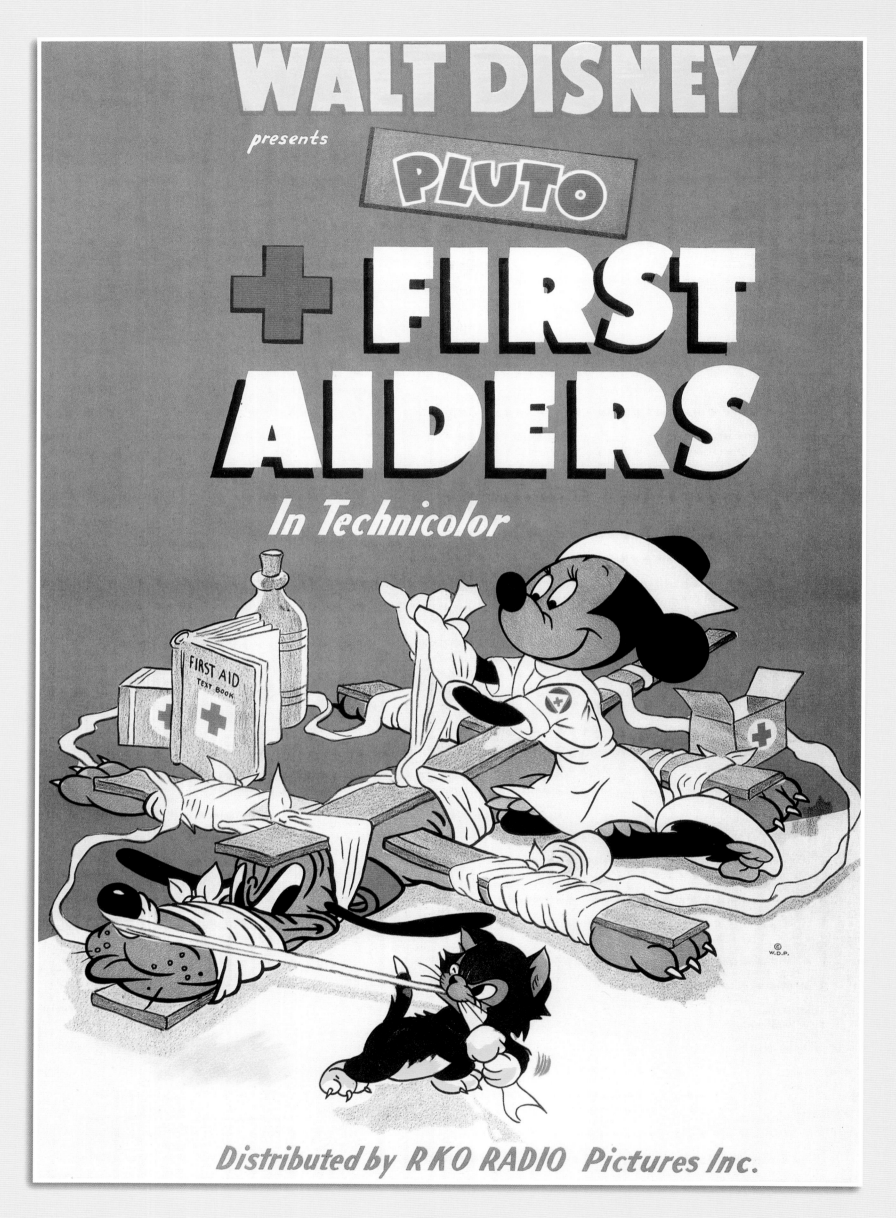

FIRST AIDERS, 1944

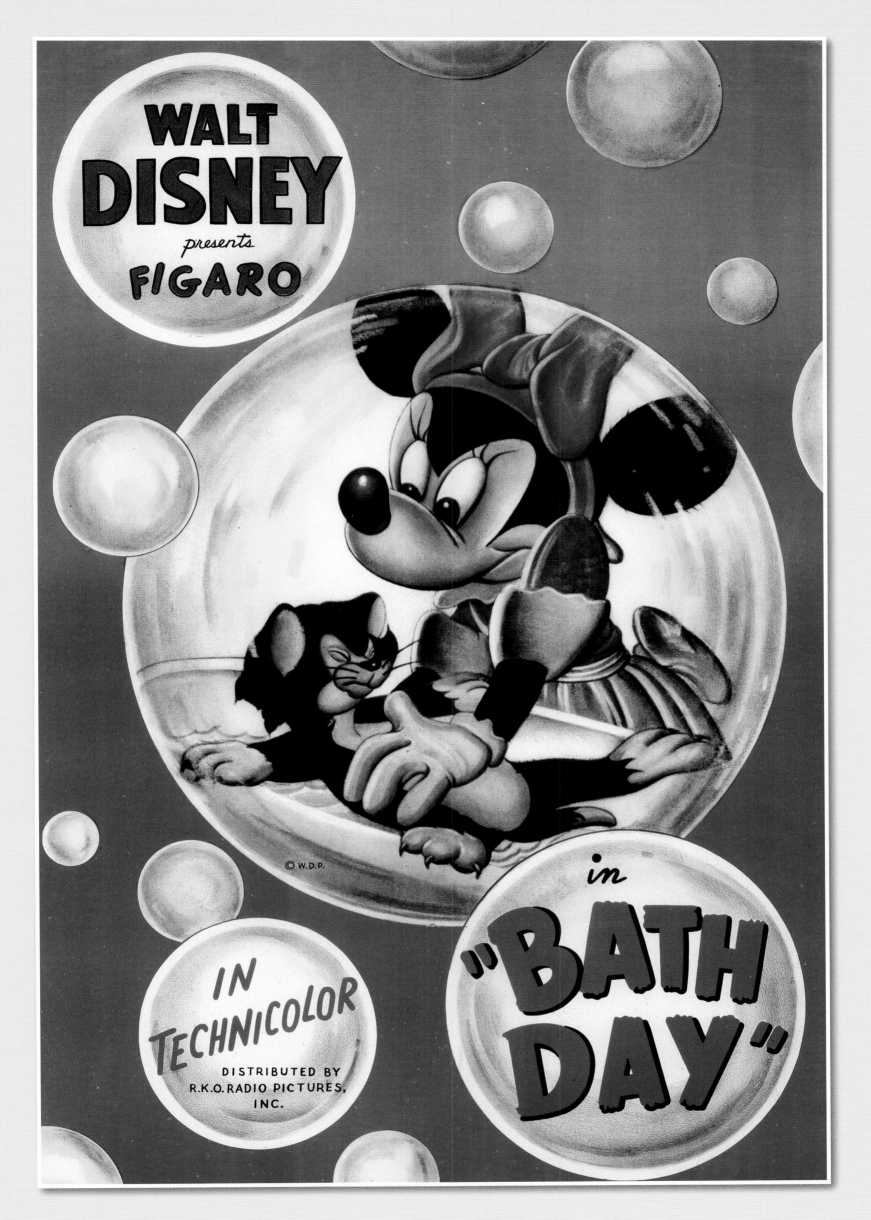

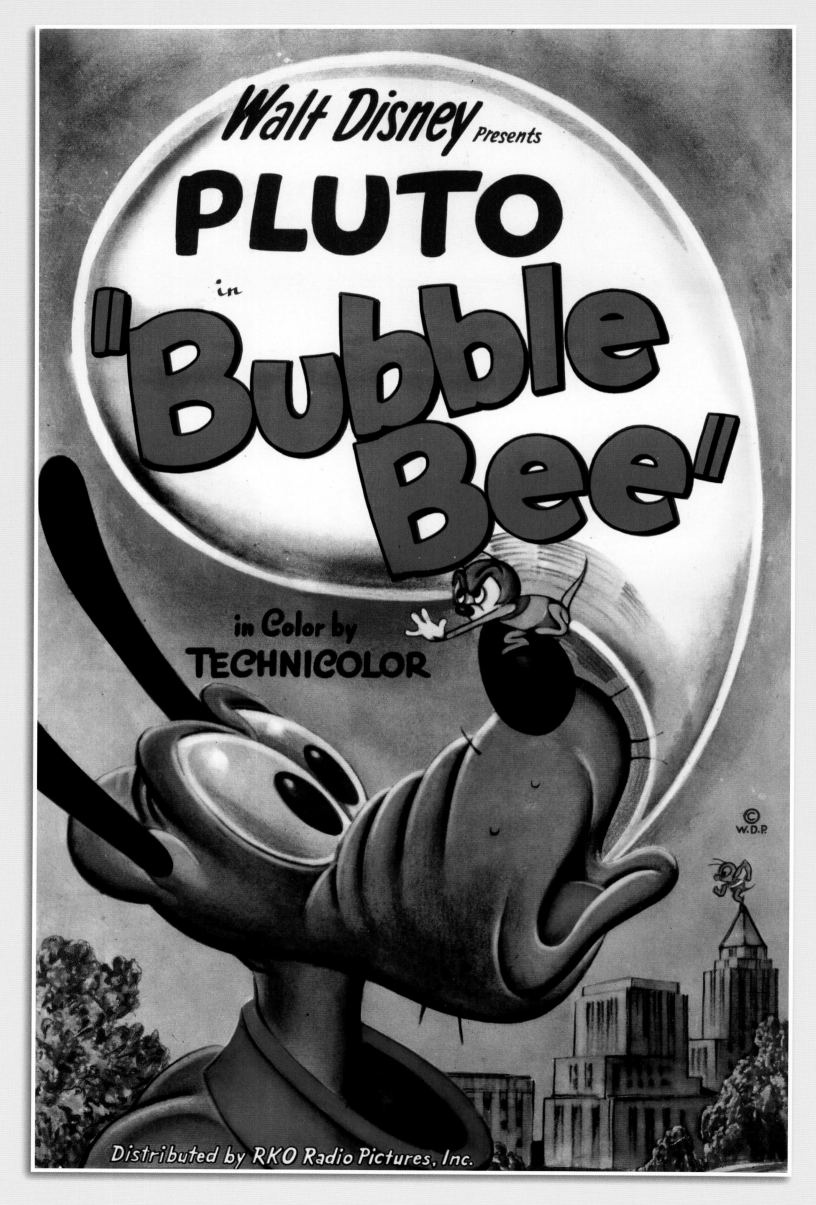

BUBBLE BEE, 1949

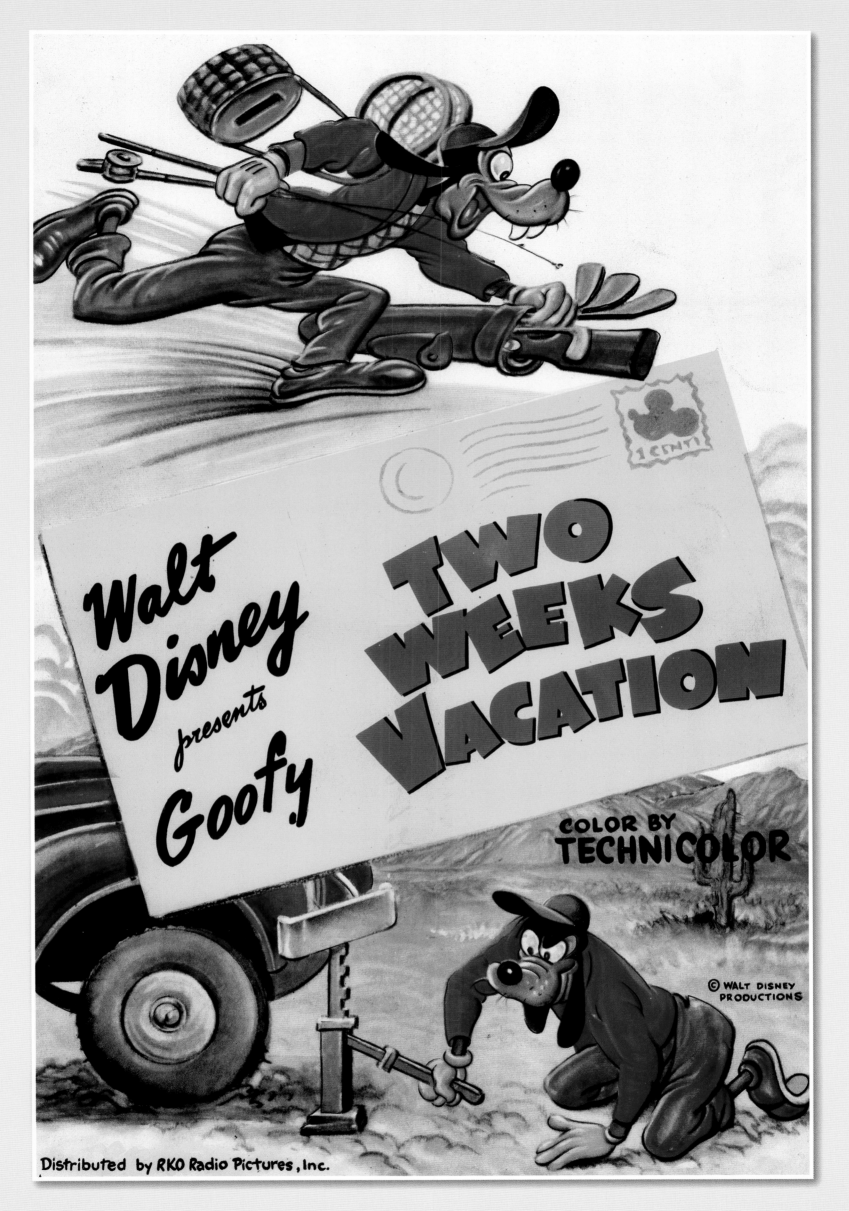

TWO WEEKS VACATION, 1952

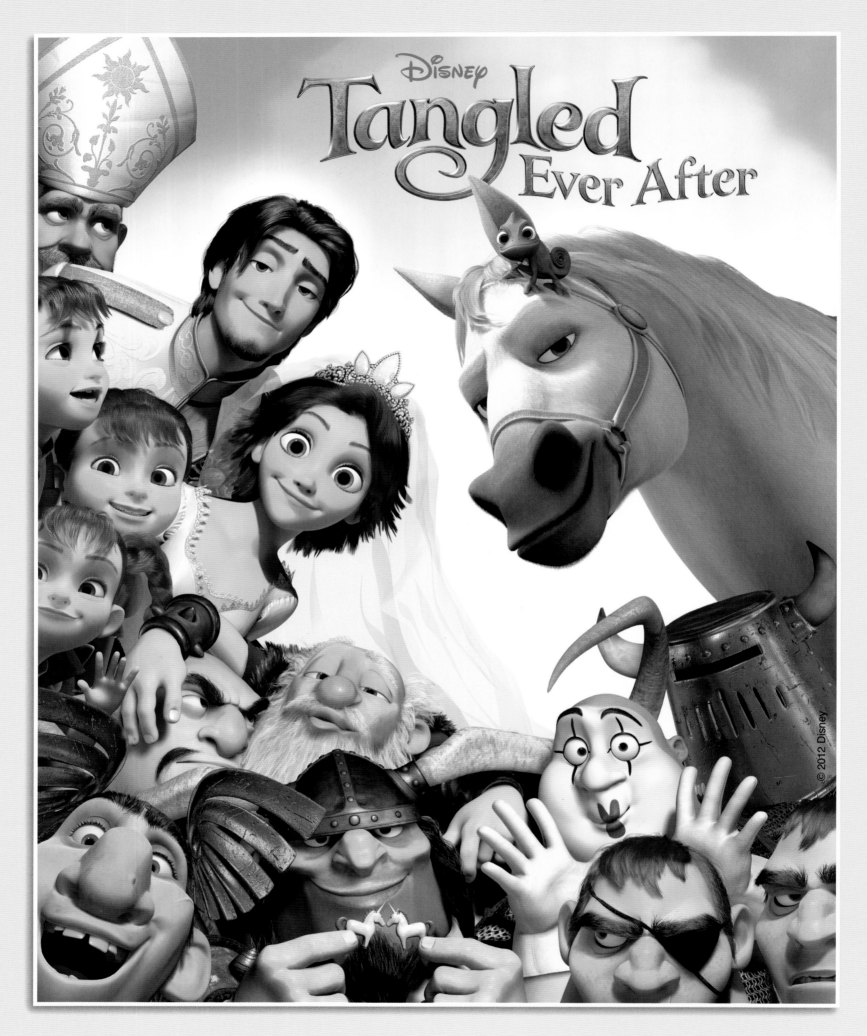

TANGLED EVER AFTER, 2012

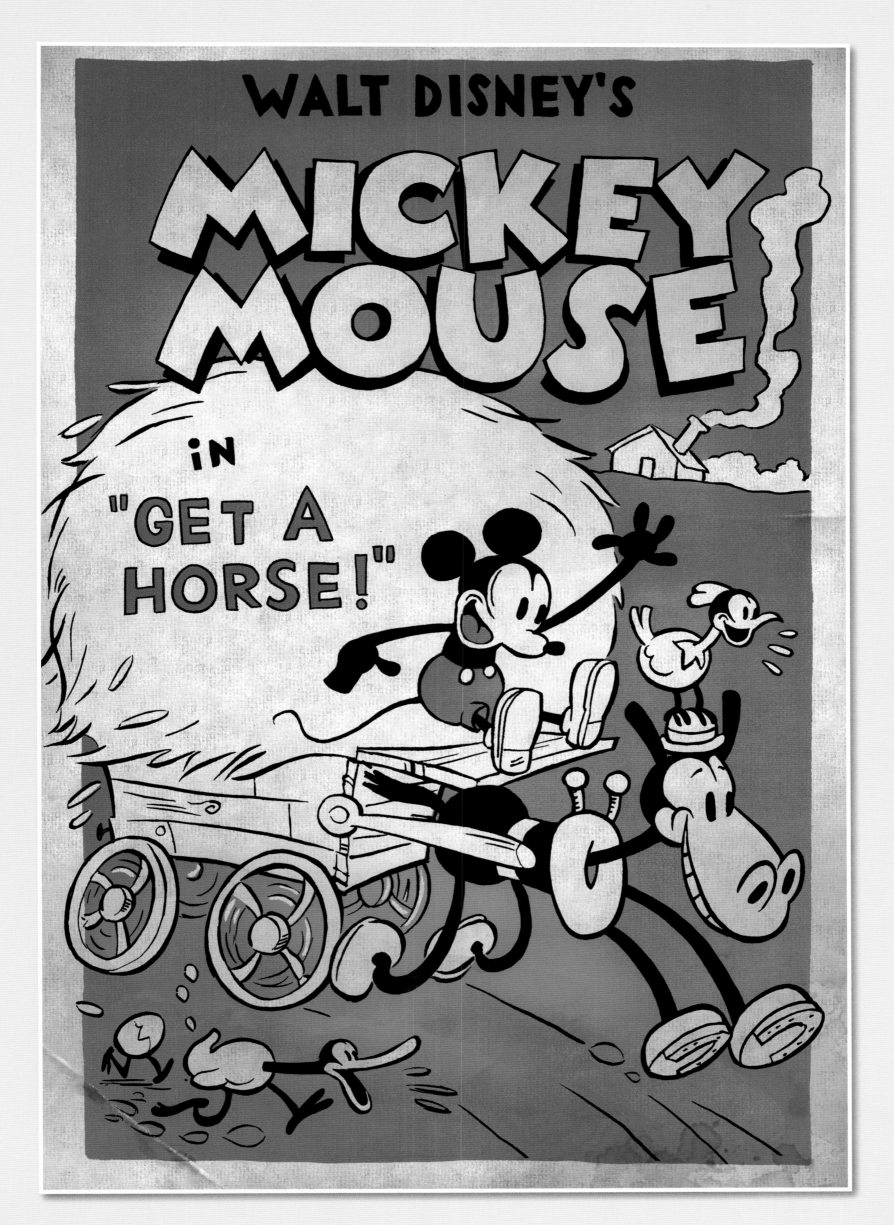

GET A HORSE!, 2013

THE GOLDEN AGE

"I can move! I can walk! I can talk!"

— Pinocchio, *Pinocchio*, 1940

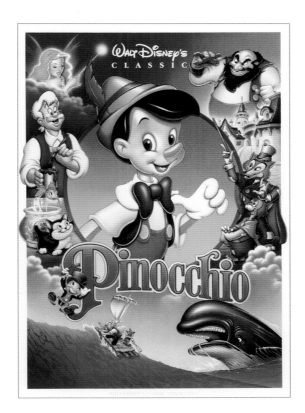

PINOCCHIO, 1992
(rerelease, marketed to children)

IN 1934, emboldened by the success of his animated shorts, Walt Disney announced plans to produce a full-length animated movie. *Snow White and the Seven Dwarfs*, based on the Grimm fairy tale, was a massive undertaking for the fledgling Disney studio and its small but dedicated band of artists. One of these artists, Gustav Tenggren, also designed the posters for the movie.

Ever the perfectionist, Walt hired an art teacher to instruct his team and also urged them to study live animals in order to accurately portray their natural movement. As costs spiraled, the project became known around Hollywood as "Disney's Folly." Walt would eventually have to mortgage his house to complete the movie.

Ultimately, Disney's faith and investment in the project were vindicated—several times over. *Snow White* was both a critical and commercial success upon its release in December of 1937, and the film earned Disney an honorary Academy Award (and seven mini ones—a nod to the film's diminutive costars).

The astonishing success of *Snow White* gave Walt the freedom to continue making his special brand of movies. Over the next five years, the so-called "Golden Years," Disney would produce four more classics: *Pinocchio*, *Fantasia*, *Dumbo*, and *Bambi*.

But by the time *Bambi* was released in 1942, World War II was raging throughout Europe and much of Asia. Walt, who had served as an ambulance driver following the First World War, channeled his resources—and popular characters like Mickey and Donald—into aiding the Allied effort. The studio produced training videos and pro-American propaganda films like *Victory Through Air Power* for every branch of the U.S. military, a total of sixty-eight hours of film.

Throughout the rest of the 1940s, with many foreign markets remaining closed to American media, Walt focused on producing "package films" like *Make Mine Music* and *The Three Caballeros*. These collections of short animated stories were less expensive to produce than full-length features, which was important given how much Disney had spent to support the war effort.

Still, Walt Disney's studio, which had seemed poised for enormous growth and success following the release of *Snow White*, found itself in a precarious position at the dawn of the 1950s. Fortunately, the birth of another Disney princess was just over the horizon.

SNOW WHITE AND THE SEVEN DWARFS, CIRCA 1937 (Germany)

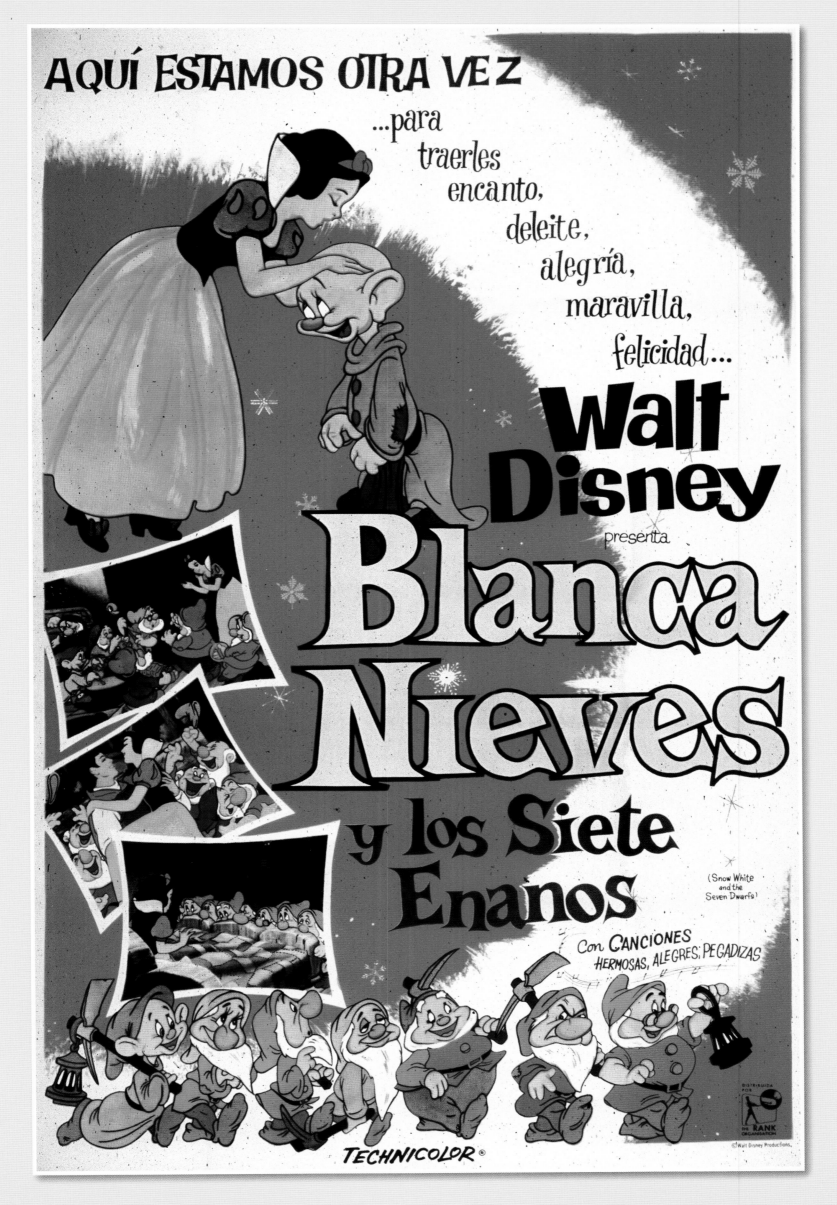

SNOW WHITE AND THE SEVEN DWARFS, 1937 (Spanish)

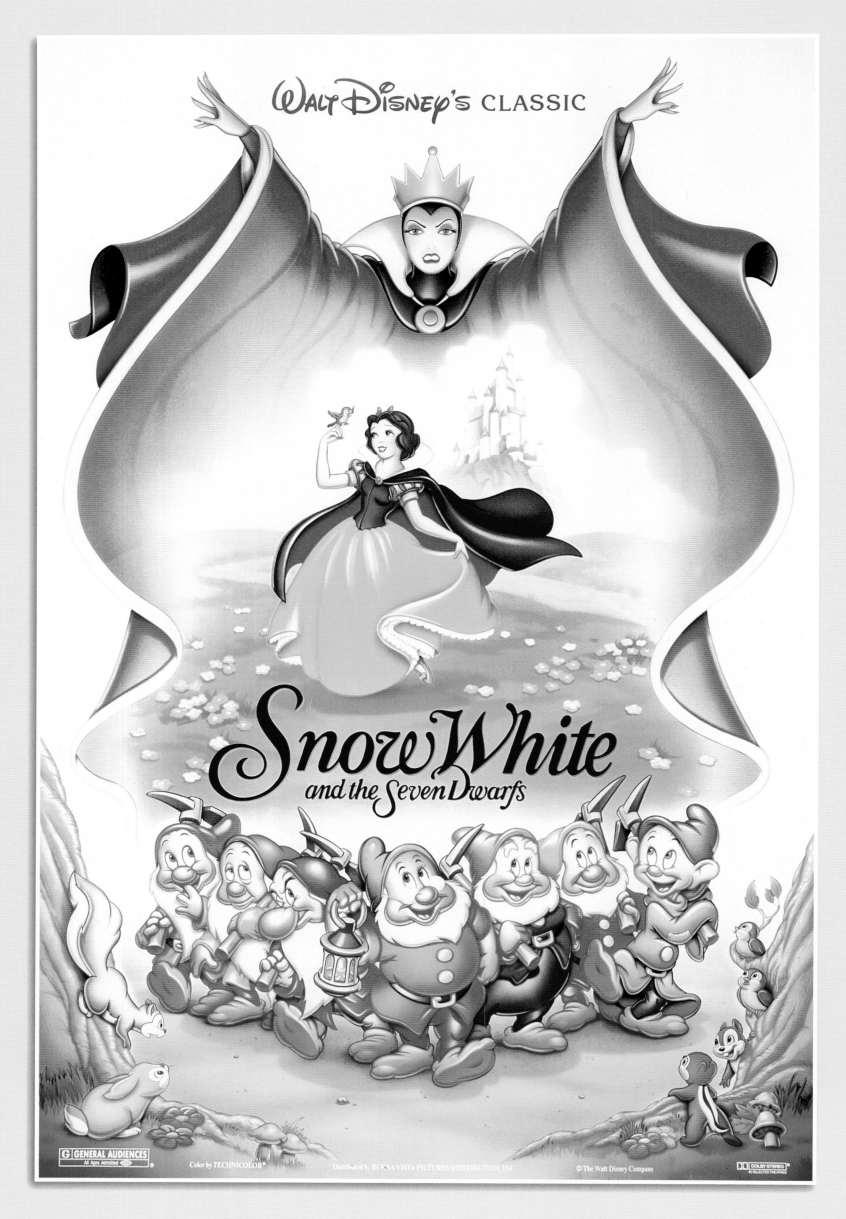

SNOW WHITE AND THE SEVEN DWARFS, 1993 (rerelease, marketed to children)

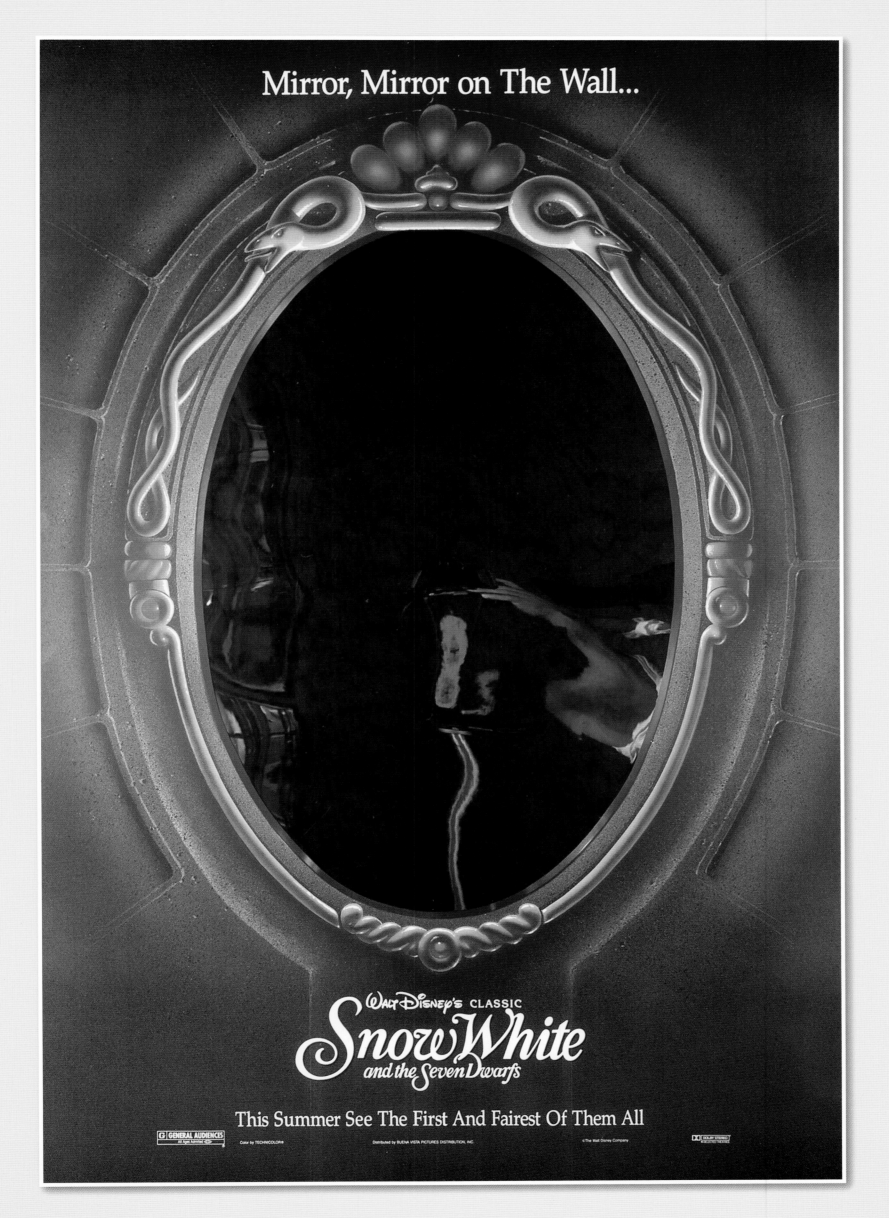

SNOW WHITE AND THE SEVEN DWARFS, 1993 (rerelease, marketed to adults)

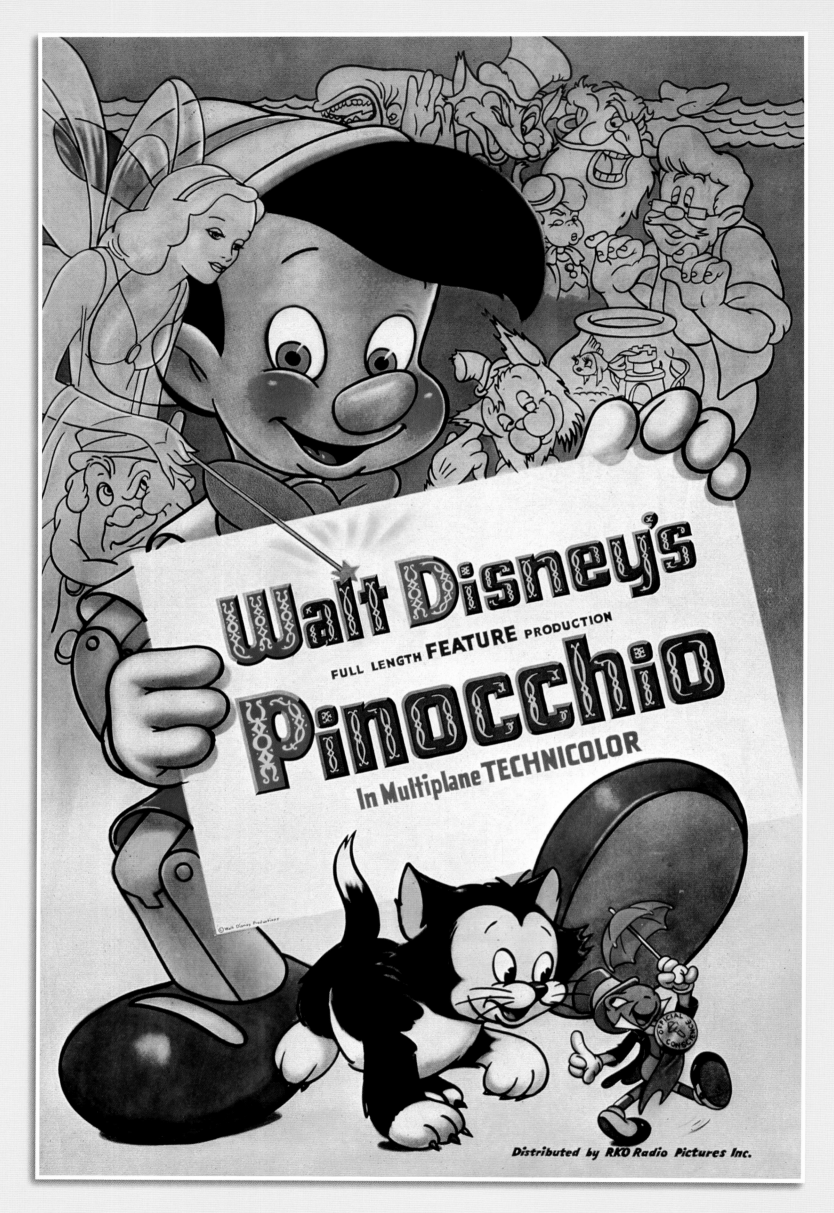

PINOCCHIO, 1940

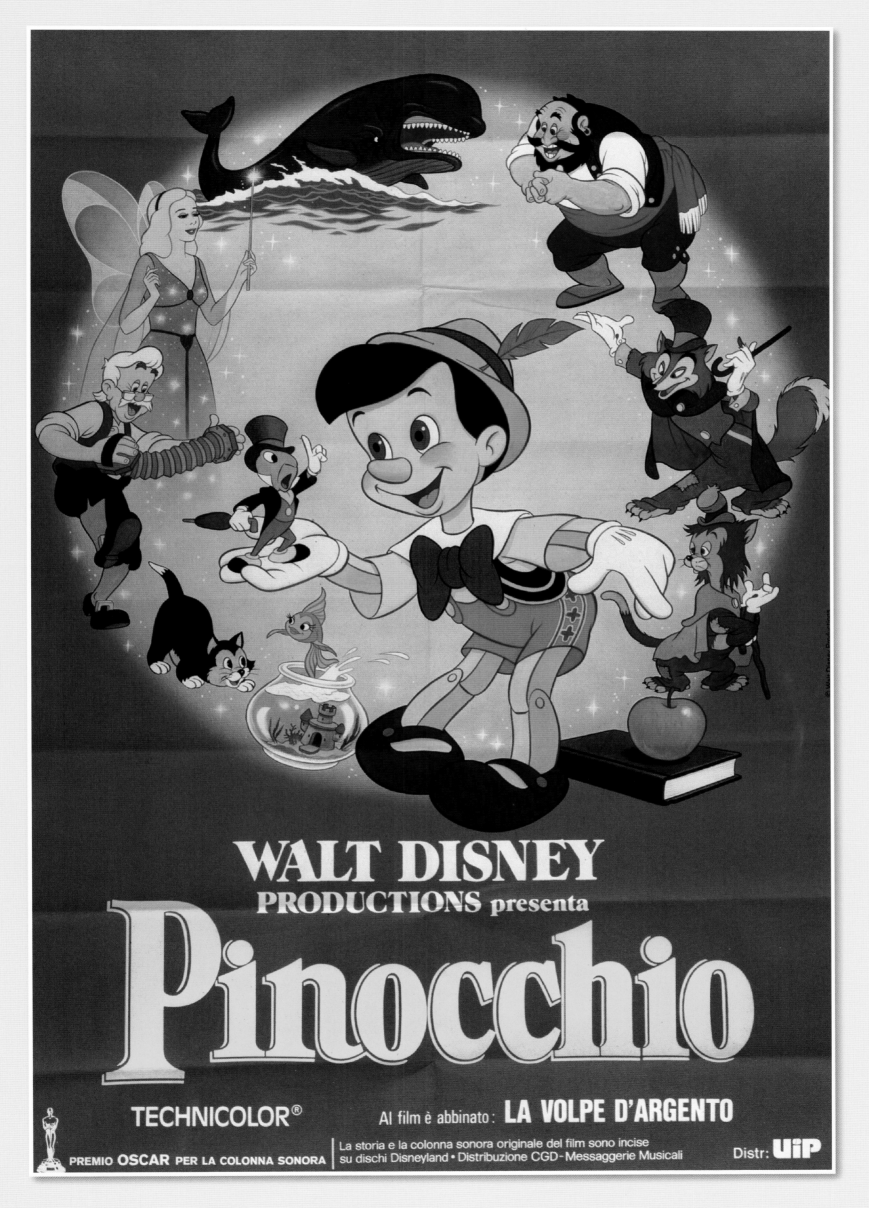

PINOCCHIO, CIRCA 1940 (Italy)

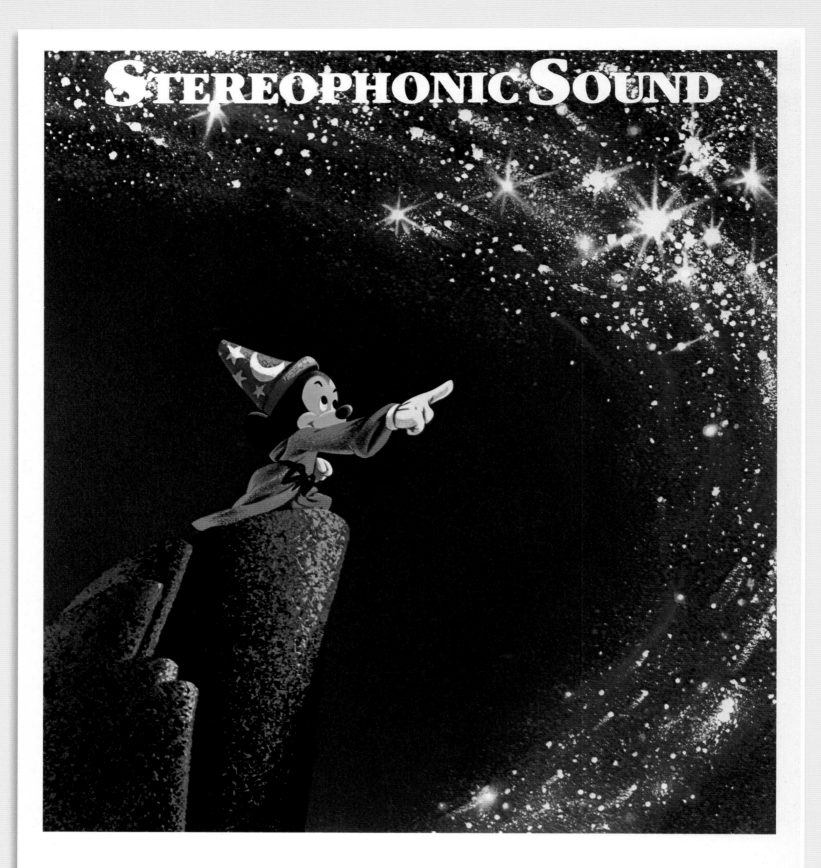

FANTASIA, 1940 (rerelease 1981)

FANTASIA 2000, 2000

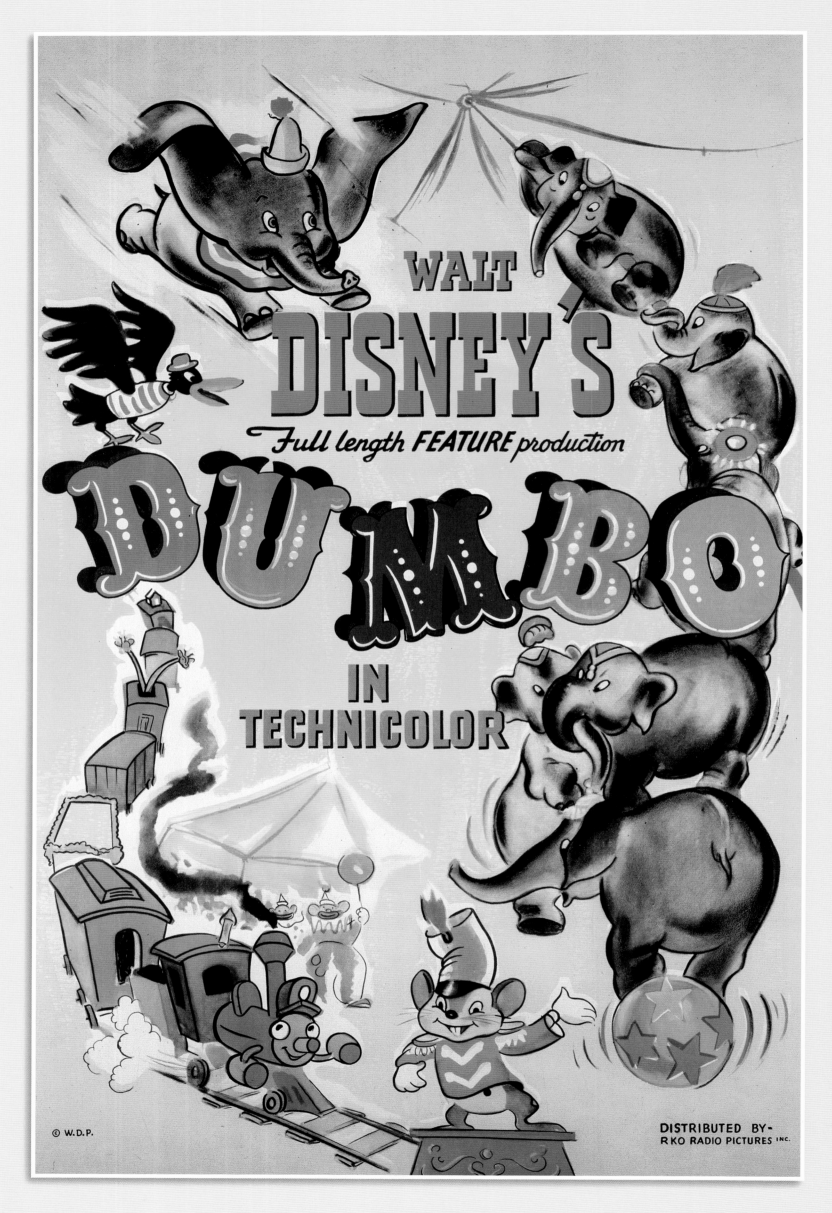

DUMBO, 1941

DUMBO, 1972 (rerelease)

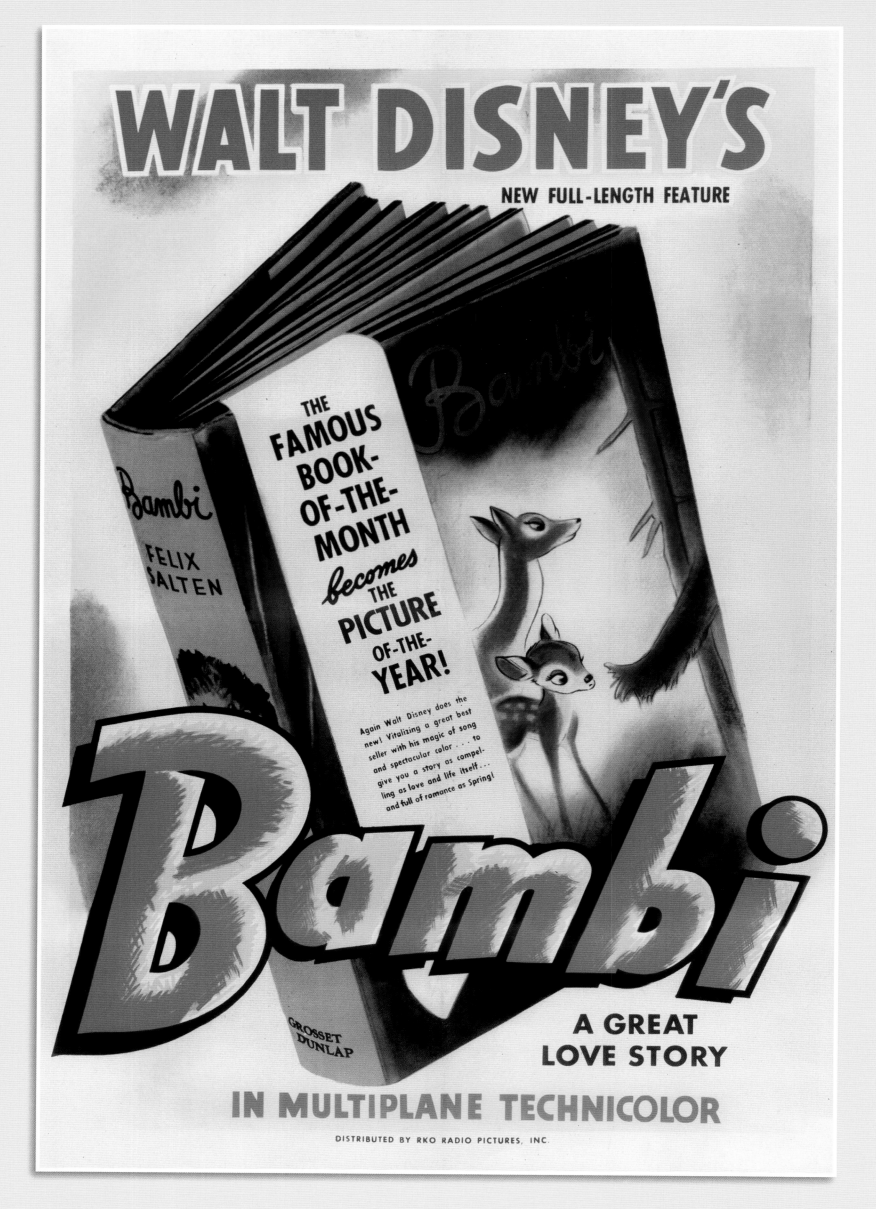

BAMBI, 1942

VICTORY THROUGH AIR POWER, 1943

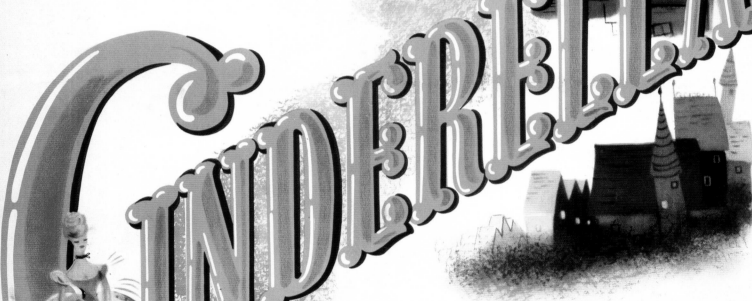

CINDERELLA, 1950

THE REBIRTH OF ANIMATION

"If I had a world of my own,
everything would be nonsense.
Nothing would be what is
because everything would be what isn't."

— Alice, *Alice in Wonderland*, 1951

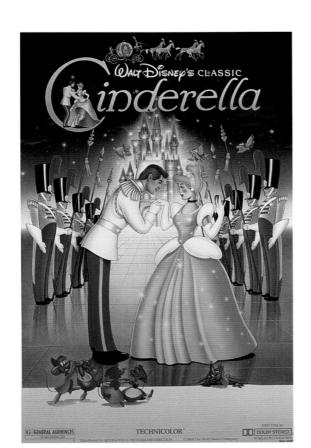

CINDERELLA, 1987
(rerelease)

EIGHT long years had passed since the release of *Bambi*, the last of Disney's remarkable Golden Age movies, when the studio released *Cinderella* in early 1950. Like *Snow White*, this new film was based on a fairy tale and would go on to headline a new era of animated hits that would save Walt's struggling studio. Wildly popular in the United States, *Snow White* was equally beloved abroad, allowing Disney's brand to spread rapidly worldwide. Posters advertising *Alice in Wonderland*, *Peter Pan*, and *Sleeping Beauty* would soon appear in theaters as far away as Japan and Israel.

Each of this time period's stories—and the posters promoting them—featured the Disney hallmarks that fans had grown to expect: vivid animation, bold effects, and endlessly memorable characters. There was good reason for this continuity—Walt himself remained intimately involved in every movie's development until his death in 1966, and he was keenly interested in using technological innovation to improve his movies. In shorts such as *Steamboat Willie* and *The Old Mill,* and early movies such as *Pinocchio* and *Fantasia*, he had pioneered the use of synchronized sound, the multiplane camera, Technicolor, and stereo sound channels. With *Lady and the Tramp* in 1955, he championed the use of wide-screen.

The Jungle Book, which Walt had been working on during his illness, was released the year after his death, followed by *The Aristocats* in 1970. Both were hits, but the loss of Walt, and his brother Roy, who died in 1971, left a creative void that would be felt in many of the Disney films released during the 1970s and 1980s.

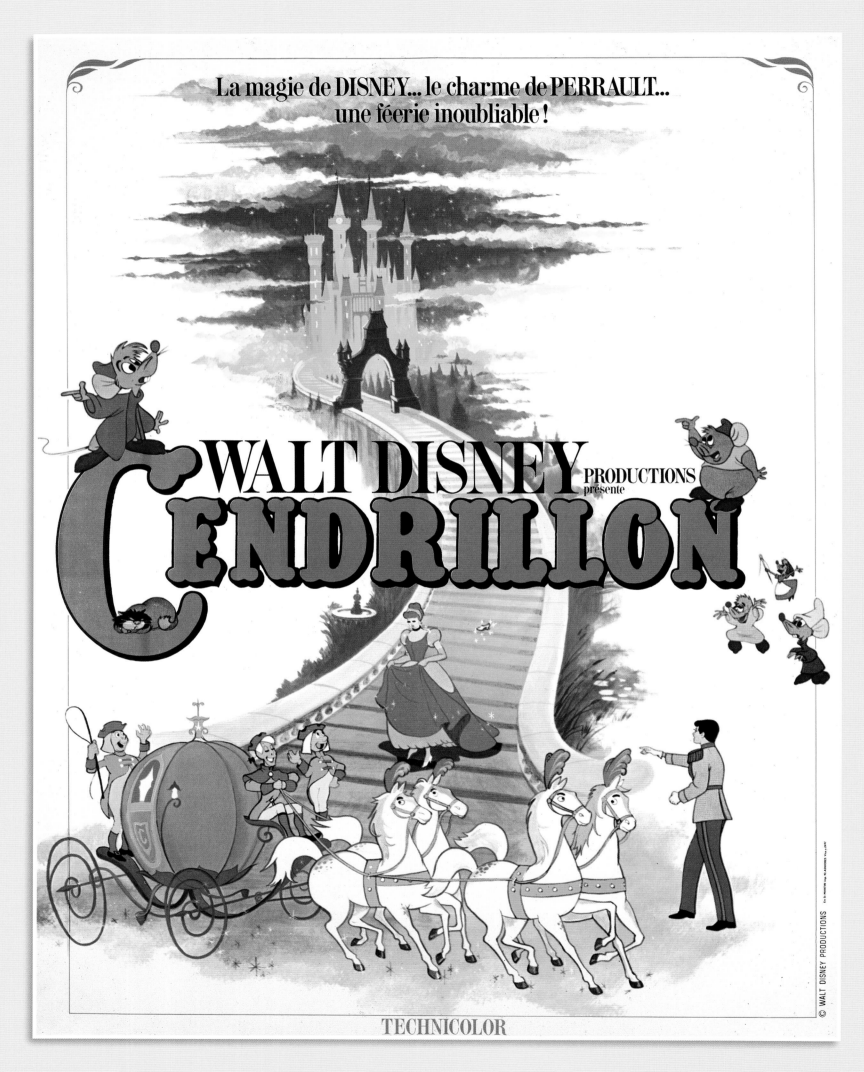

CINDERELLA, 1950 (France)

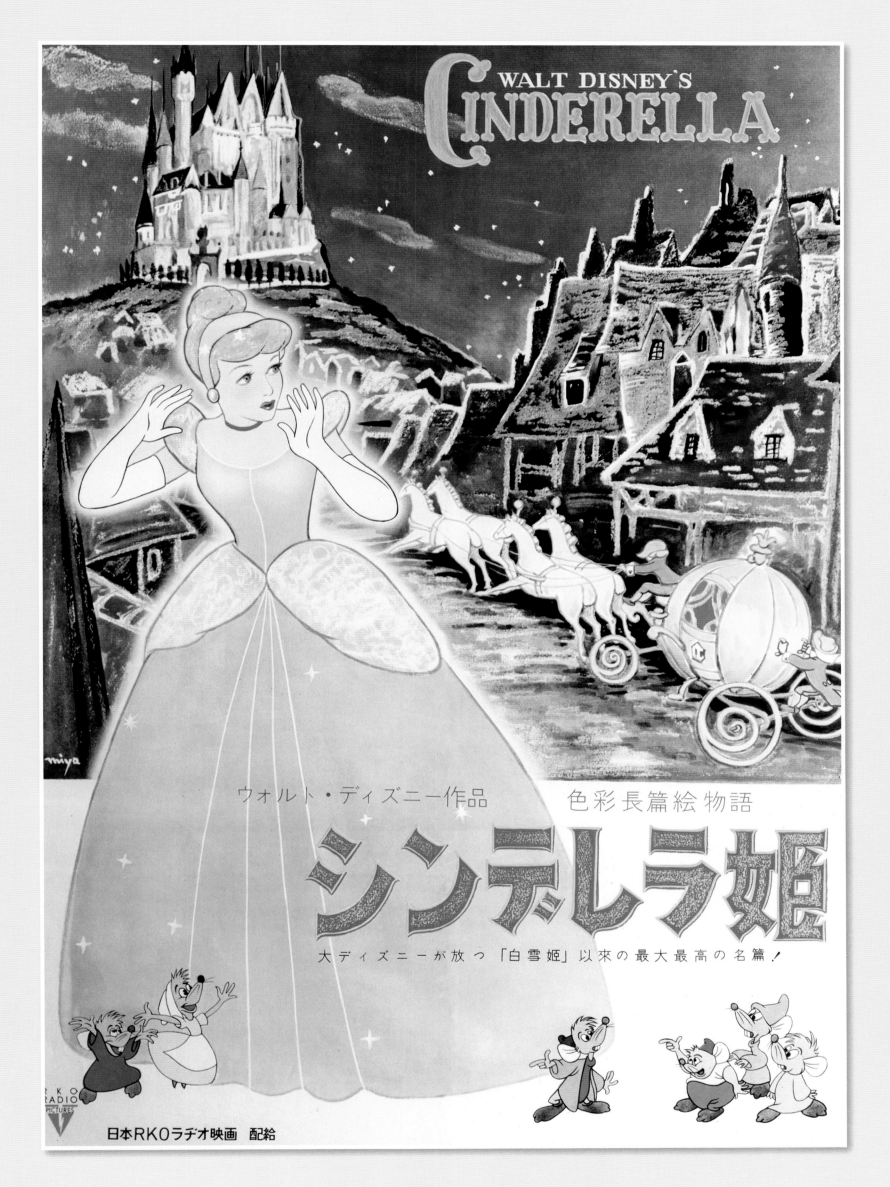

CINDERELLA, 1950 (Japan)

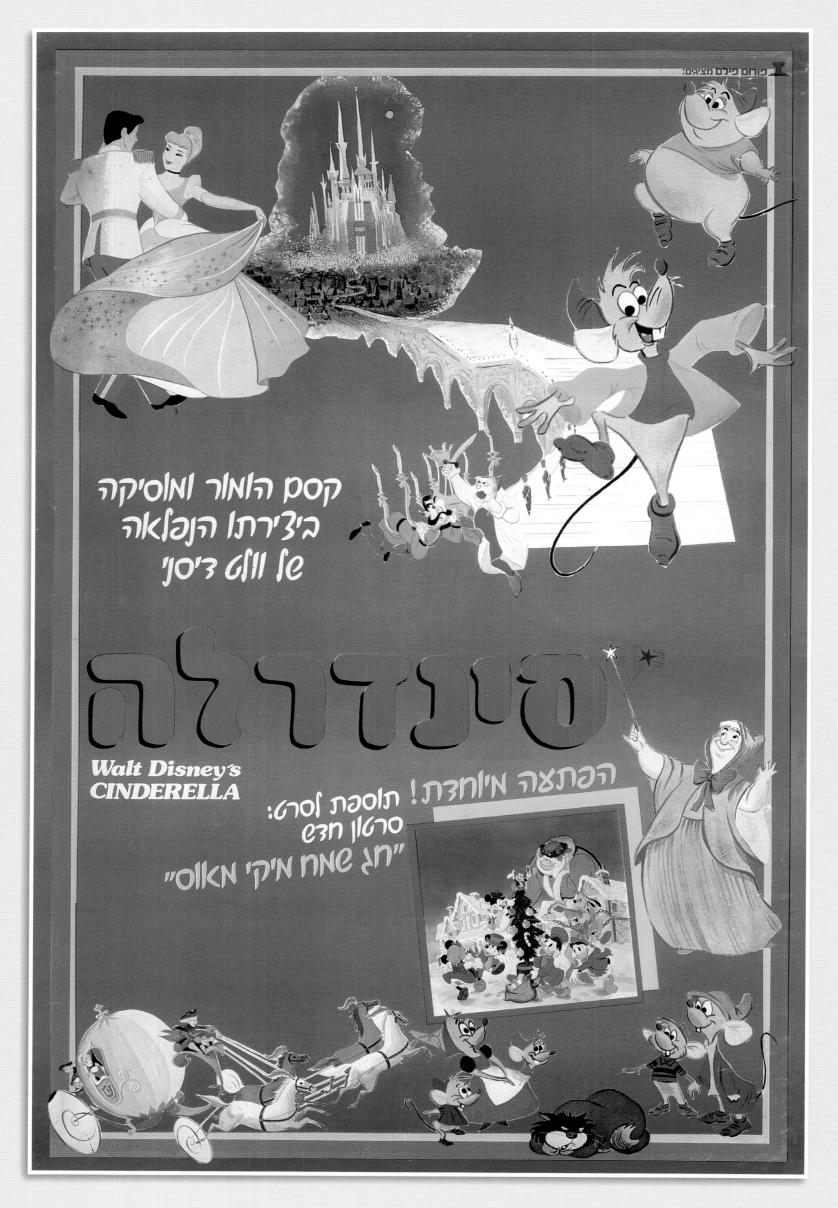

CINDERELLA, 1950 (Israel)

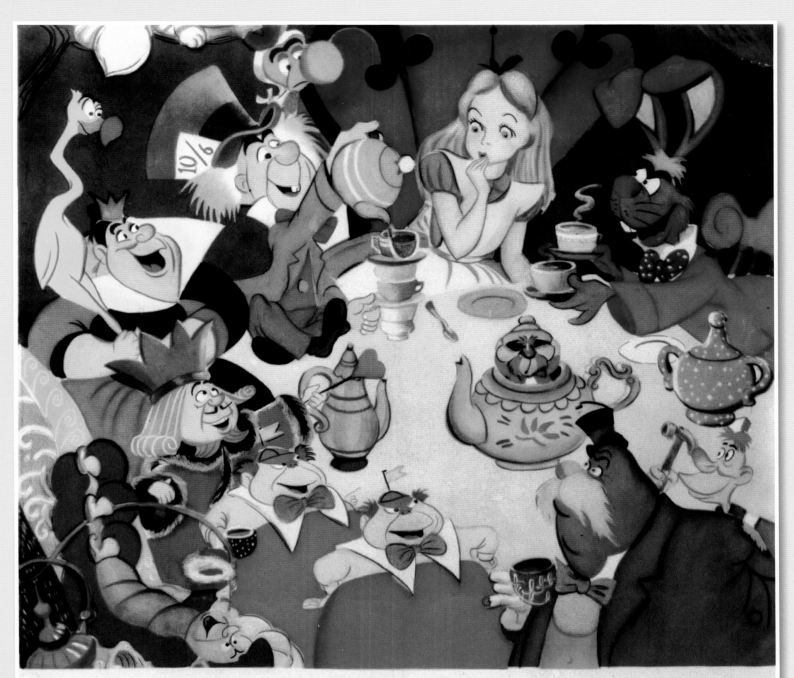

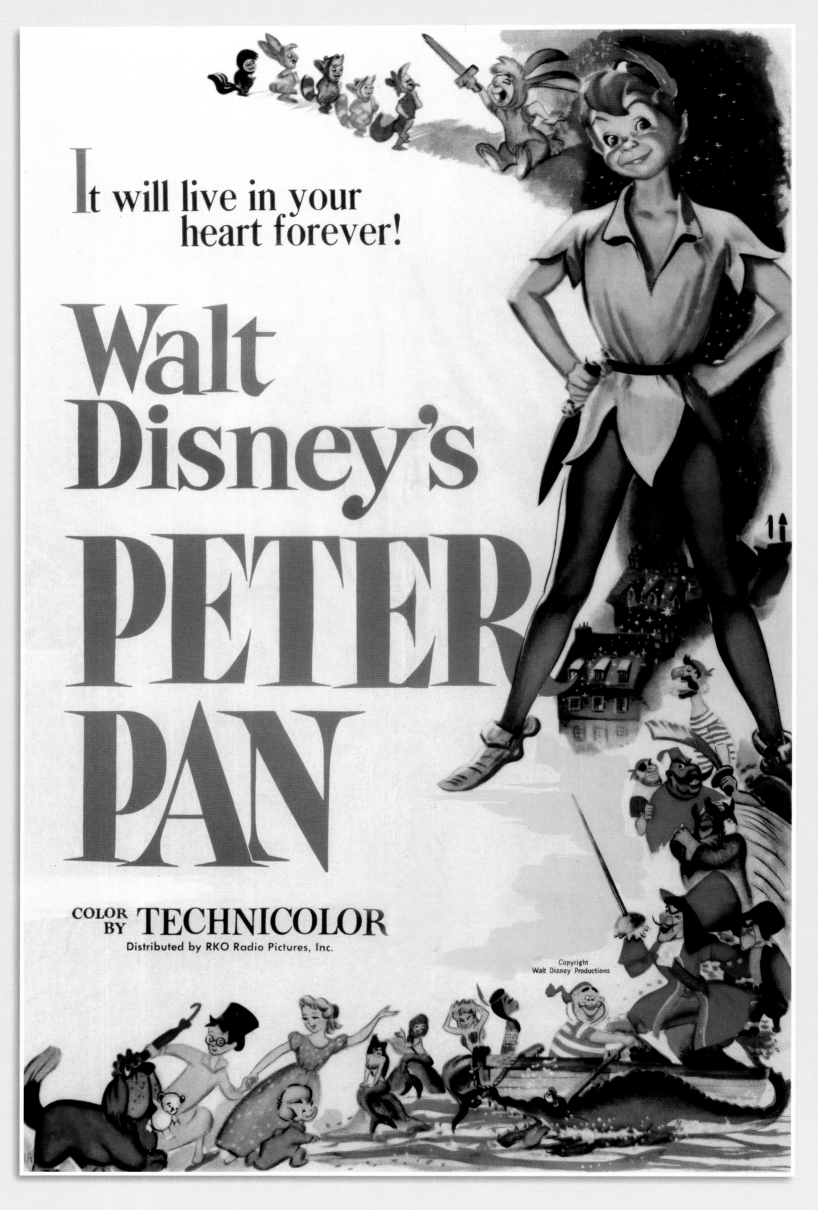

PETER PAN, 1953

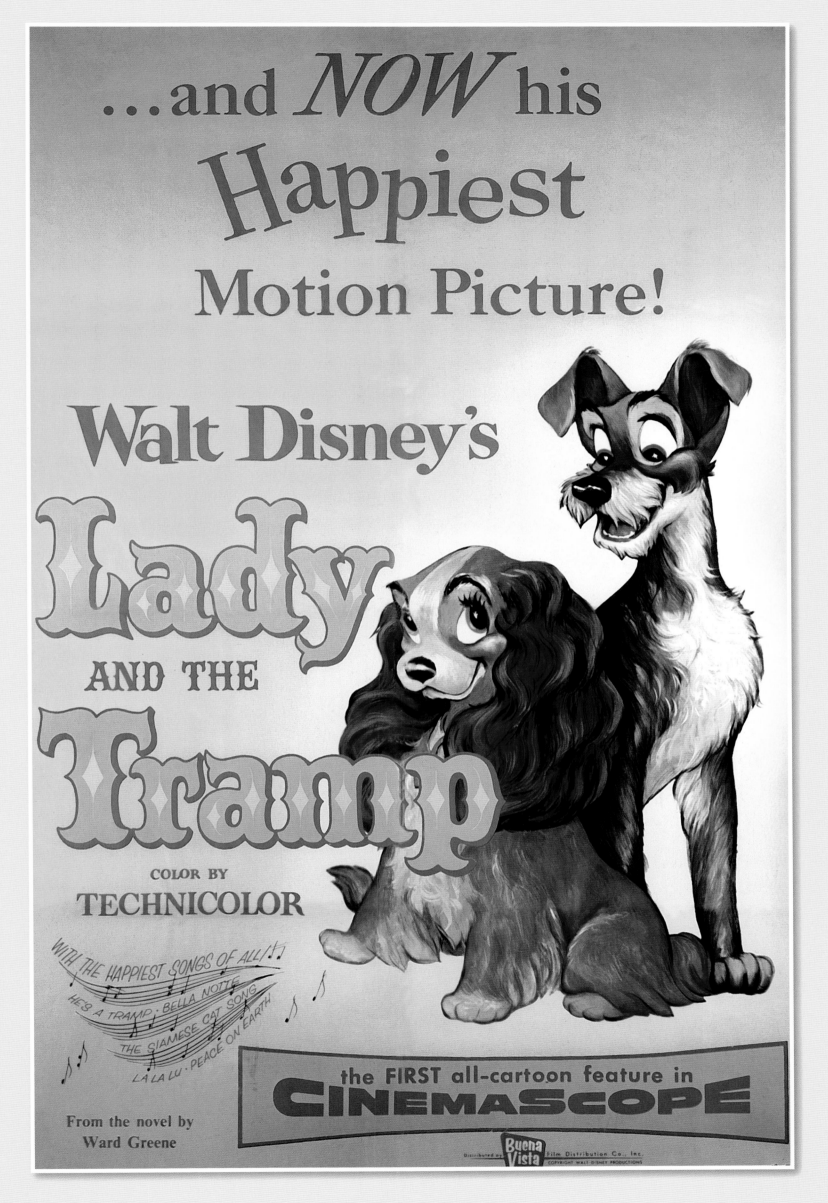

LADY AND THE TRAMP, 1955

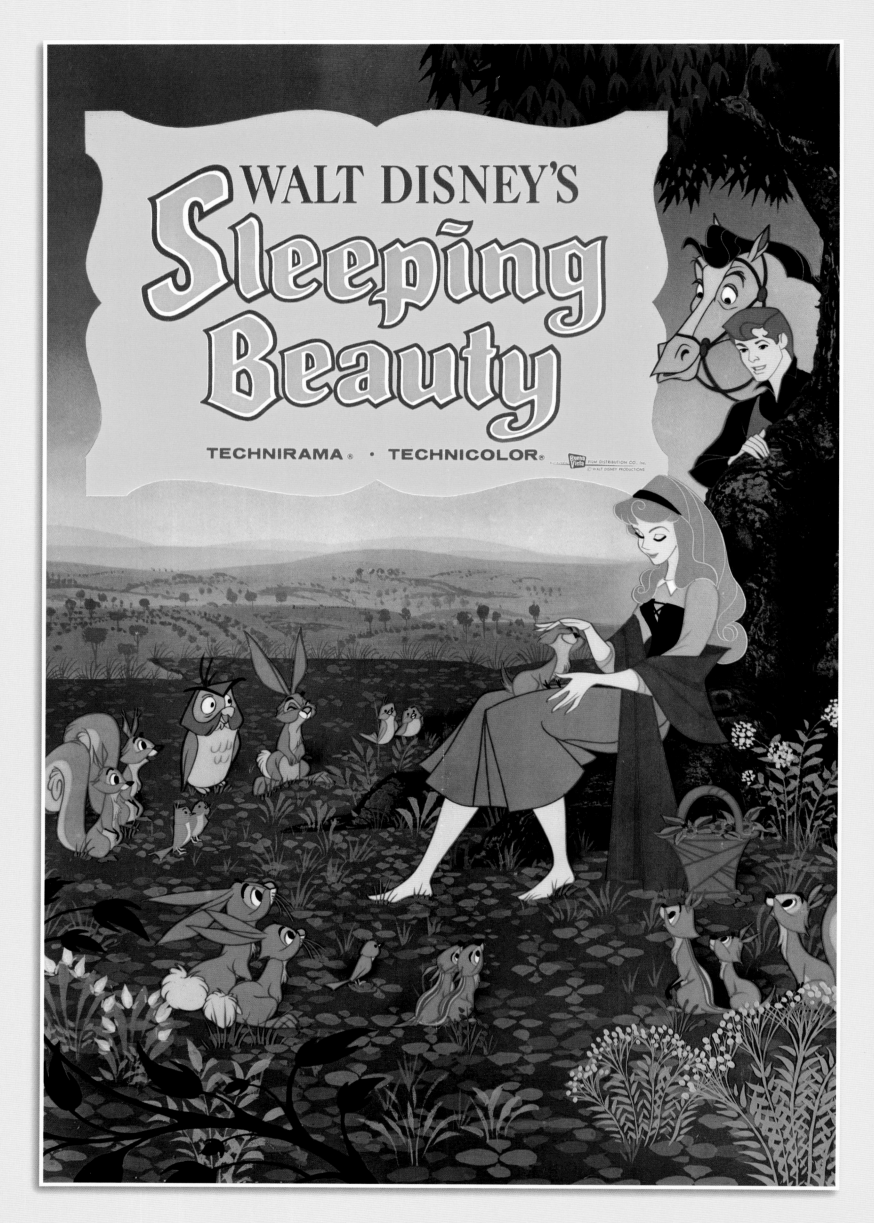

SLEEPING BEAUTY, 1959

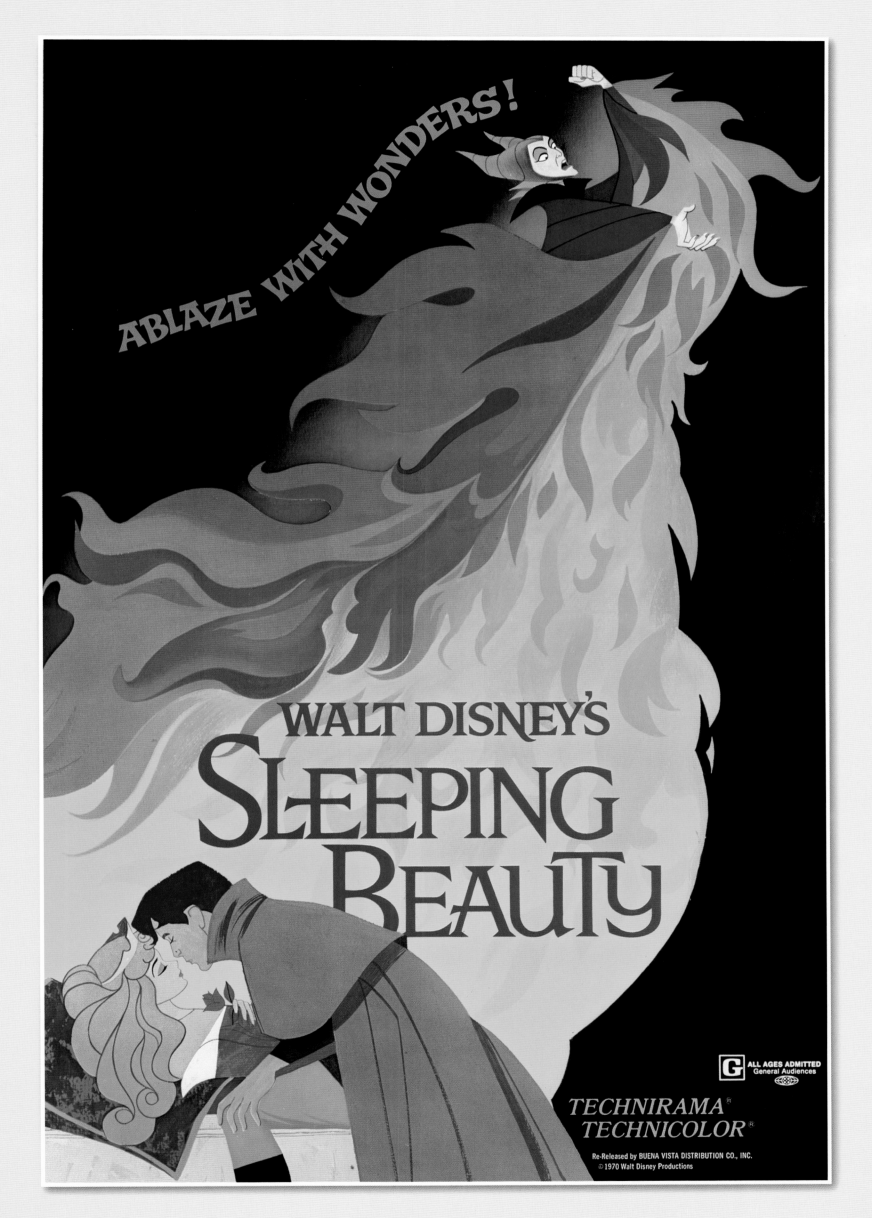

SLEEPING BEAUTY, 1970 (rerelease)

ONE GREAT BIG
ONEDERFUL MOTION PICTURE

WALT DISNEY'S
NEW ALL-CARTOON FEATURE

One Hundred and One
Dalmatians

technicolor®

Released by BUENA VISTA Distribution Co., Inc. ©Walt Disney Productions

ONE HUNDRED AND ONE DALMATIANS, 1961

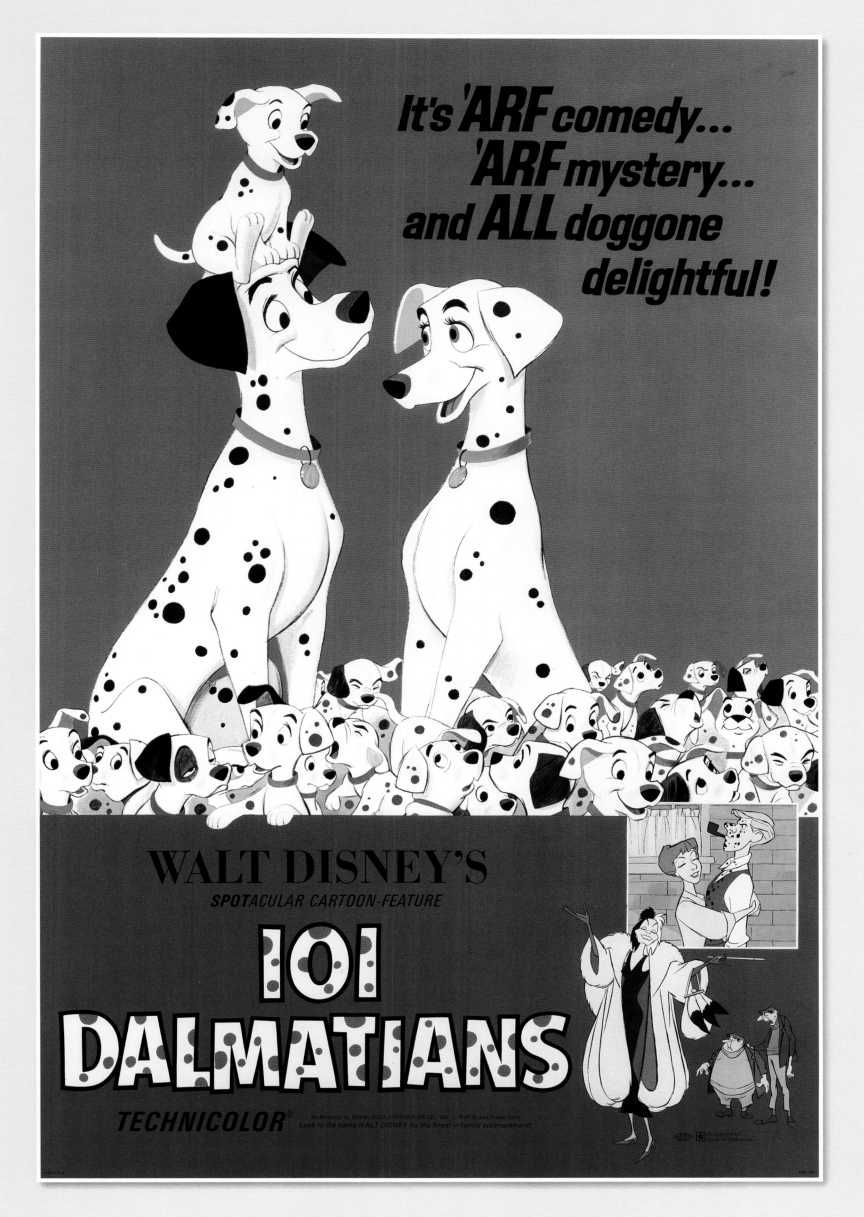

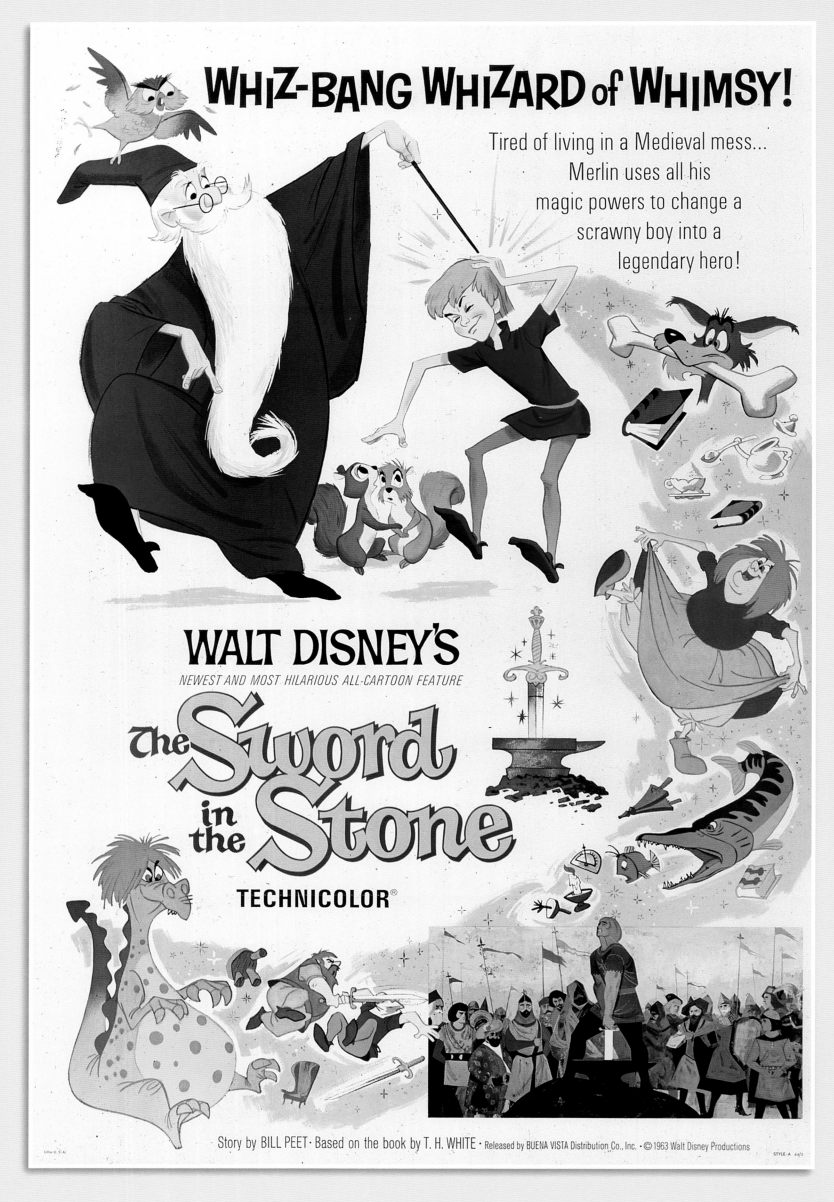

THE SWORD IN THE STONE, 1963

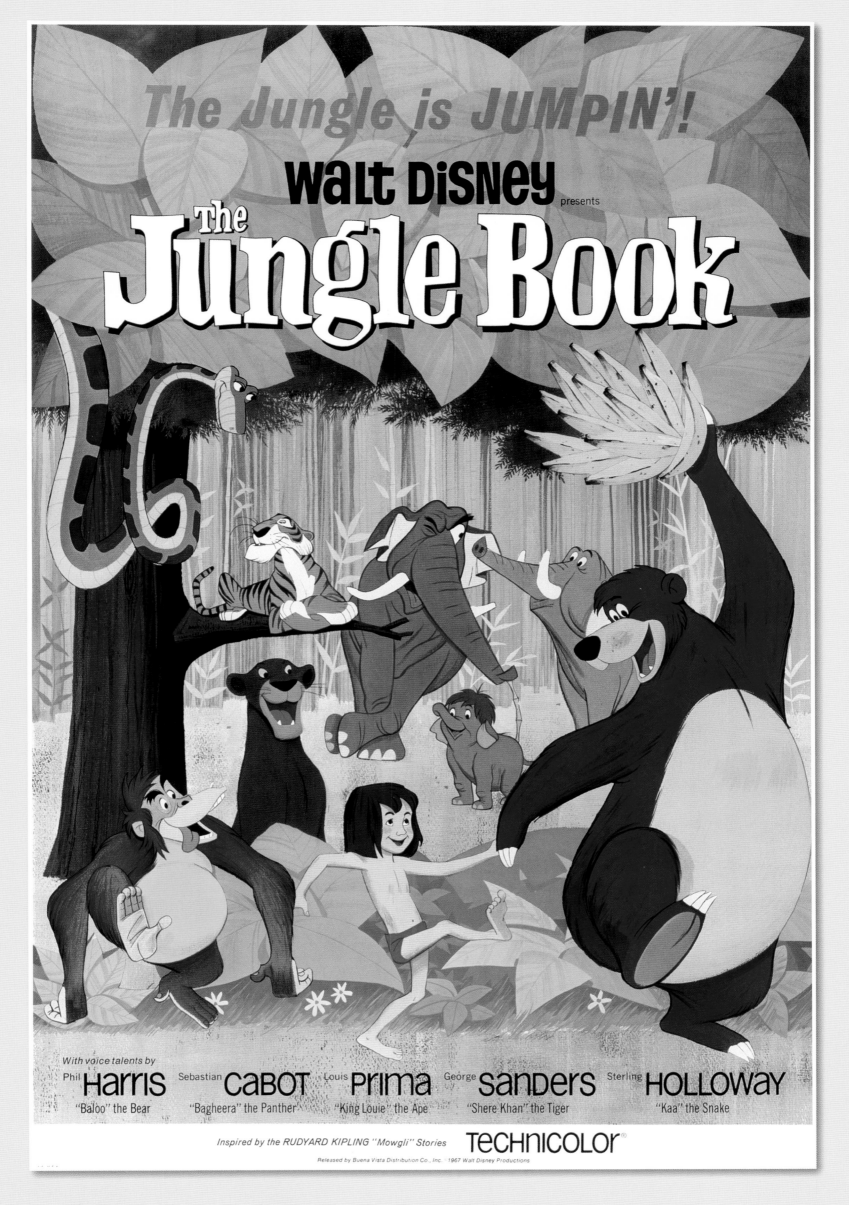

THE JUNGLE BOOK, 1967

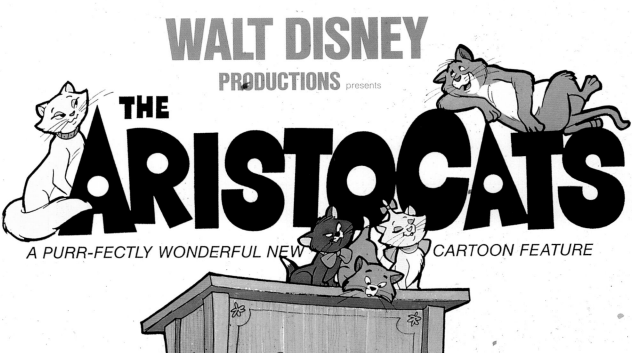

WALT DISNEY PRODUCTIONS presents

THE ARISTOCATS

A PURR-FECTLY WONDERFUL NEW CARTOON FEATURE

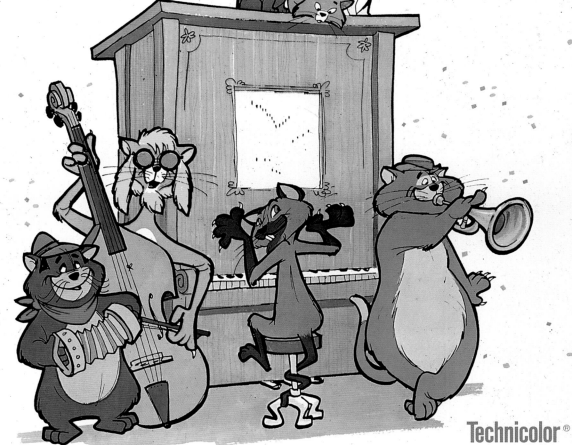

Technicolor ®

G

RELEASED BY BUENA VISTA DISTRIBUTION CO., INC.
©1970 Walt Disney Productions

**Meet the cats who know where it's at...
for fun, music and adventure!**

DUCHESS—
the creme
de la creme
of Paris catdom
voice — Eva Gabor

O'MALLEY—
the swinging king
of the alley
voice — Phil Harris

**BERLIOZ—
TOULOUSE—** **MARIE—**

he plays — he paints — she sings

MADAME—

cat lover
extraordinaire
voice —
Hermione Baddeley

EDGAR—
the butler who
serves nothing
but trouble
voice —
Roddy Maude-Roxby

ROQUEFORT—
the big cheese
detective
voice —
Sterling Holloway

**NAPOLEON &
LAFAYETTE—**
hillbilly hounds who
get to the seat
of the problem
voices — Pat Buttram
George Lindsey

LOOK TO THE NAME WALT DISNEY FOR THE FINEST IN FAMILY ENTERTAINMENT.

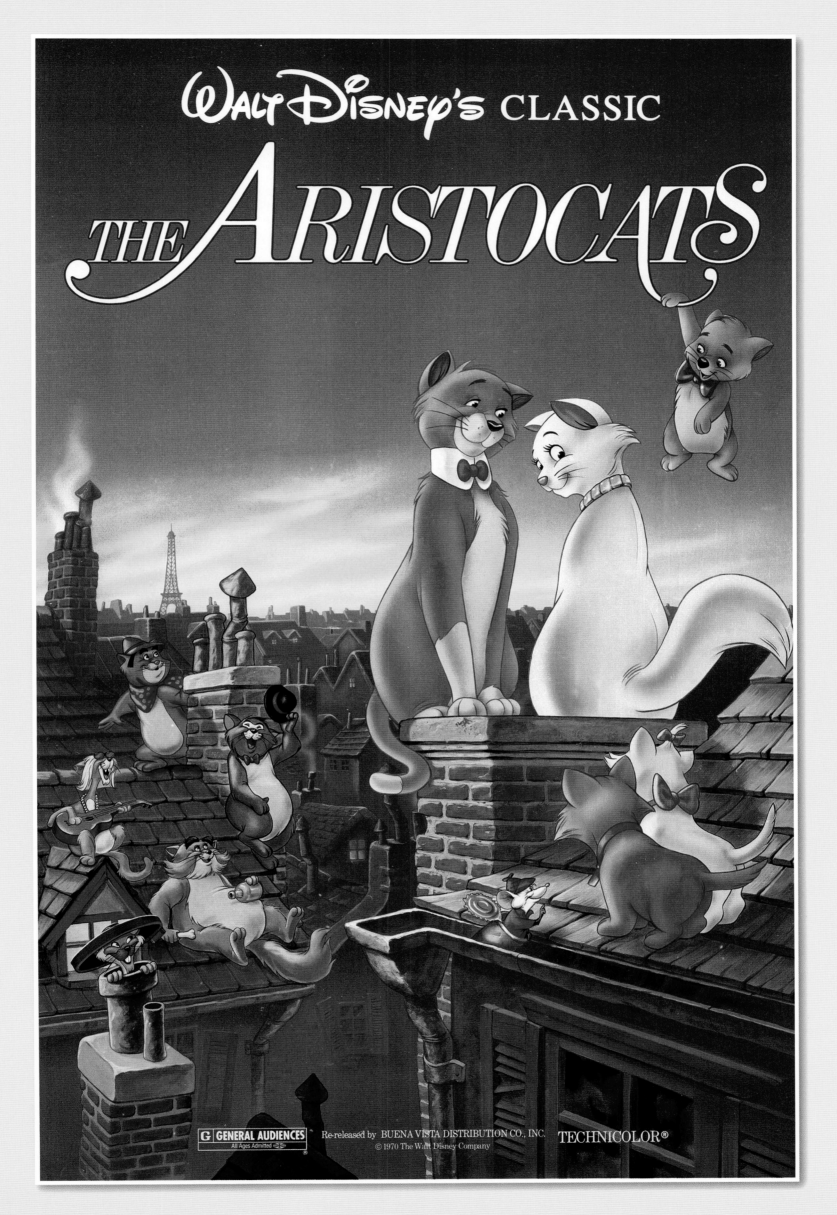

THE ARISTOCATS, 1987 (rerelease)

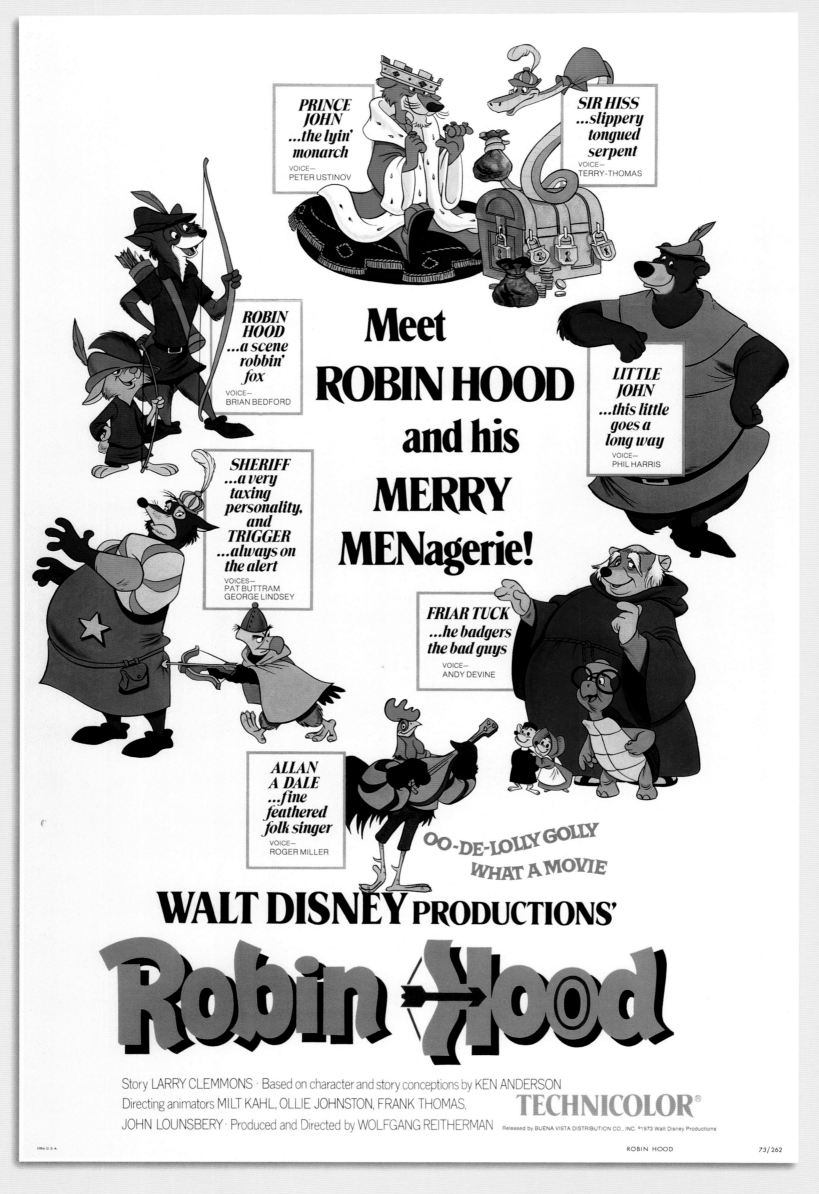

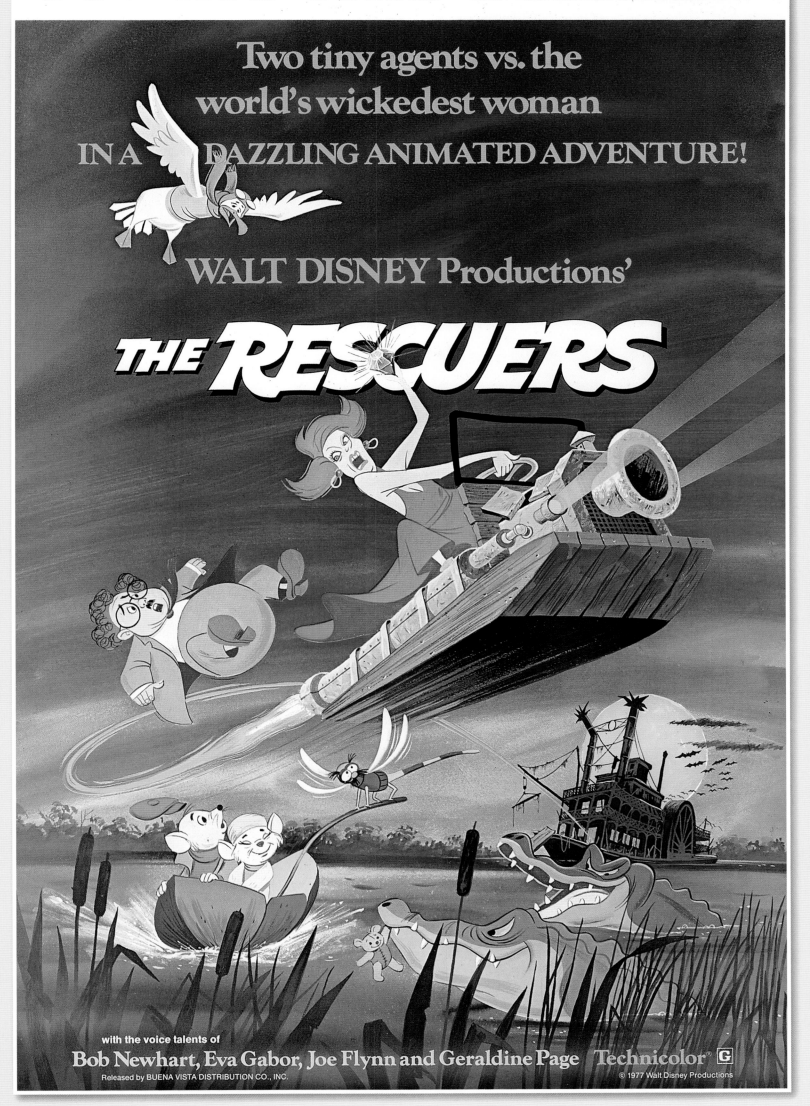

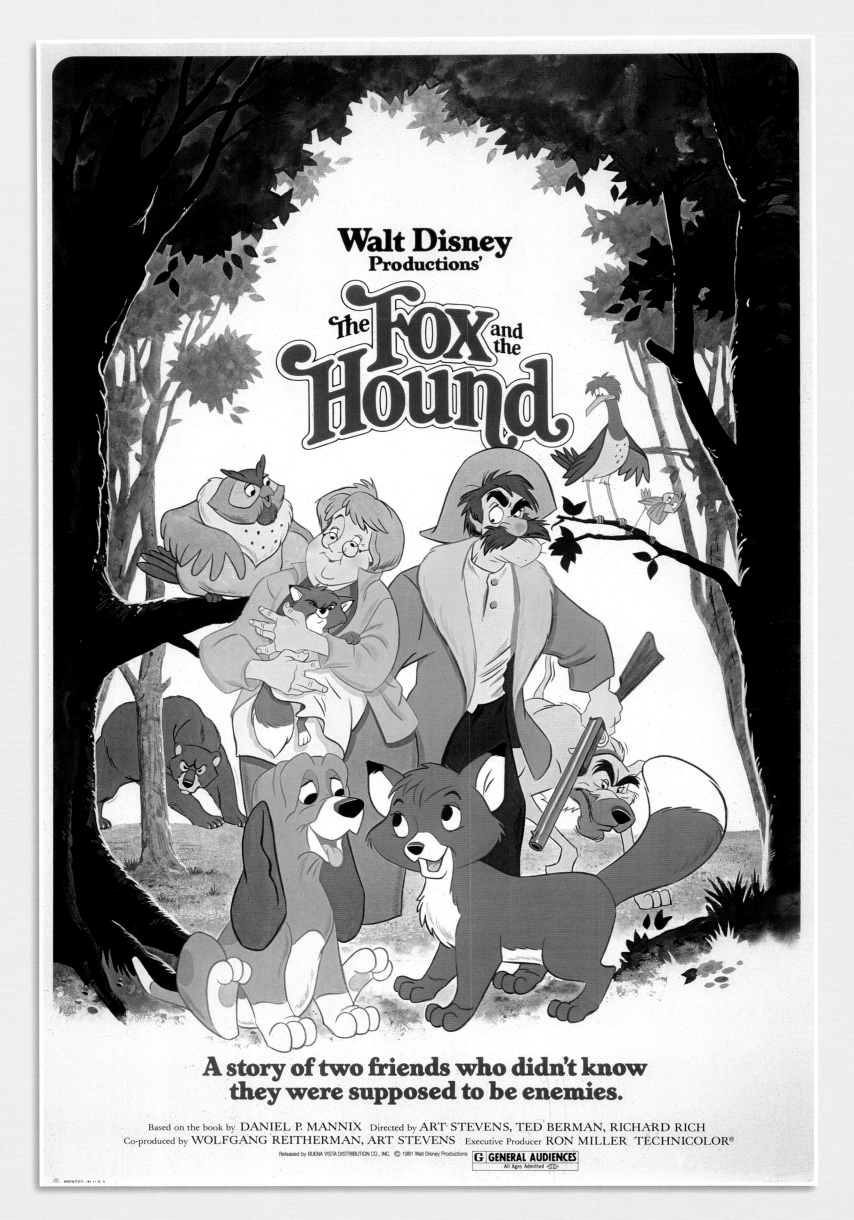

THE FOX AND THE HOUND, 1981

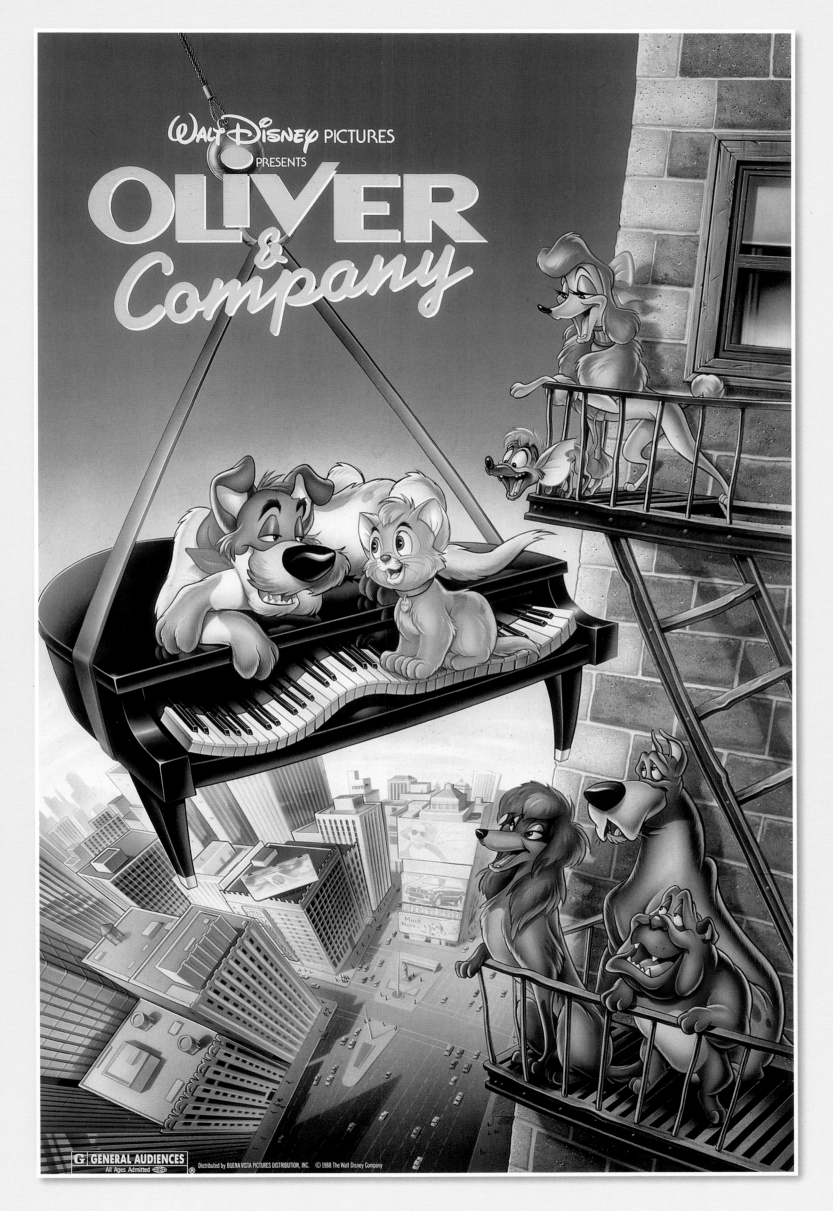

OLIVER & COMPANY, 1988

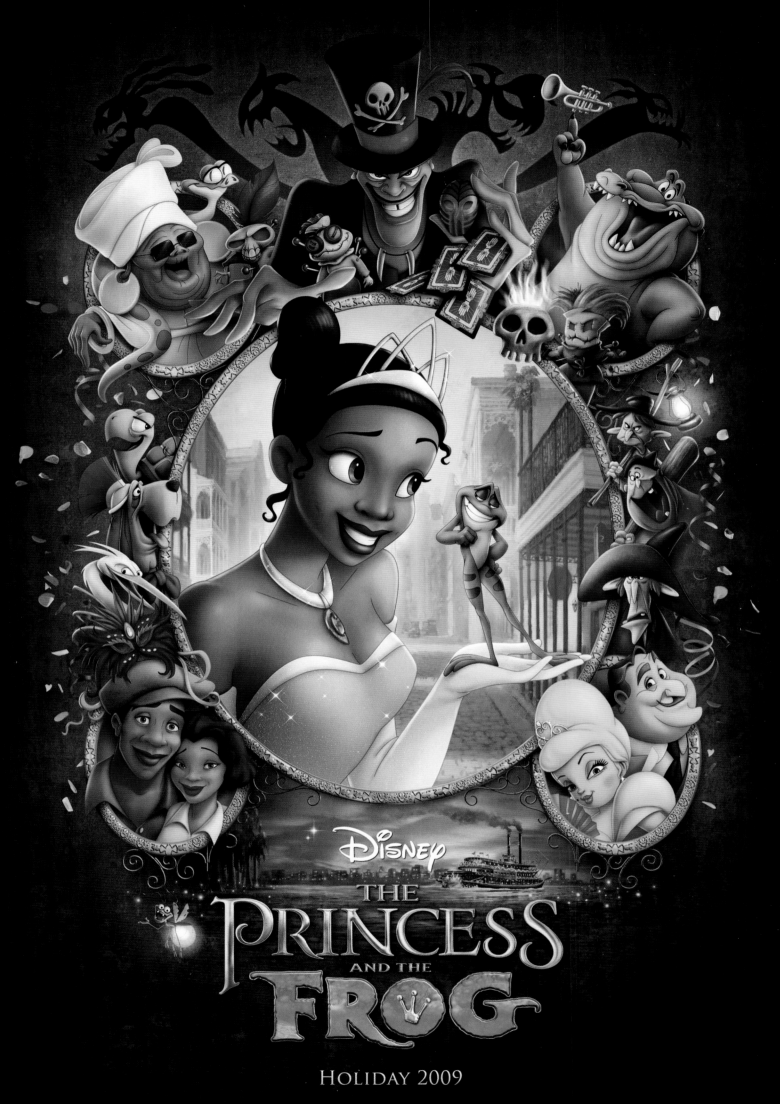

THE PRINCESS AND THE FROG, 2009

SECOND GOLDEN AGE AND BEYOND

"Fairy tales can come true.
You gotta make them happen;
it all depends on you."

— Tiana, *The Princess and the Frog*, 2009

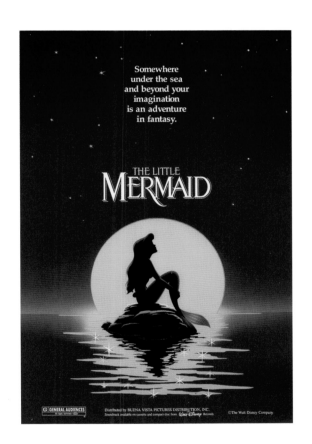

THE LITTLE MERMAID, 1989
(marketed to adults)

THE *Little Mermaid* was hailed as an instant classic upon its release in 1989. Today the movie chronicling the adventures of Ariel, the young mermaid, both above as well as "under the sea," is widely considered the start of a new Golden Age of Disney animation, which is only fitting considering the story began taking shape during Disney's *first* Golden Age.

Walt Disney had taken an interest in the idea around the same time *Snow White and the Seven Dwarfs* was conceived. The plan, which was eventually shelved in favor of other projects, was to create a package film featuring *The Little Mermaid* and other Hans Christian Andersen fairy tales.

In fact, several elements of the original plan made it into the film fifty years later.

Much as *Snow White* paved the way for *Pinocchio*, *Dumbo*, and the other classics, *The Little Mermaid* led to *Beauty and the Beast*, *The Lion King*, and *The Hunchback of Notre Dame*. This second Golden Age also took advantage of technological innovations such as IMAX and 3-D. Even

the animation itself changed as the old hand-drawn style gave way to computer-based painting programs. This evolution is reflected in the posters for the films as well, as shown in the different look and feel of the 1989 original poster for *The Little Mermaid* compared to that of the 1997 rerelease.

As the second Golden Age gave way to the modern era, Disney's heroes and settings have become increasingly multicultural in movies such as *Mulan*, *The Emperor's New Groove*, and *The Princess and the Frog*. But the success of 2013's *Frozen*, based on another story by Andersen, shows that classic fairy tales remain as popular as ever with Disney fans around the world.

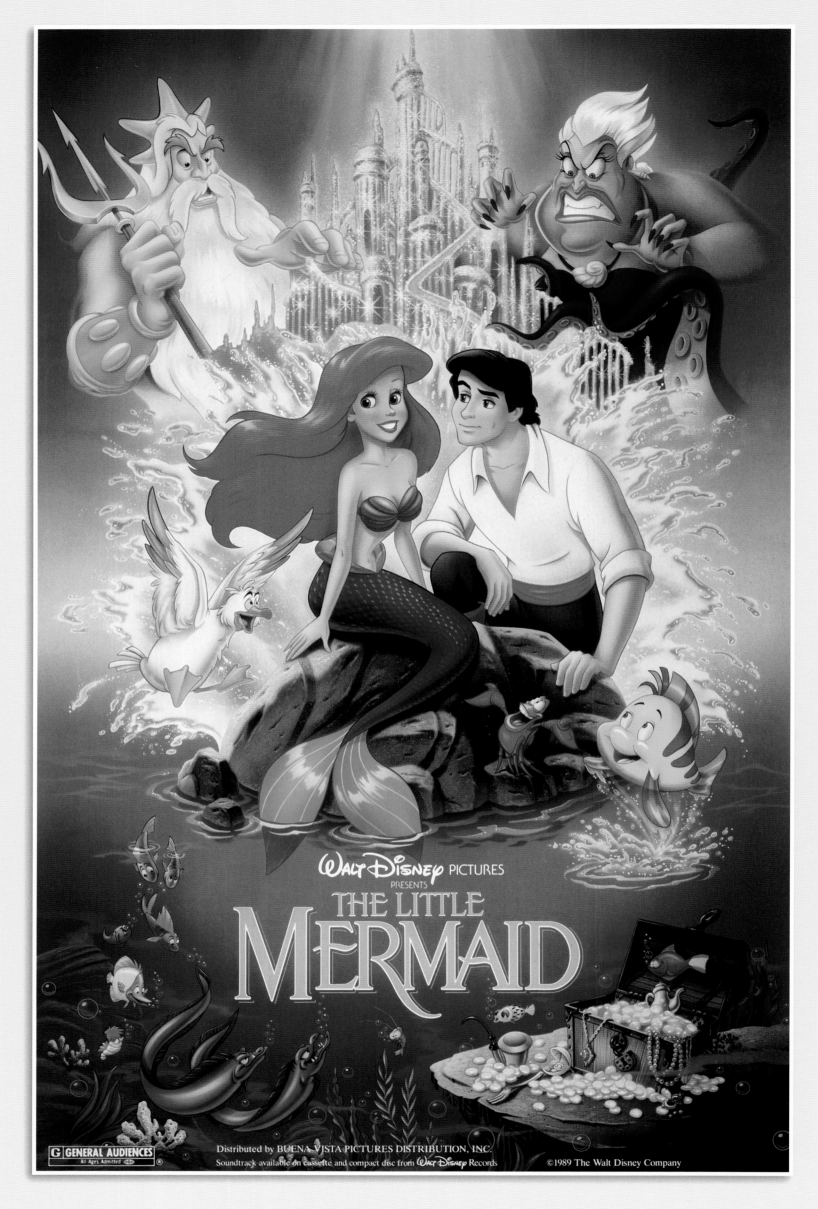

THE LITTLE MERMAID, 1989 (marketed to children)

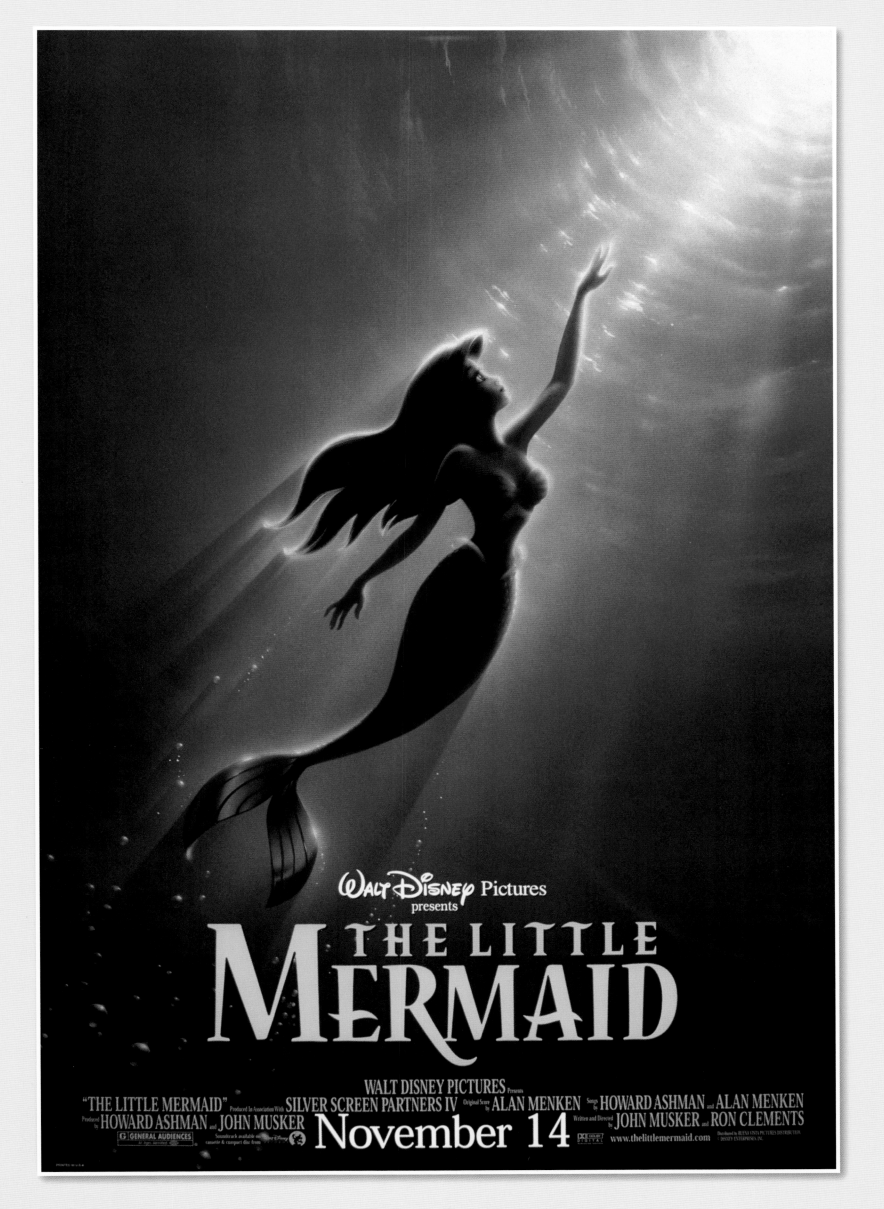

THE LITTLE MERMAID, 1997 (rerelease)

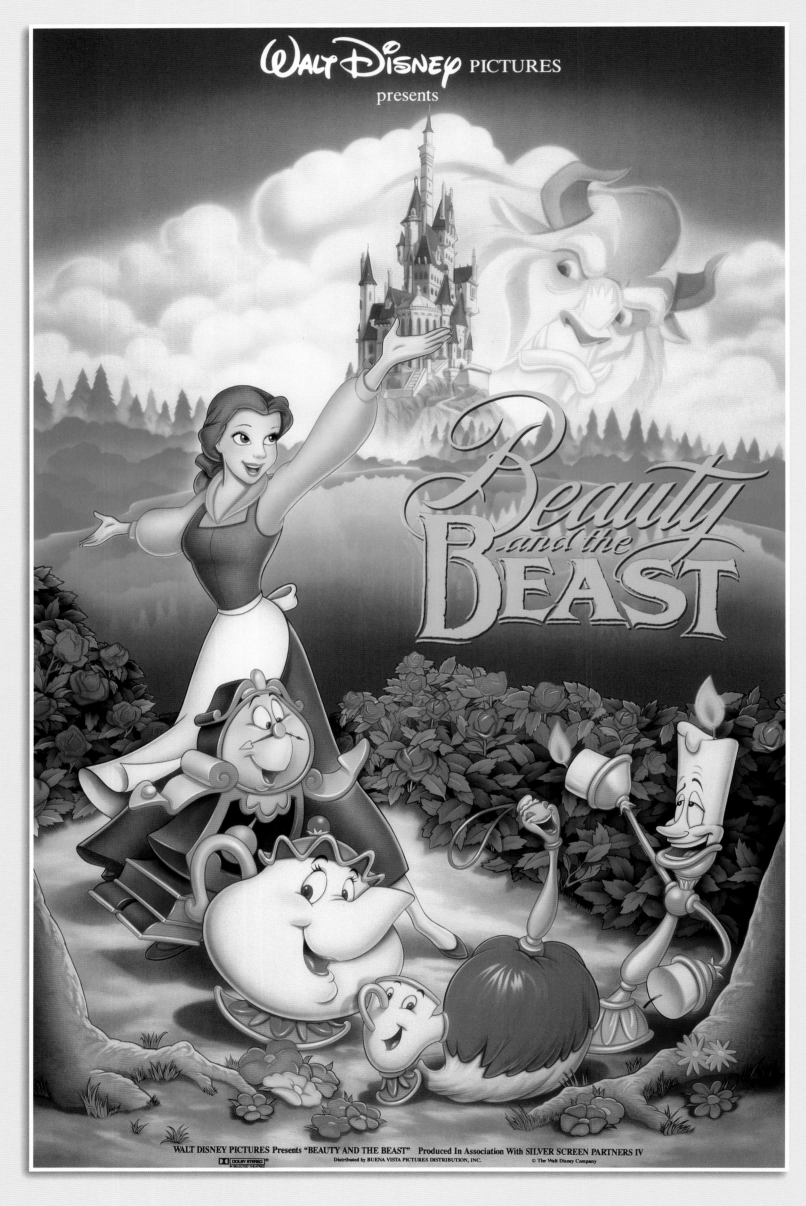

BEAUTY AND THE BEAST, 1991 (marketed to children)

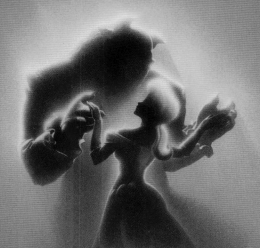

The

most

beautiful

love

story

ever

told.

WALT DISNEY PICTURES
presents

Beauty and the Beast

WALT DISNEY PICTURES Presents "BEAUTY AND THE BEAST" Produced In Association With SILVER SCREEN PARTNERS IV
Distributed by BUENA VISTA PICTURES DISTRIBUTION, INC. The Walt Disney Company

BEAUTY AND THE BEAST, 1991 (marketed to adults)

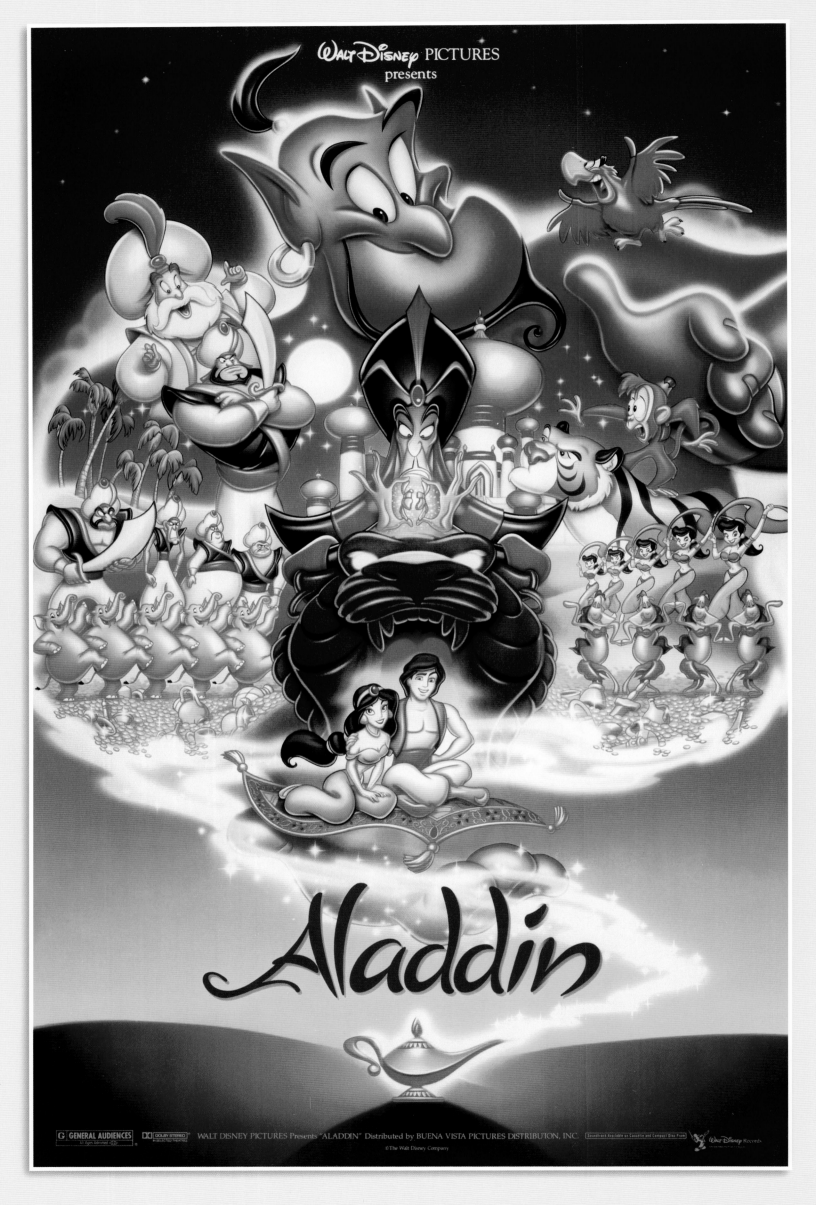

ALADDIN, 1992 (marketed to children)

ALADDIN, 1992 (marketed to adults)

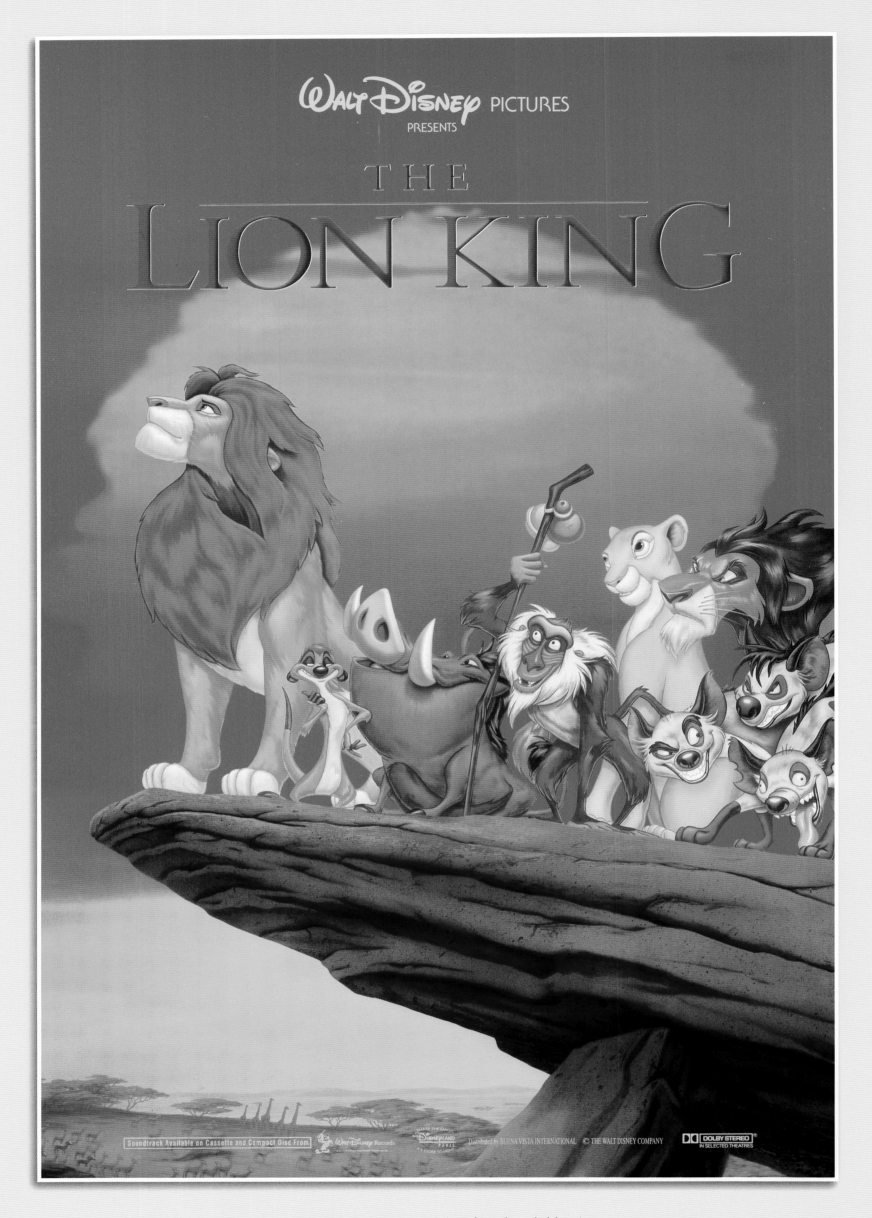

THE LION KING, 1994 (marketed to children)

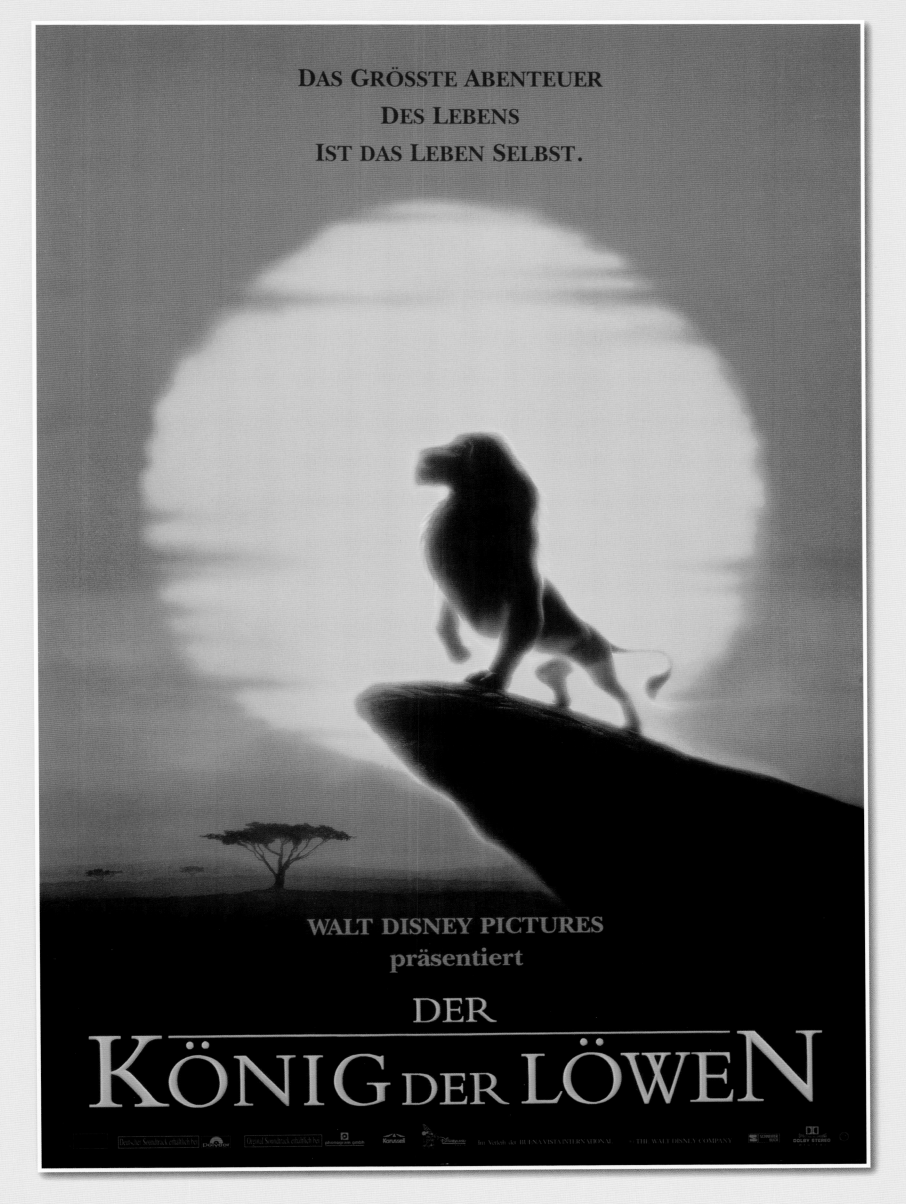

THE LION KING, 1994 (Germany)

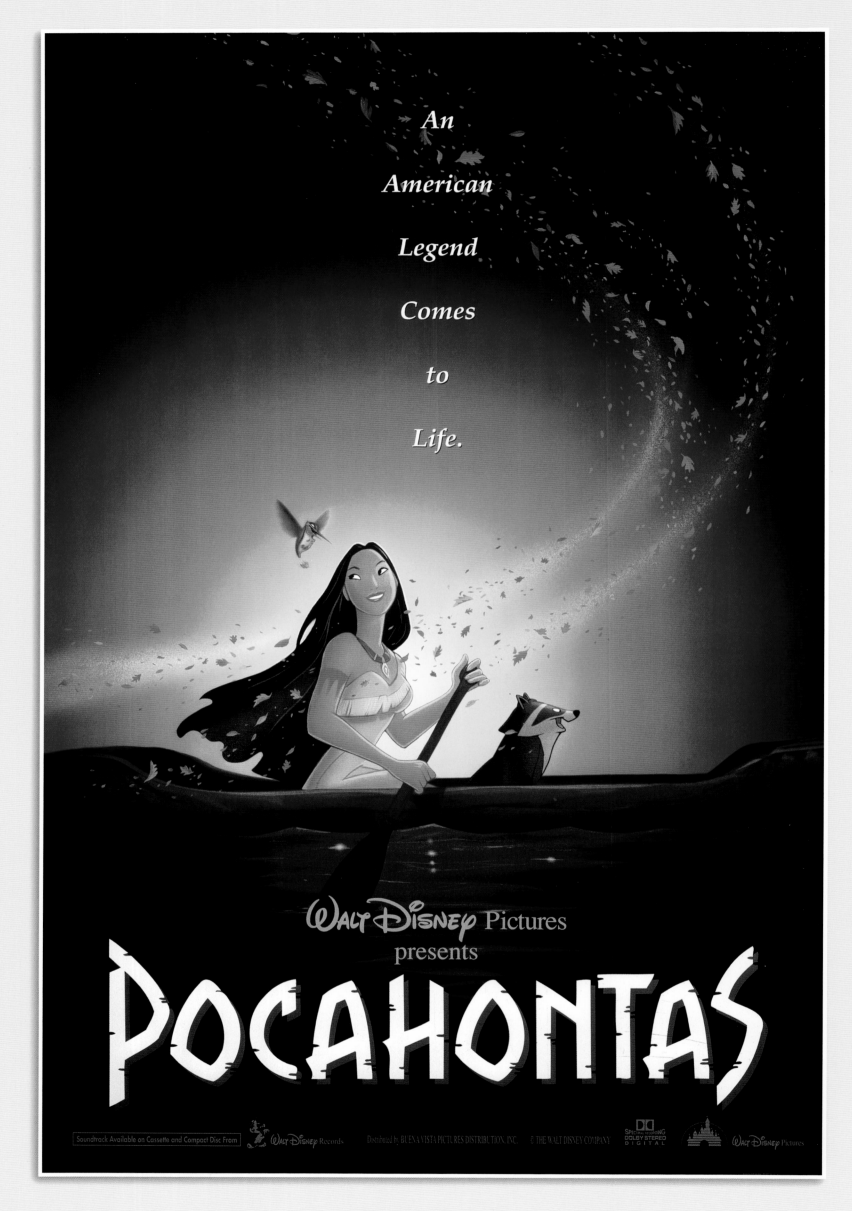

POCAHONTAS, 1995

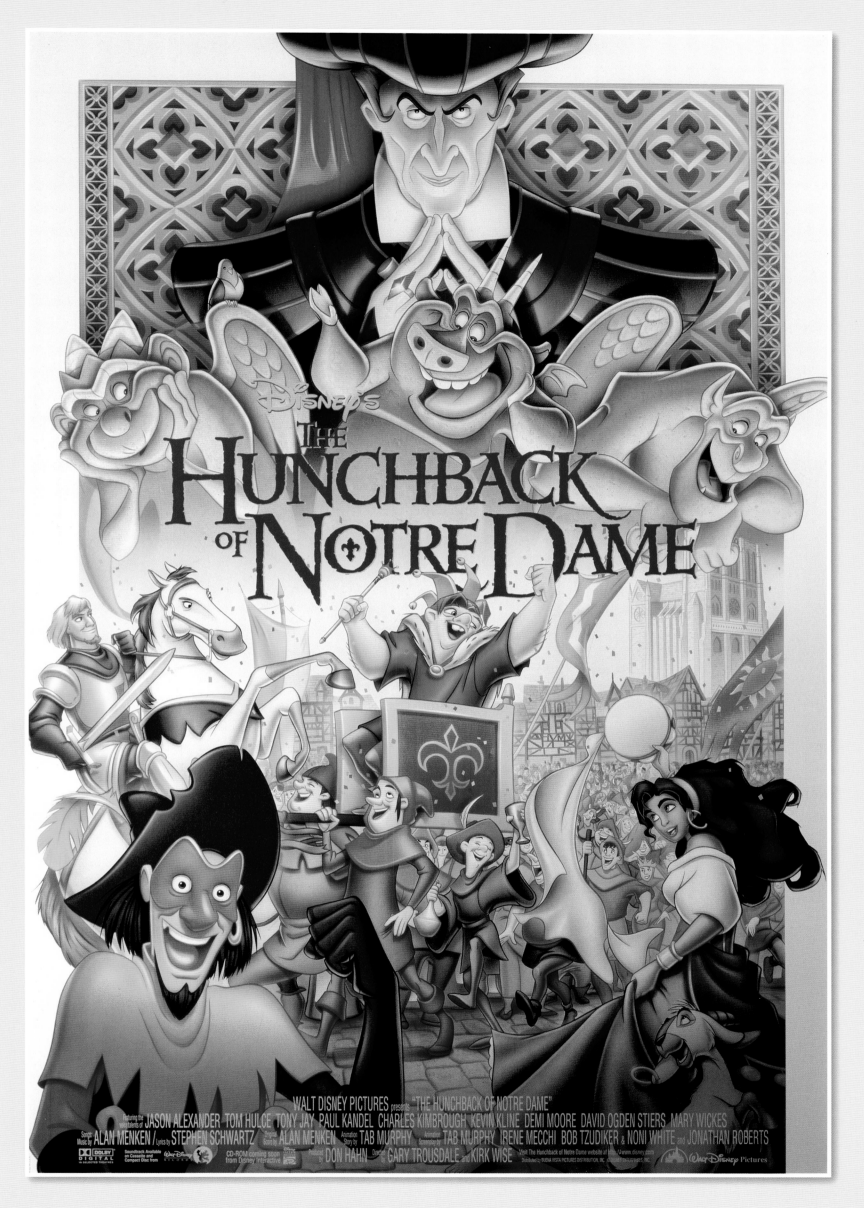

THE HUNCHBACK OF NOTRE DAME, 1996

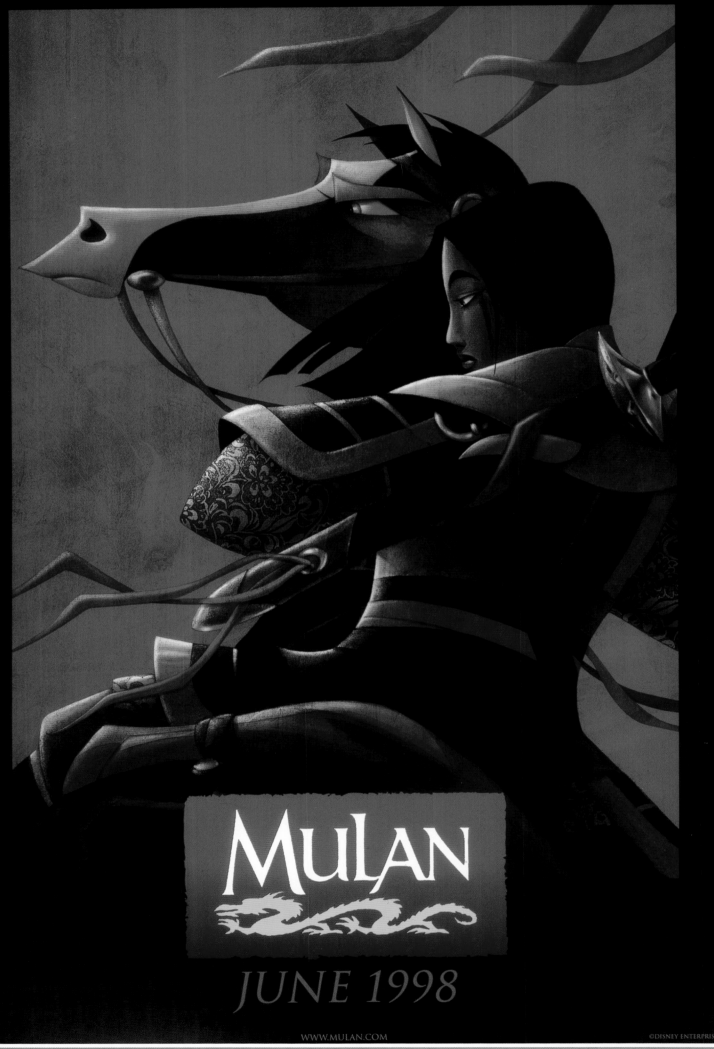

MULAN, 1998 (teaser poster)

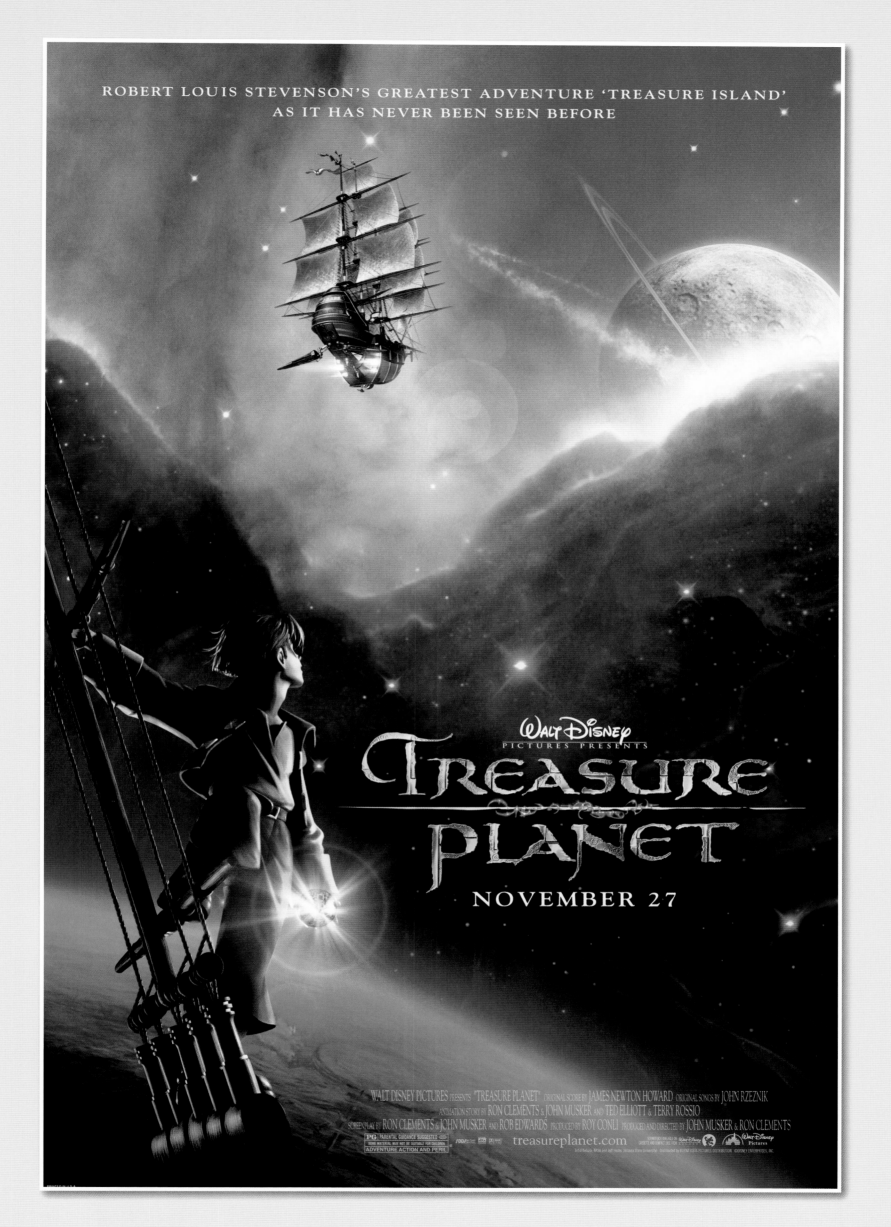

TREASURE PLANET, 2002

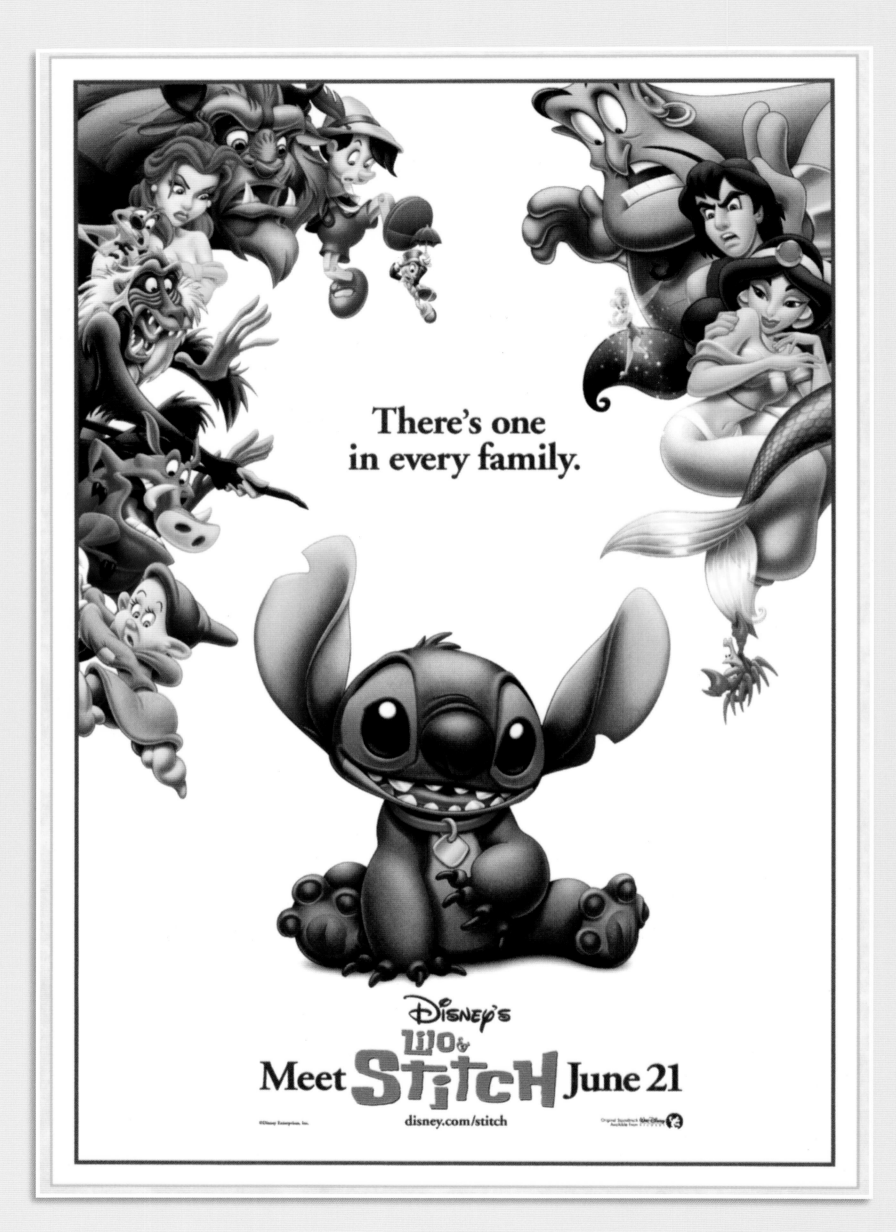

There's one
in every family.

Disney's

Meet StitcH June 21

disney.com/stitch

LILO & STITCH, 2002

BROTHER BEAR, 2003

CHICKEN LITTLE, 2005

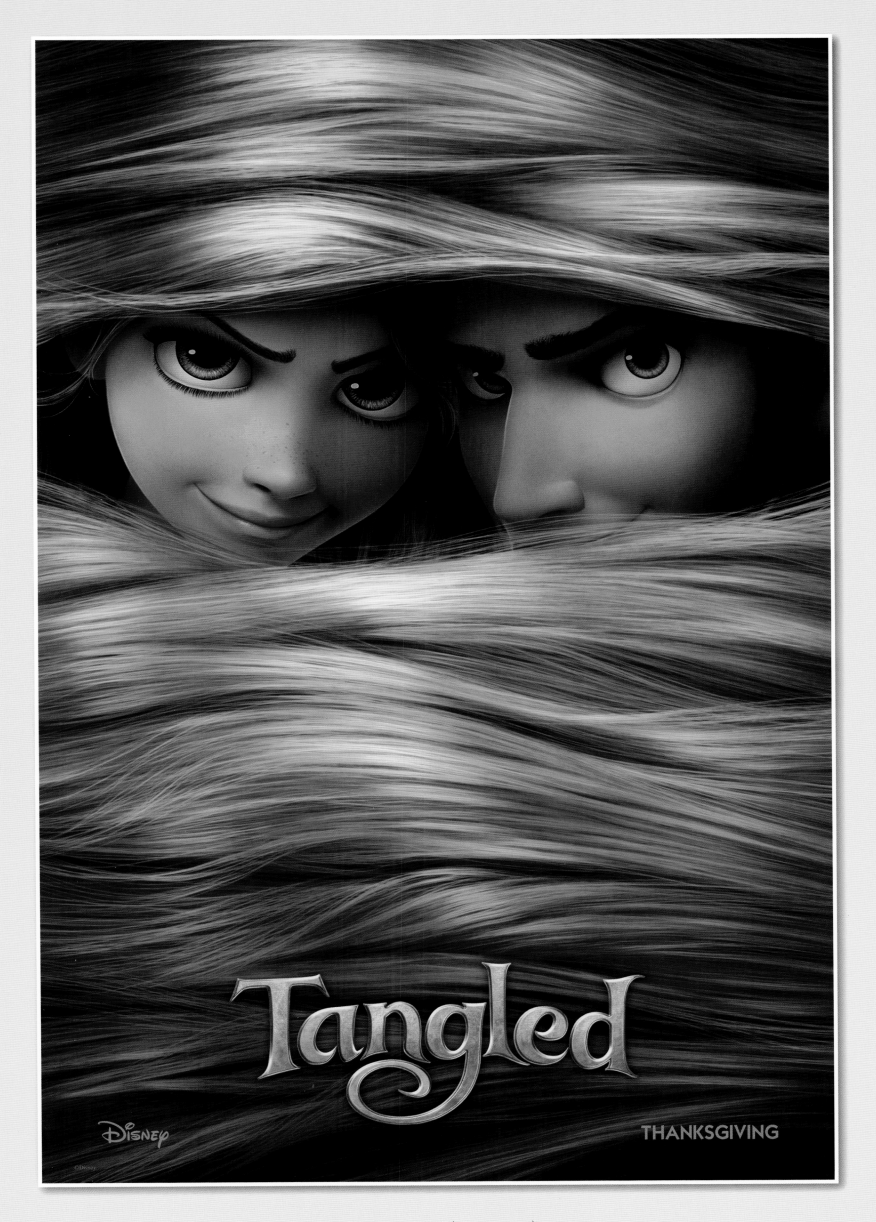

TANGLED, 2010 (teaser poster)

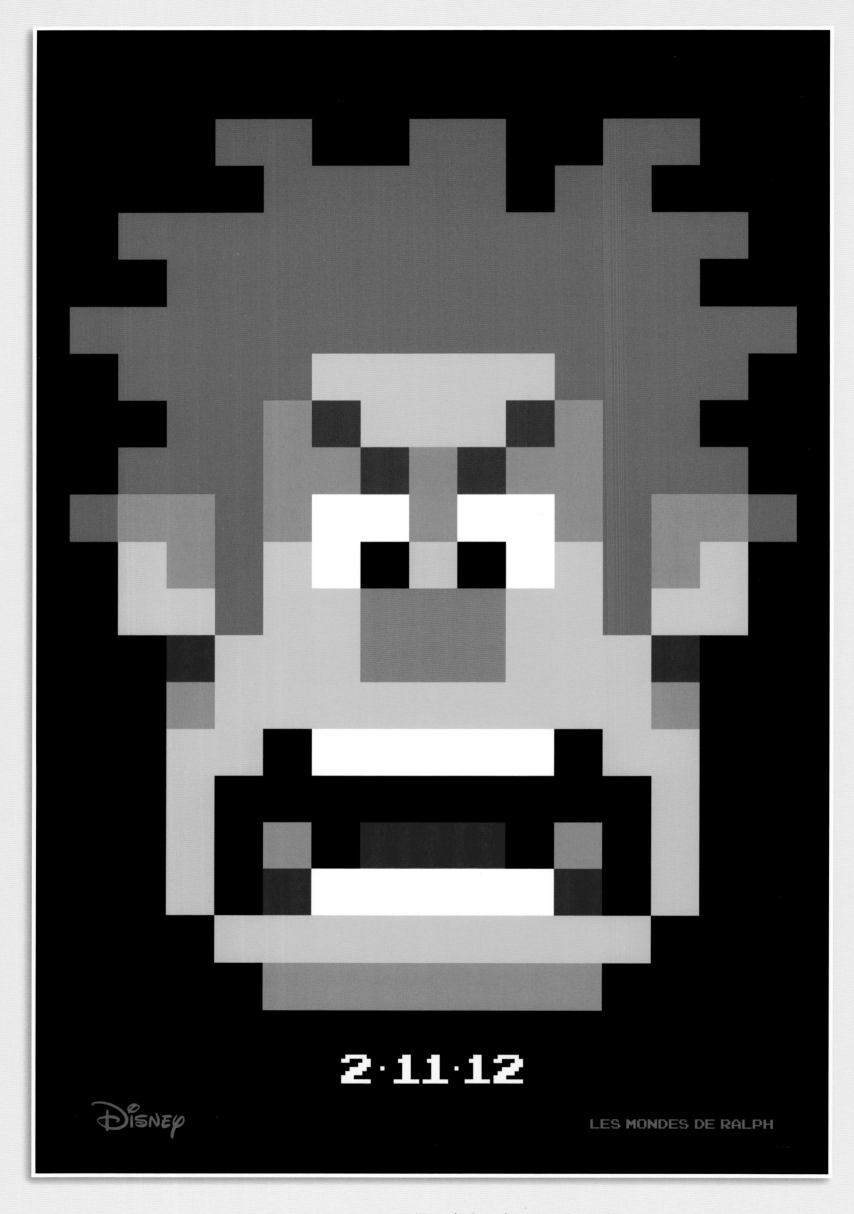

WRECK-IT RALPH, 2012 (French-Canadian teaser poster)

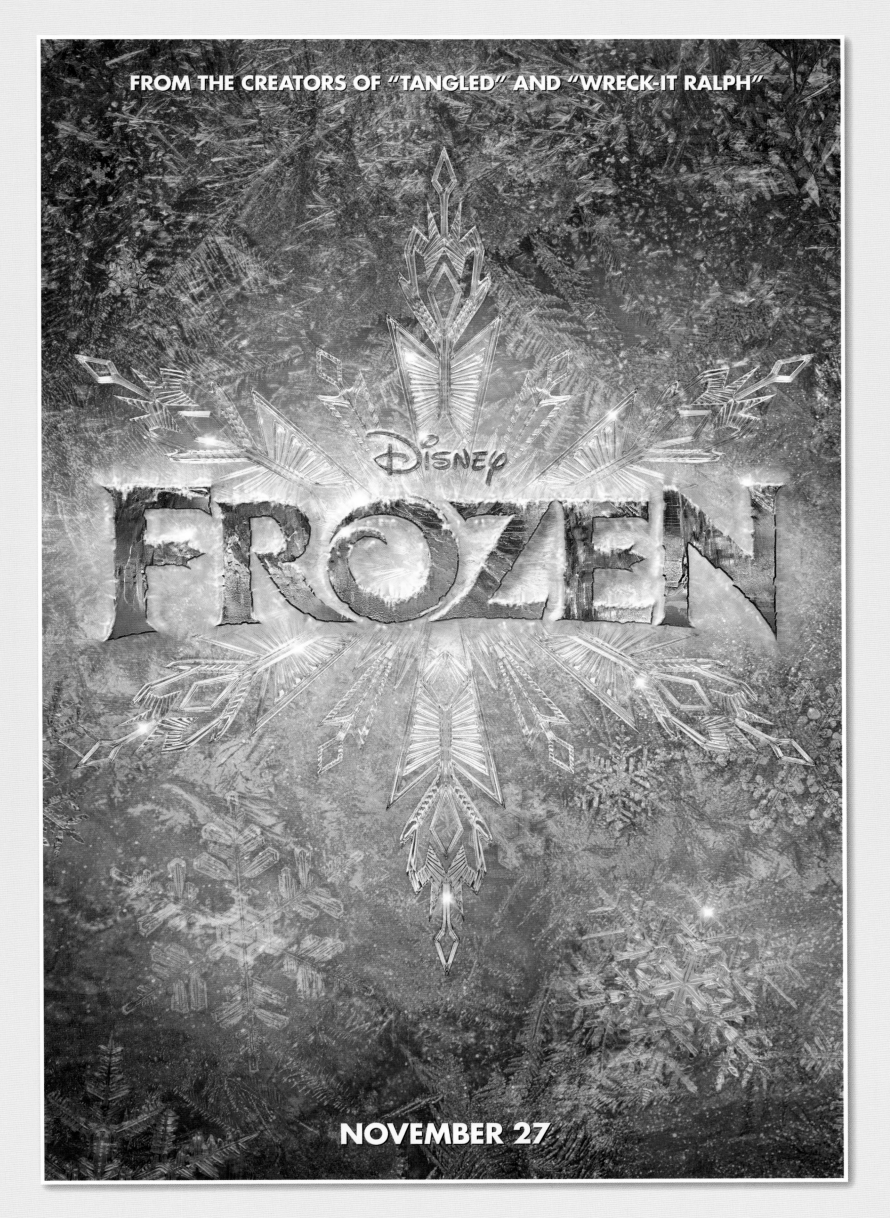

FROZEN, 2013 (teaser poster)

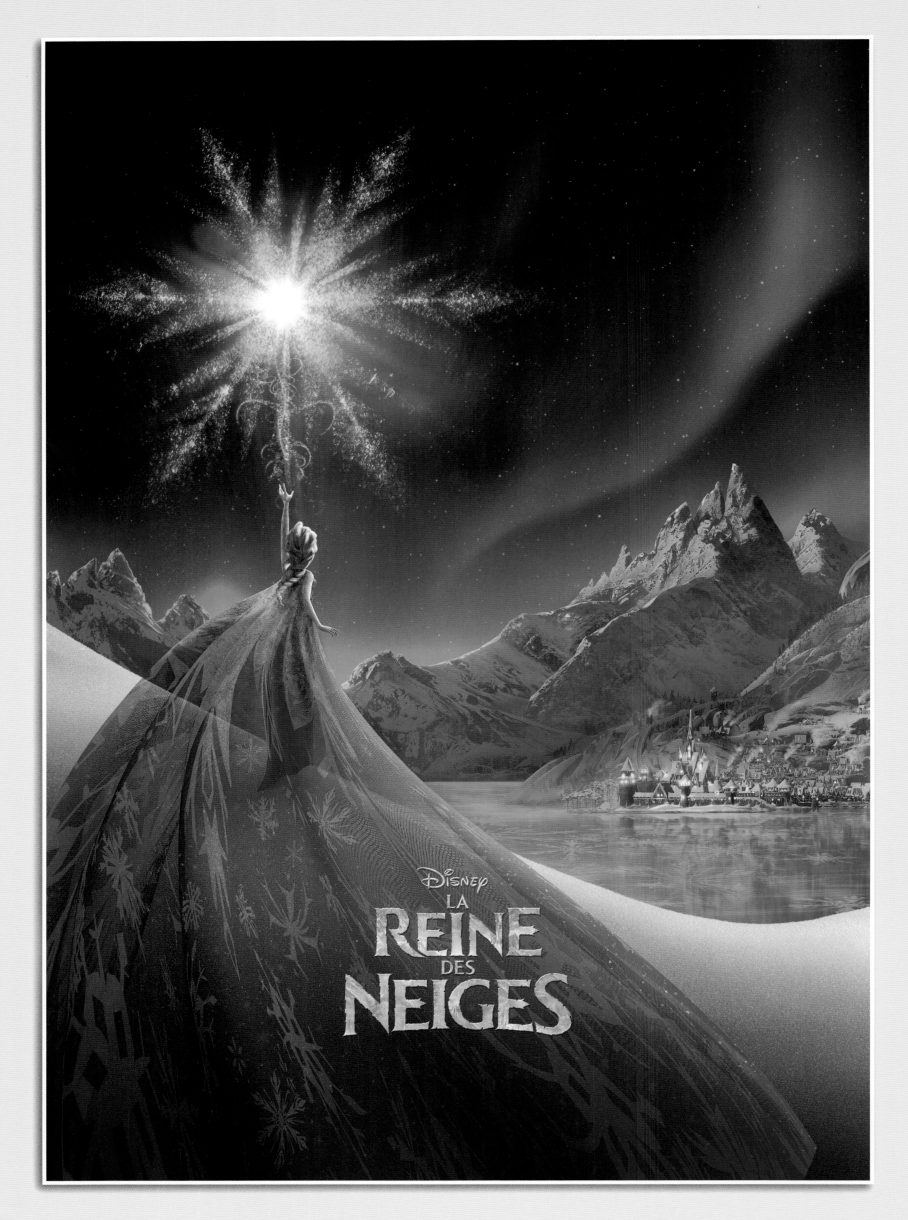

FROZEN, 2013 (France teaser poster)

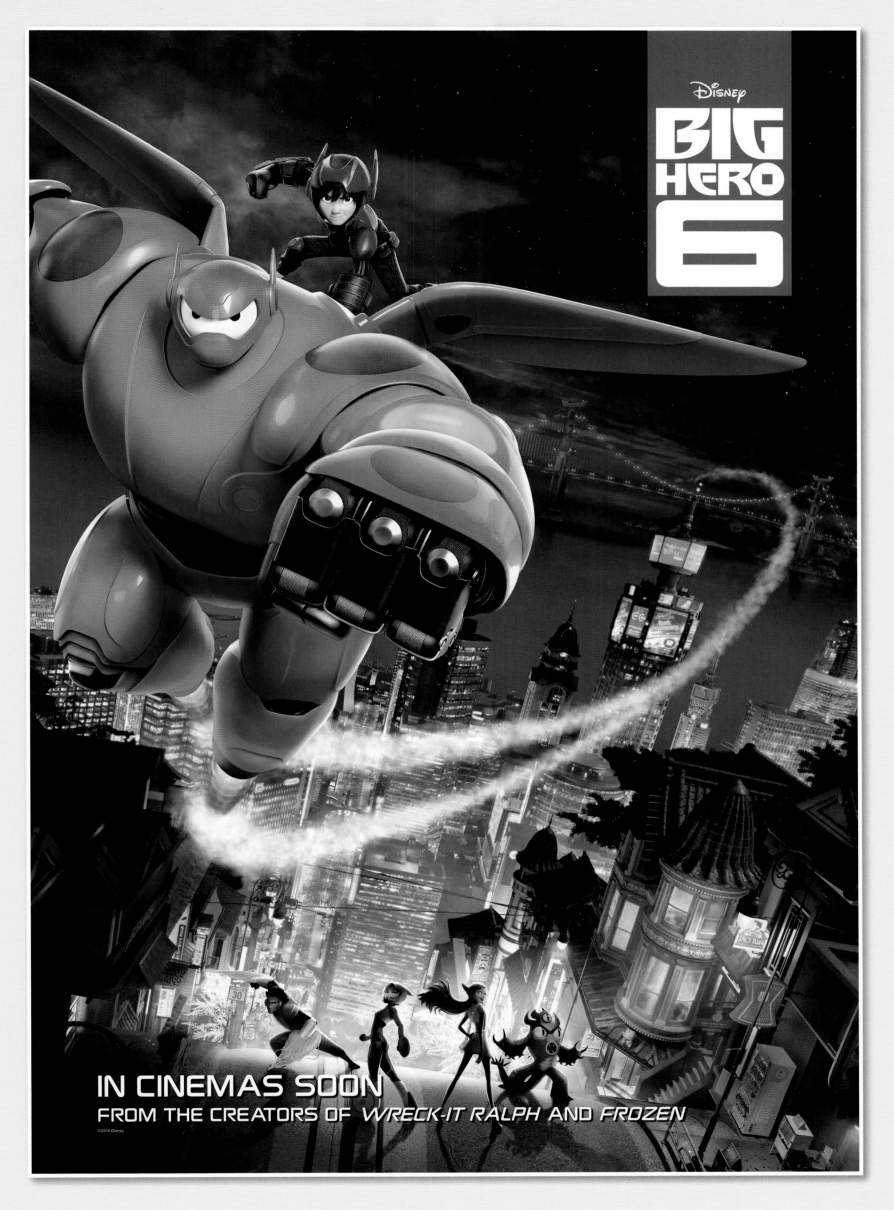

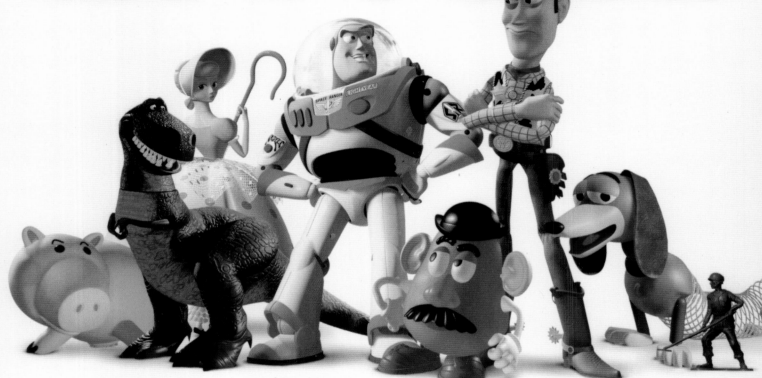

THE TOYS ARE BACK IN TOWN.

Walt Disney Pictures presents

TOY STORY

TOY STORY, 1995 (marketed to adults)

THE PIXAR REVOLUTION

"Change is nature, Dad . . .
the part that we can influence.
And it starts when we decide."

— Remy, *Ratatouille*, 2007

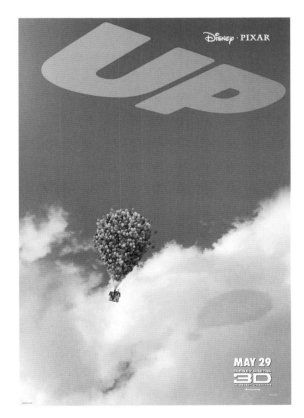

UP, 2009 (teaser poster)

SEVERAL months after the success of *Pocahontas* in 1995, Disney released a second animated movie, *Toy Story*. But moviegoers filling the seats were in for a surprise: *Toy Story* didn't look anything like the Disney animated movies they'd come to expect. In fact, it didn't look like any movie they'd ever seen.

And indeed, it wasn't. *Toy Story* was the first completely computer-animated feature film, the result of a partnership between Disney and Pixar Animation Studios. Disney had been moving away from traditional hand-drawn animation in favor of digital methods as early as 1989, but this was something else entirely. Every character, every background, down to the individual blades of grass, was built on the computer, resulting in a movie that looked too real to be animated. The posters for the movie were rendered using the same process to reflect this unique style.

Toy Story was universally praised by fans and critics, earning several Academy Award nominations. In fact, John Lasseter, the film's director and now the chief creative officer of Pixar and the Walt Disney Animation Studios, was recognized with a Special Achievement Award "For the development and inspired application of techniques that have made possible the first feature-length computer-animated film." Fresh off the success of their first venture, Disney and Pixar partnered to produce a string of computer-animated hits: *a bug's life*; *Toy Story 2*; *Monsters, Inc.*; *Finding Nemo*; *The Incredibles*; and *Cars*.

Of course, the success of the Pixar slate of movies can only partially be attributed to their distinctly modern look. The movies also boast sophisticated stories and humor, appealing to adults as well as children. The promotional art for the movies further emphasizes this balance. While the original *Toy Story* had separate posters appealing to children and adults, later Pixar movie posters, like the whimsical teaser for *Up*, targeted both simultaneously.

The computer-generated style pioneered by Pixar has had far-reaching effects within the entertainment industry, influencing everything from music videos to Saturday-morning cartoons to Disney's other animated films, including recent works such as *Tangled*, *Wreck-It Ralph*, and *Frozen*.

A BUG'S LIFE, 1998 (teaser posters)

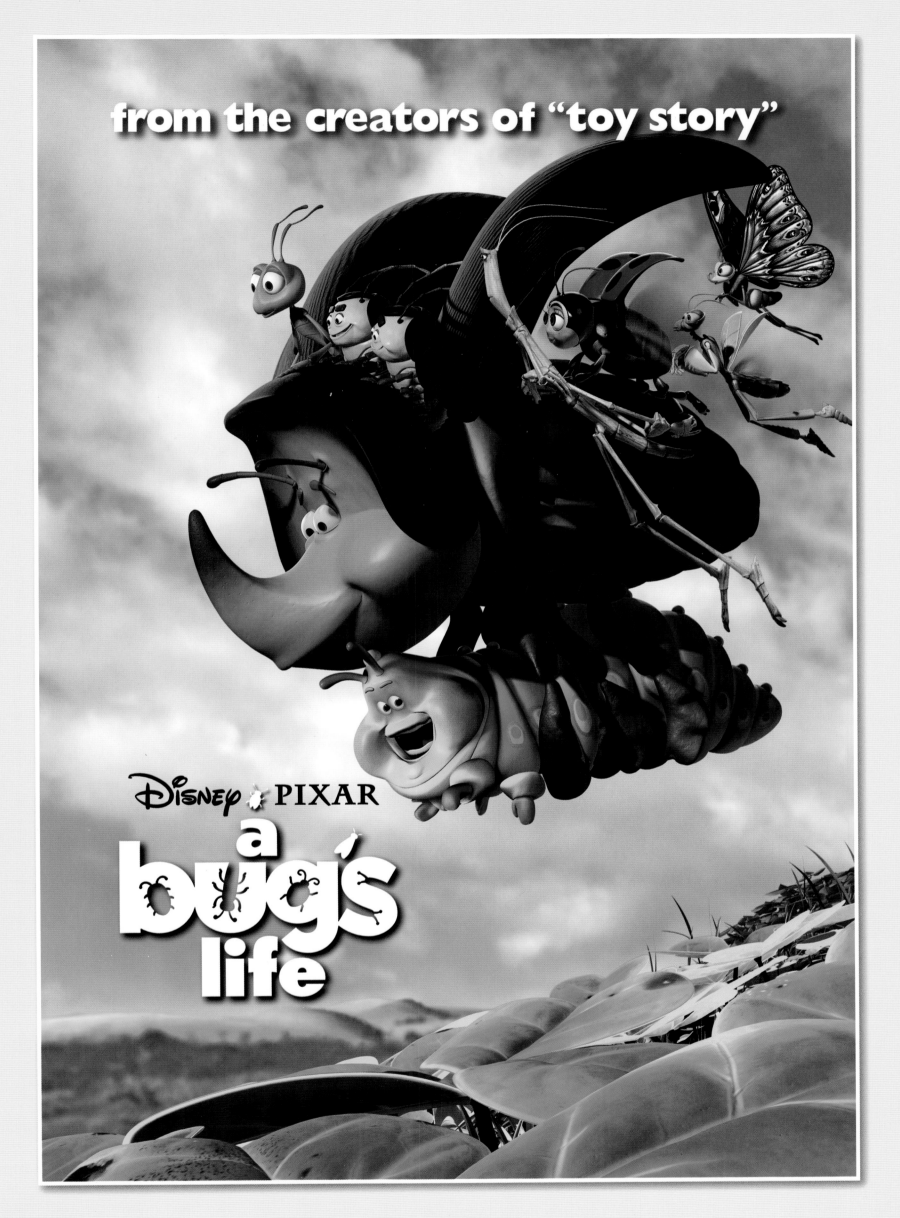

A BUG'S LIFE, 1998 (teaser poster)

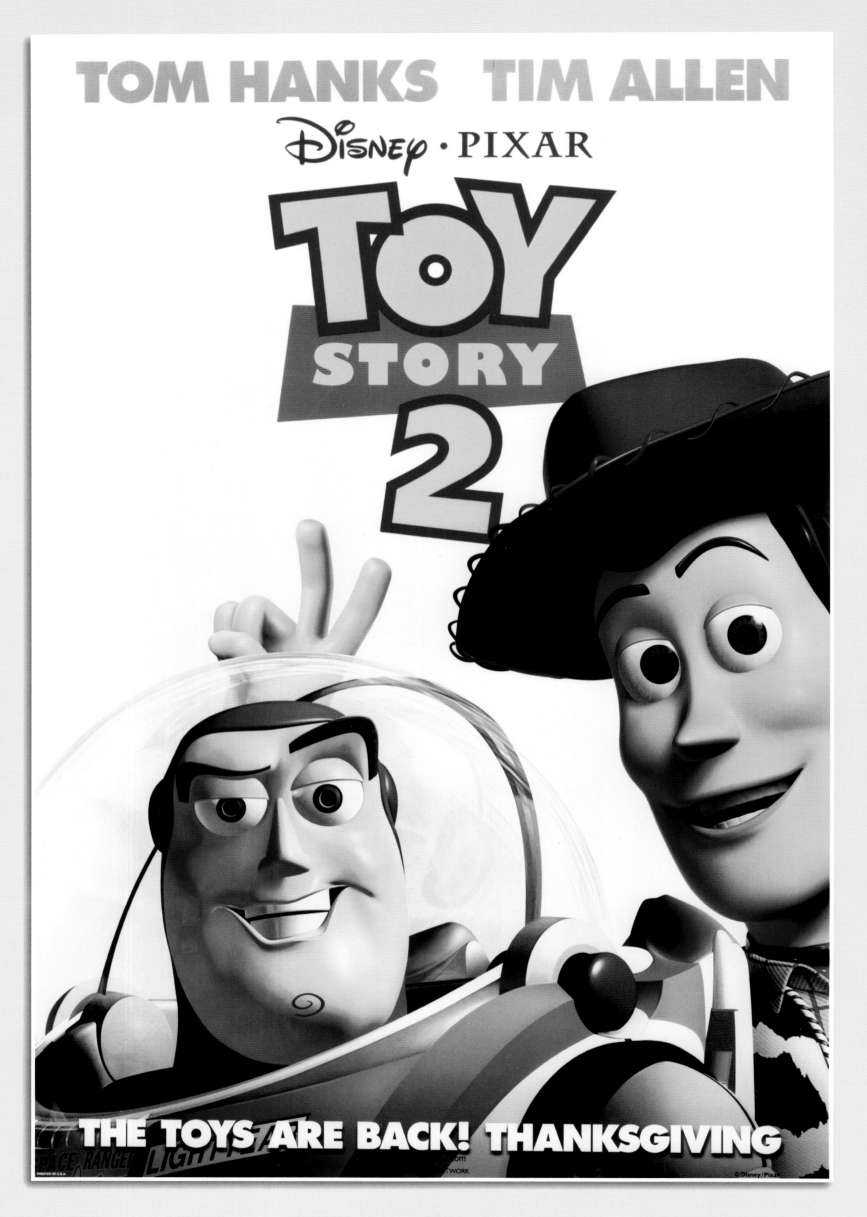

TOY STORY 2, 1999 (teaser poster)

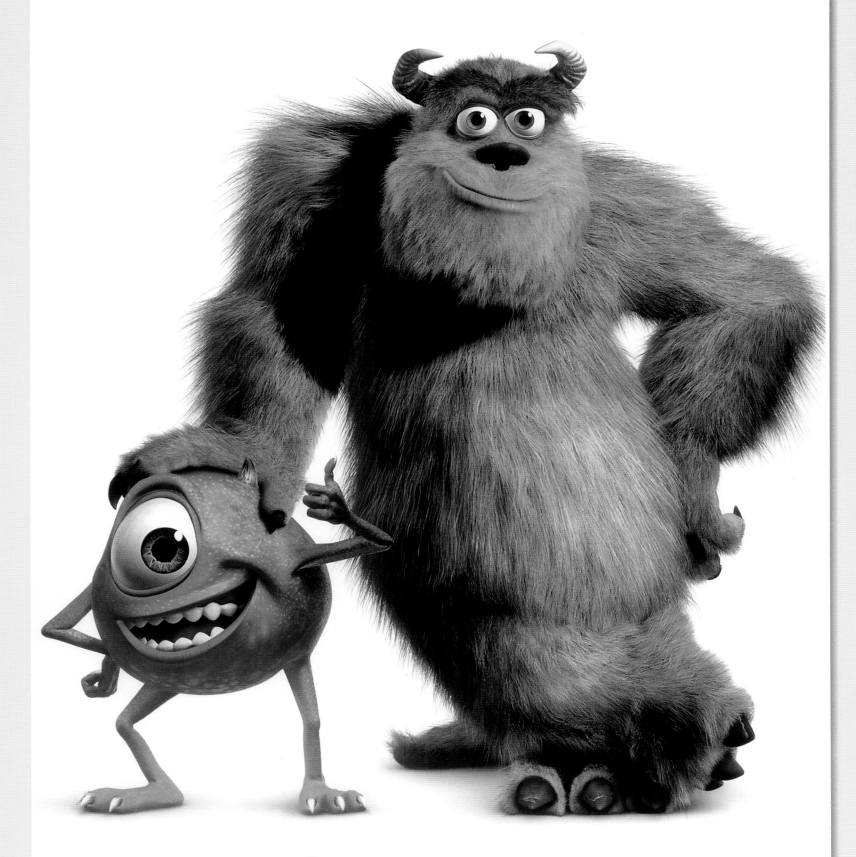

MONSTERS, INC., 2001 (teaser poster)

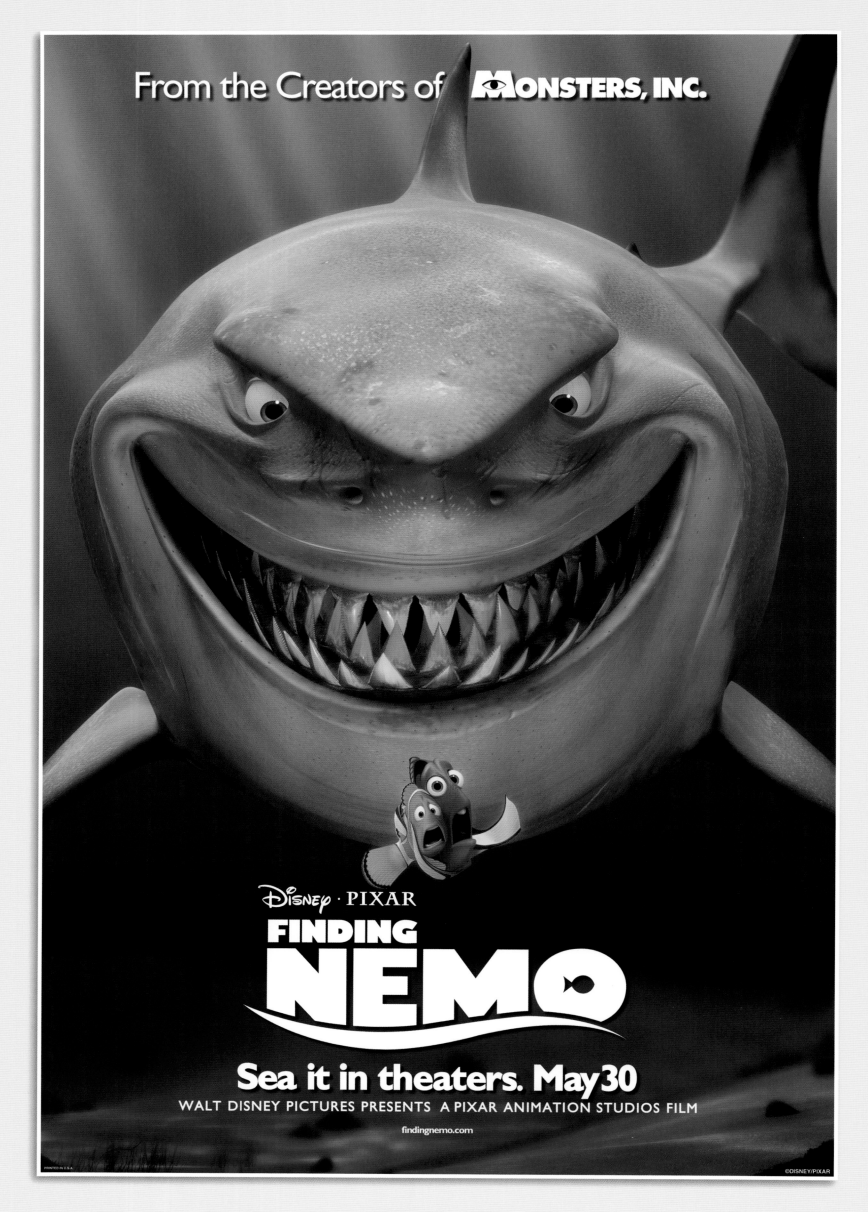

FINDING NEMO, 2003

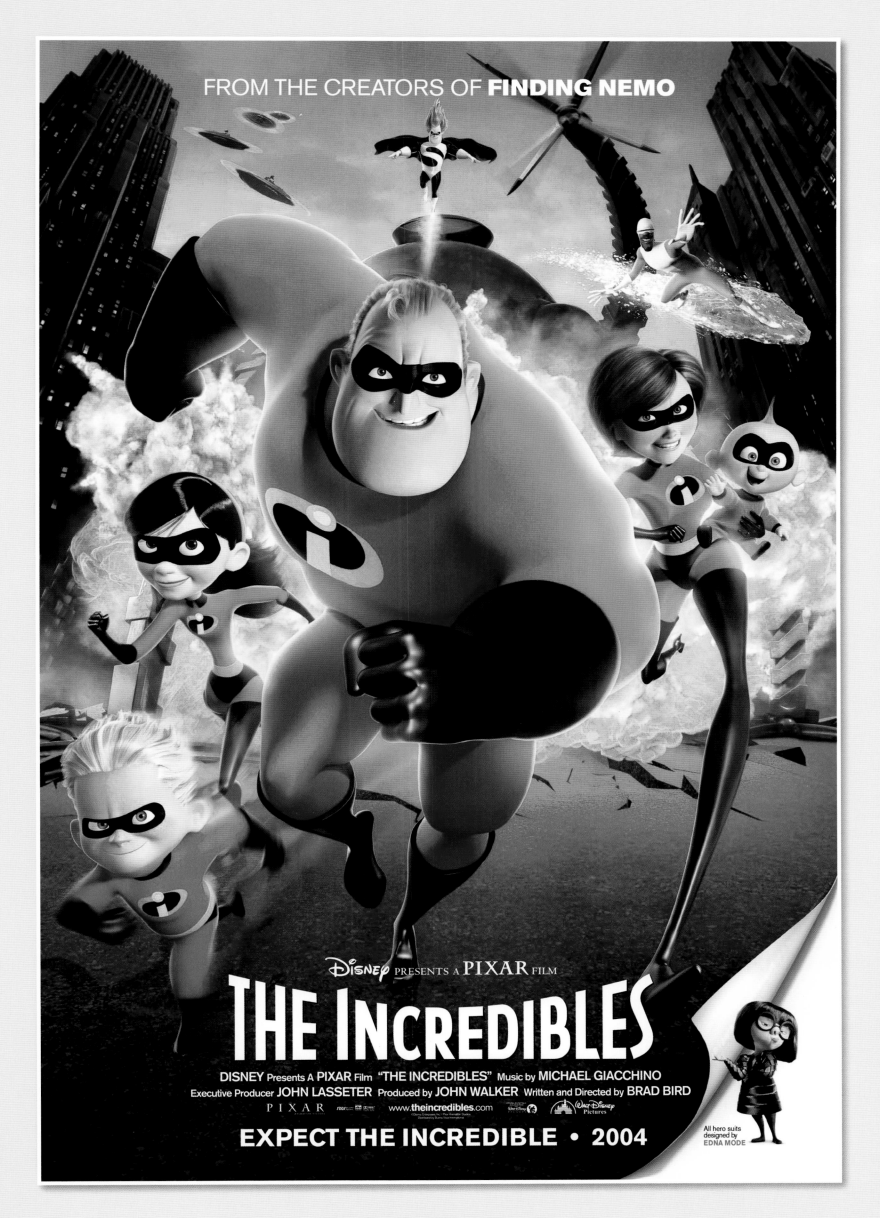

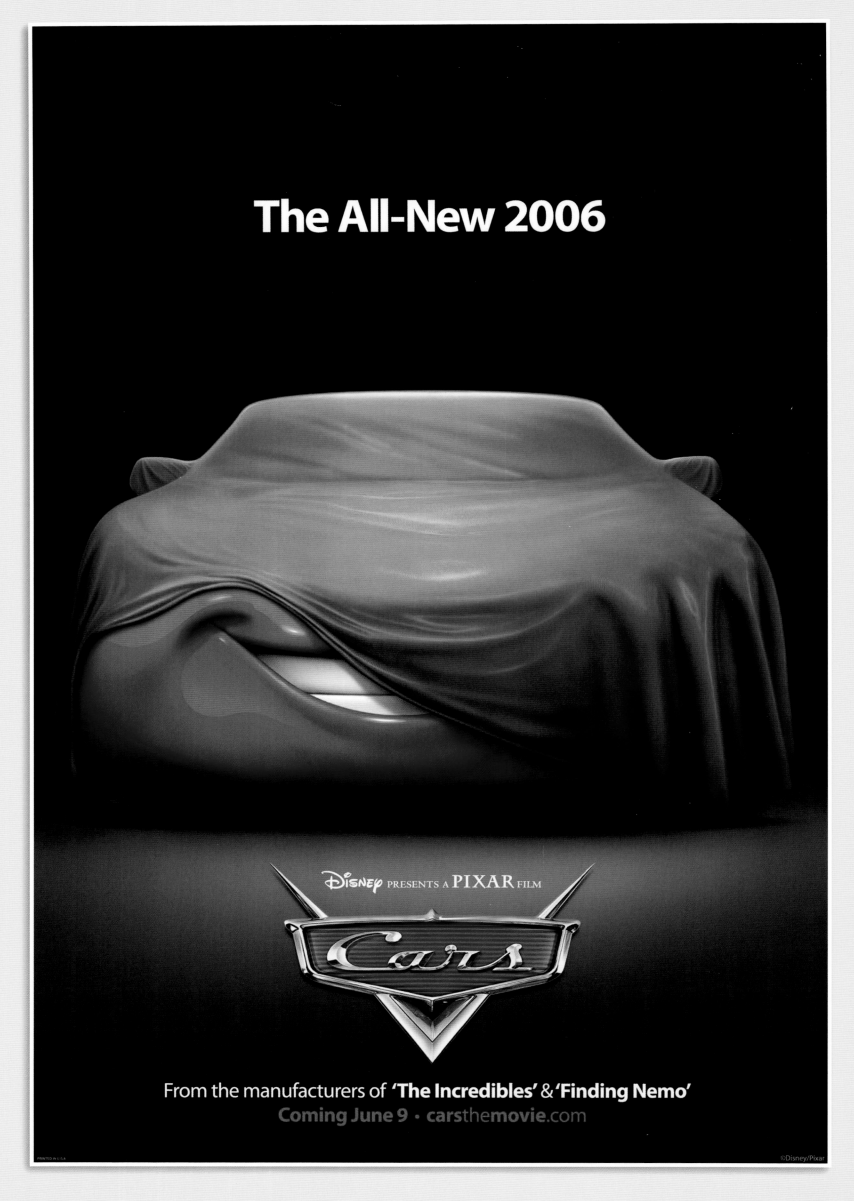

CARS, 2006 (teaser poster)

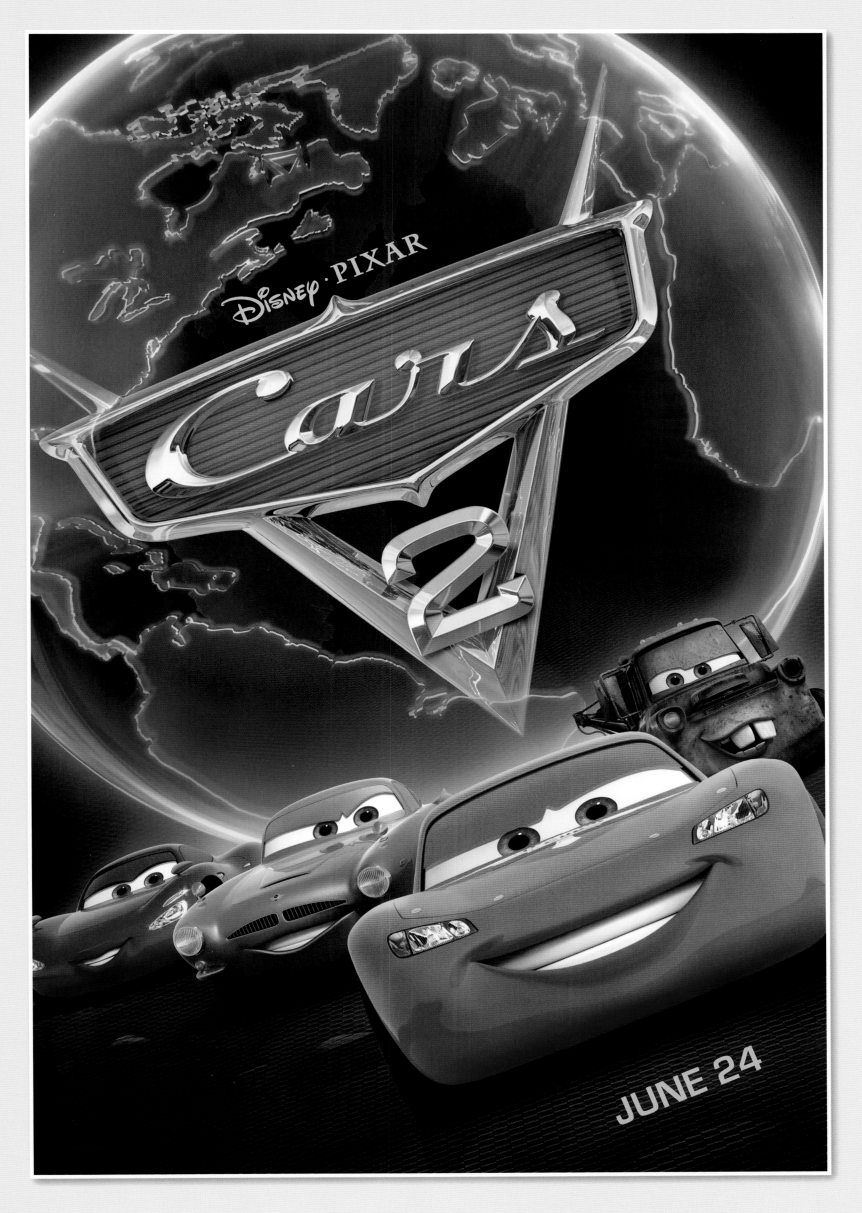

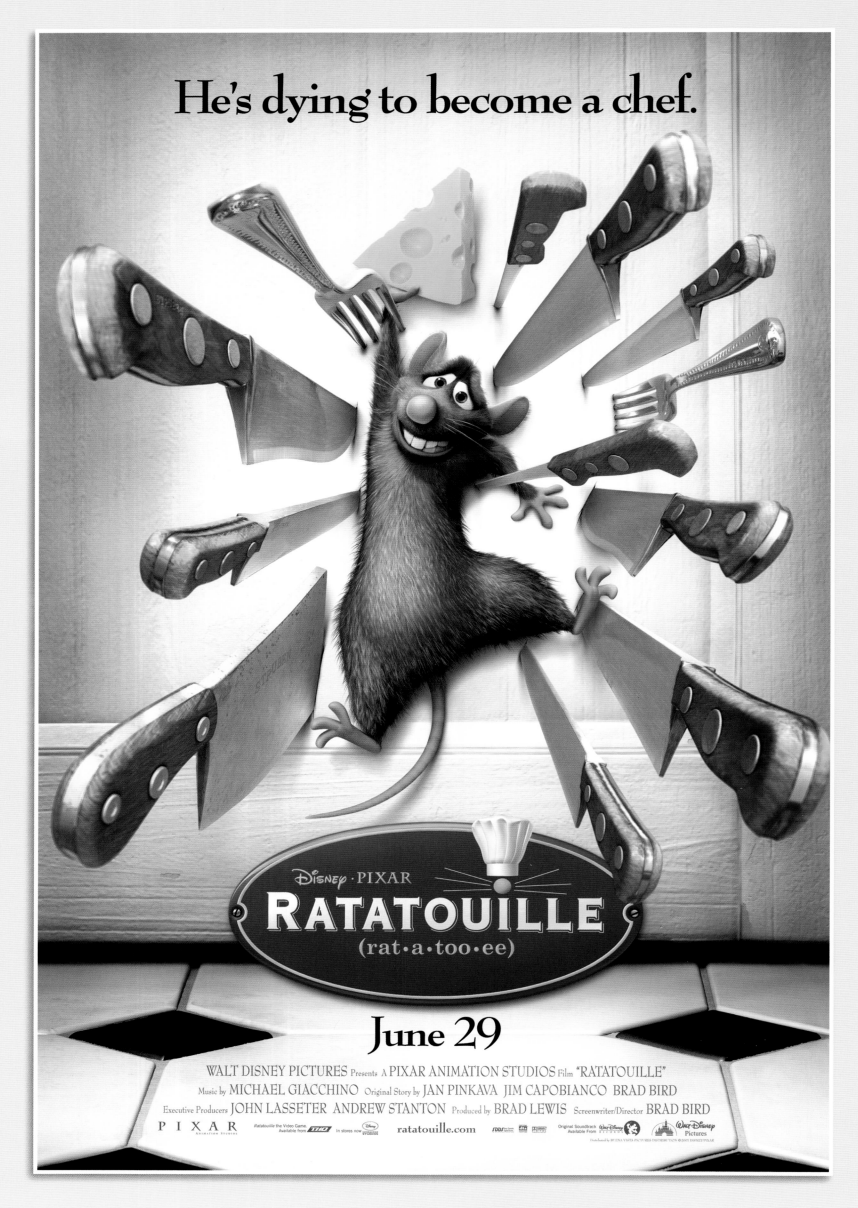

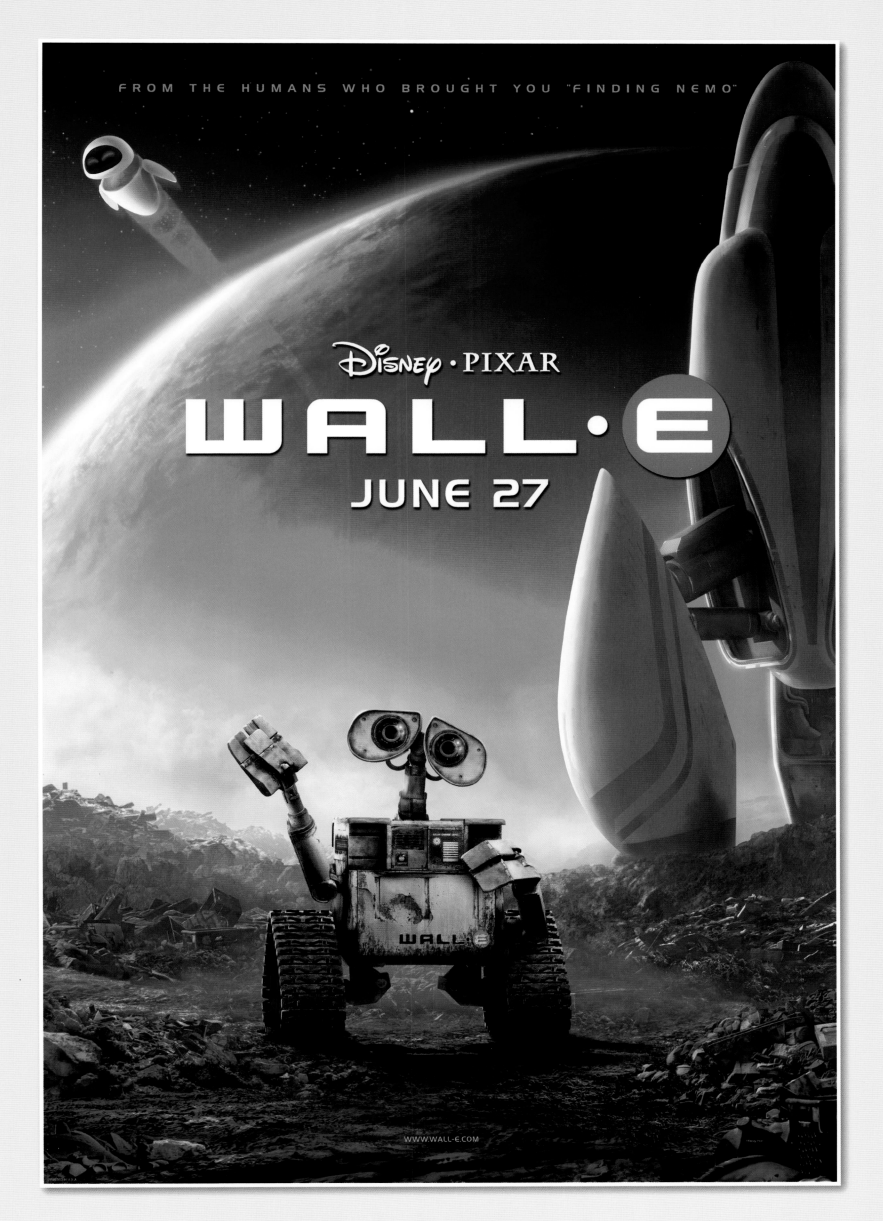

WALL·E, 2008

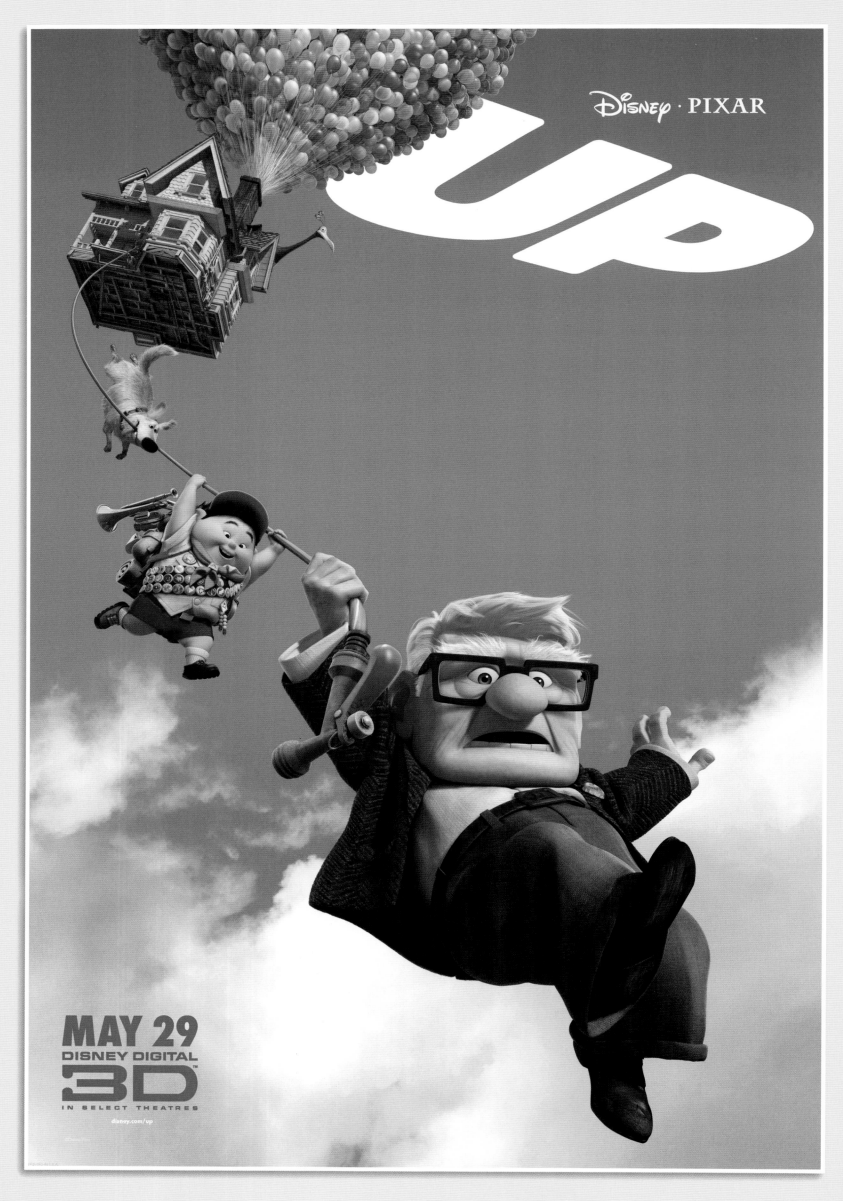

UP, 2009

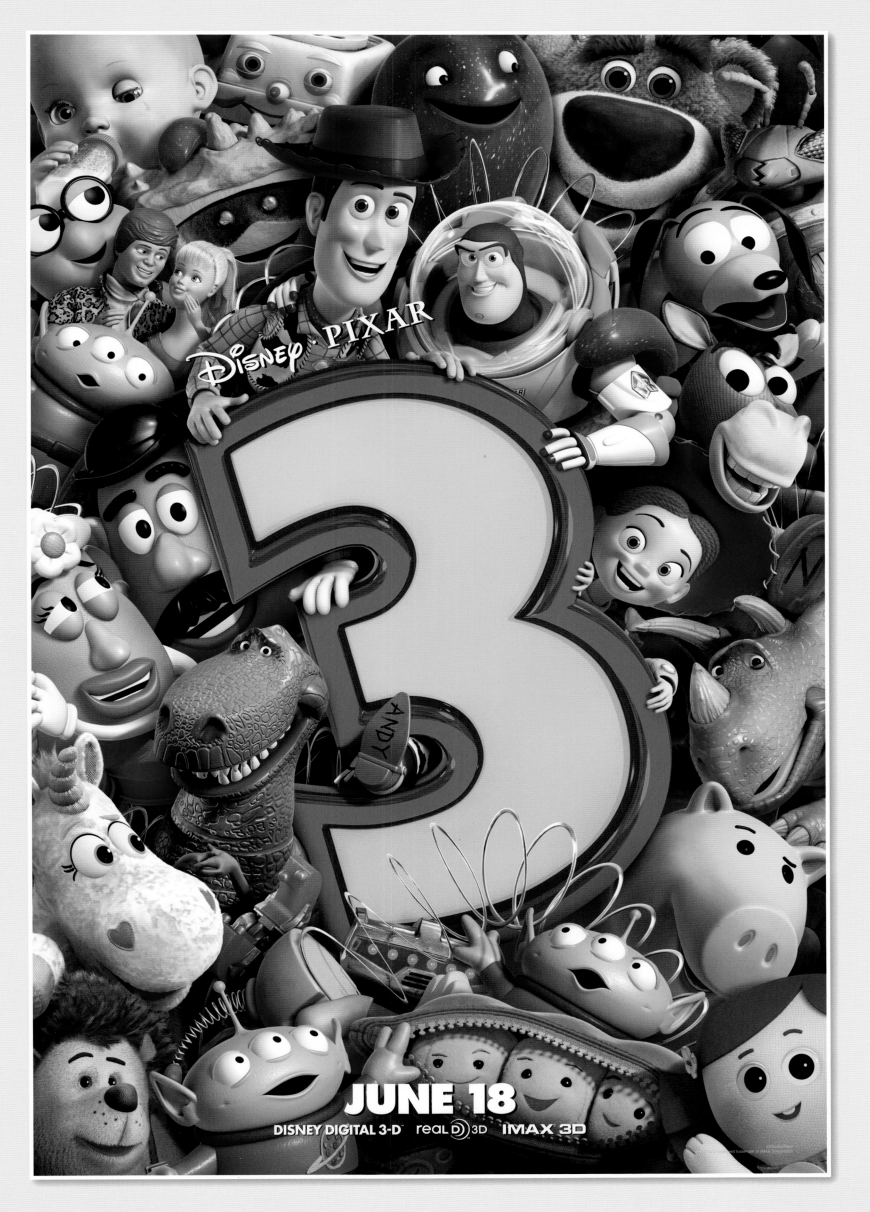

TOY STORY 3, 2010

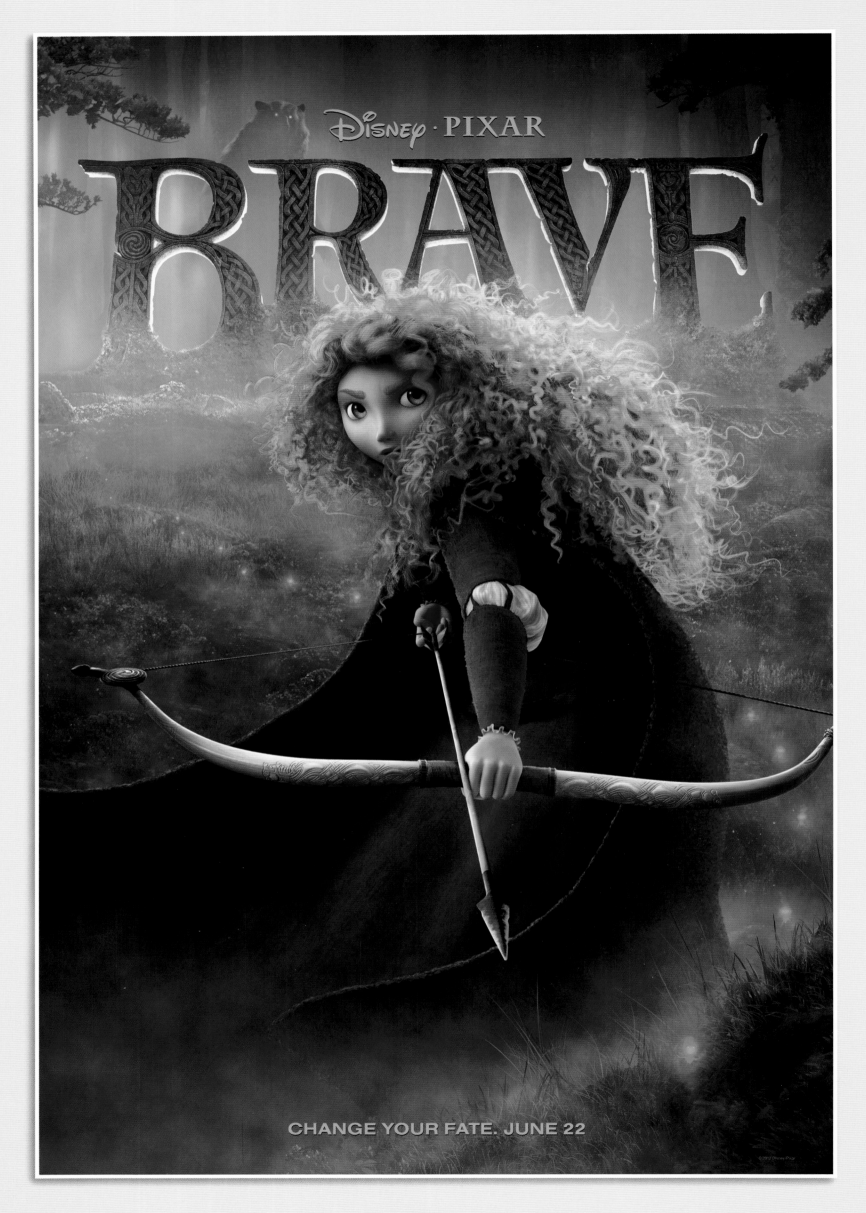

BRAVE, 2012

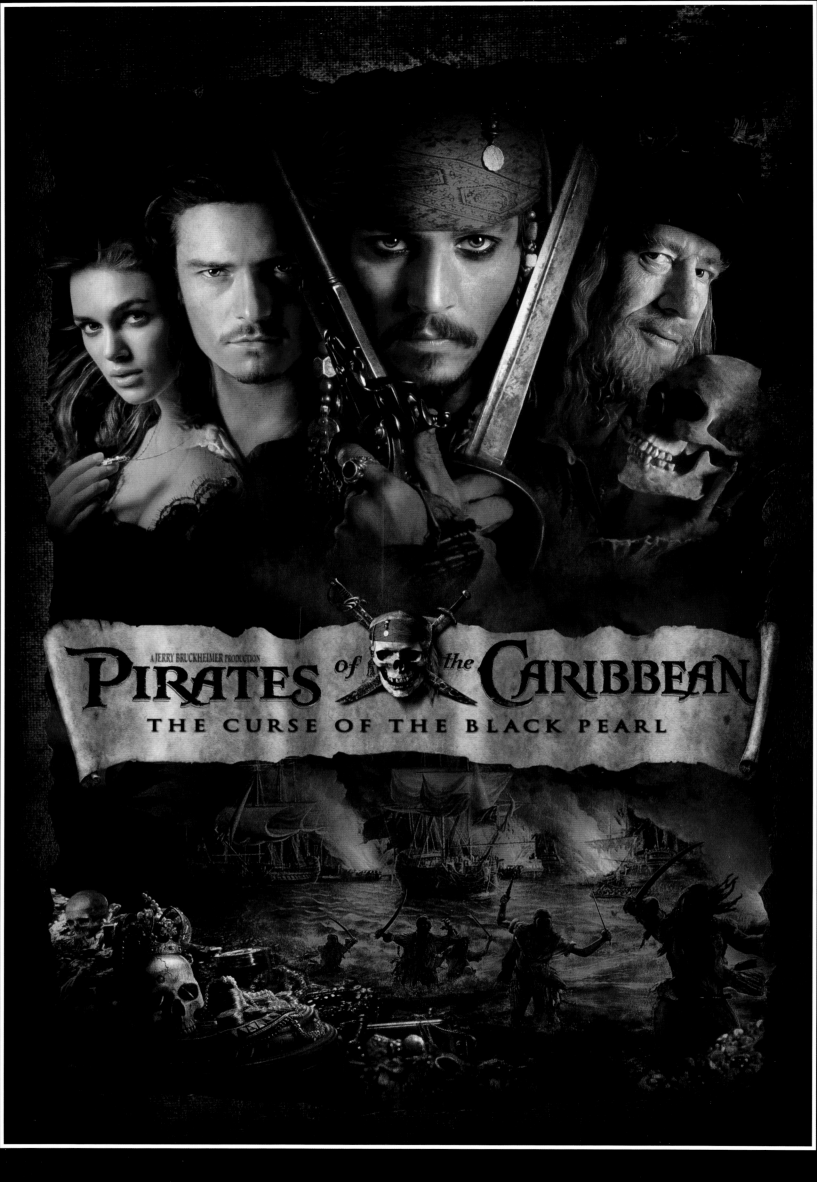

PIRATES OF THE CARIBBEAN: THE CURSE OF THE BLACK PEARL, 2003

LIGHTS, CAMERA . . . LIVE ACTION!

"When you marooned me on that god-forsaken spit of land, you forgot one very important thing, mate: I'm Captain Jack Sparrow."

— Captain Jack Sparrow (Johnny Depp), *Pirates of the Caribbean: The Curse of the Black Pearl*, 2003

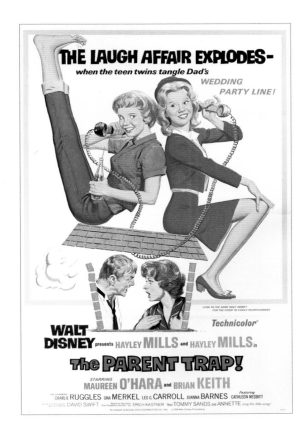

THE PARENT TRAP, 1961

LIVE-ACTION filmmaking had been a part of the Disney repertoire since Walt's first Alice Comedies, but it wasn't until 1950 that the studio released its first full-length movie. *Treasure Island*, based on Robert Louis Stevenson's novel, charmed audiences with swashbuckling action sequences and a courageous young hero in Jim Hawkins.

Disney would produce similar family-friendly adventure films such as *20,000 Leagues Under the Sea* and *Davy Crockett, King of the Wild Frontier* throughout the 1950s before branching into other genres with stories like *Old Yeller* and the fantasy *Darby O'Gill and the Little People*. Over the

subsequent decades, the studio continued to expand its creative reach with musicals (*Mary Poppins*, *Newsies*), science fiction and space odysseys (*The Black Hole*, *Flight of the Navigator*), and sports films (*Cool Runnings*, *Remember the Titans*). In recent years, Disney has begun to reinterpret some of its classic animated films as live-action productions, such as *Alice in Wonderland*, *Maleficent*, *Cinderella*, and *The Jungle Book*.

This variety of movies poses a unique challenge to the teams who design Disney's movie posters. But these artists have an important tool at their disposal: famous faces. Live-action movies, unlike their animated counterparts, have well-known stars; indeed, celebrities ranging from Kirk Douglas to Julie Andrews to Johnny Depp have headlined Disney movies. As such, photographers play an integral part in the creation of live-action movie posters. Artists and animators merge the pictures they capture with detailed, often lush, backgrounds to create truly singular images that fans instantly identify with the movies they love long after those movies have left the theaters.

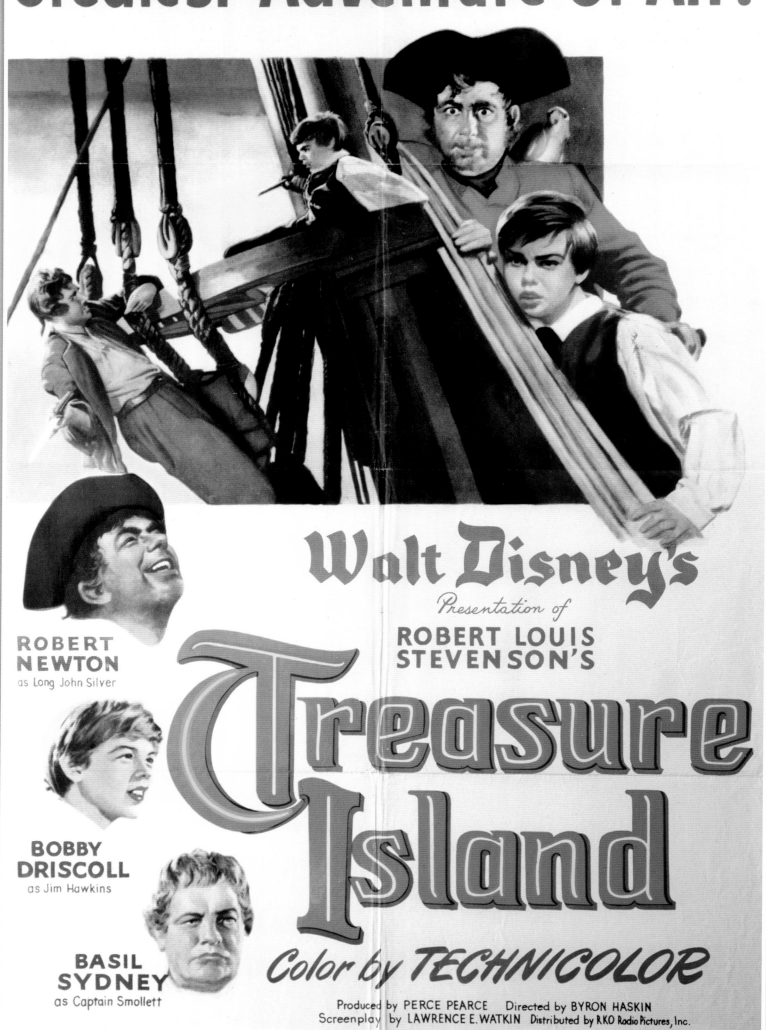

TREASURE ISLAND, 1950

20,000 LEAGUES UNDER THE SEA, 1954

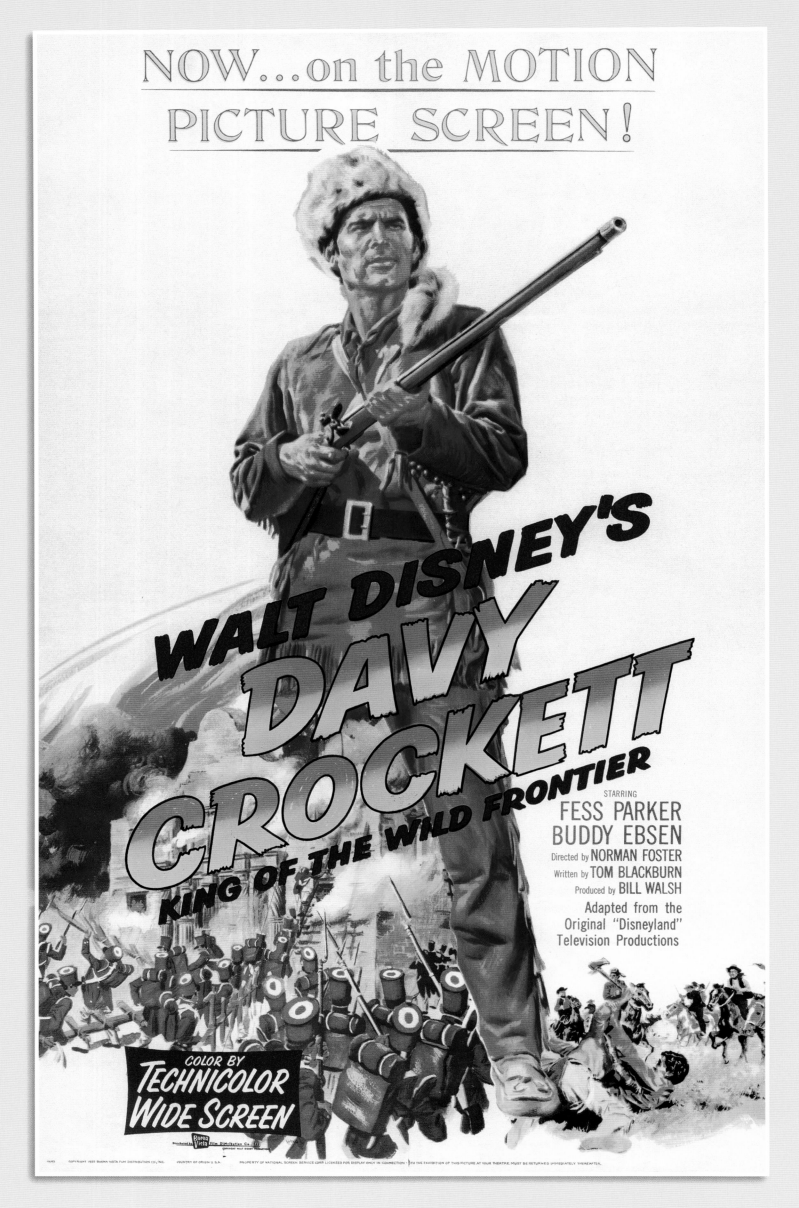

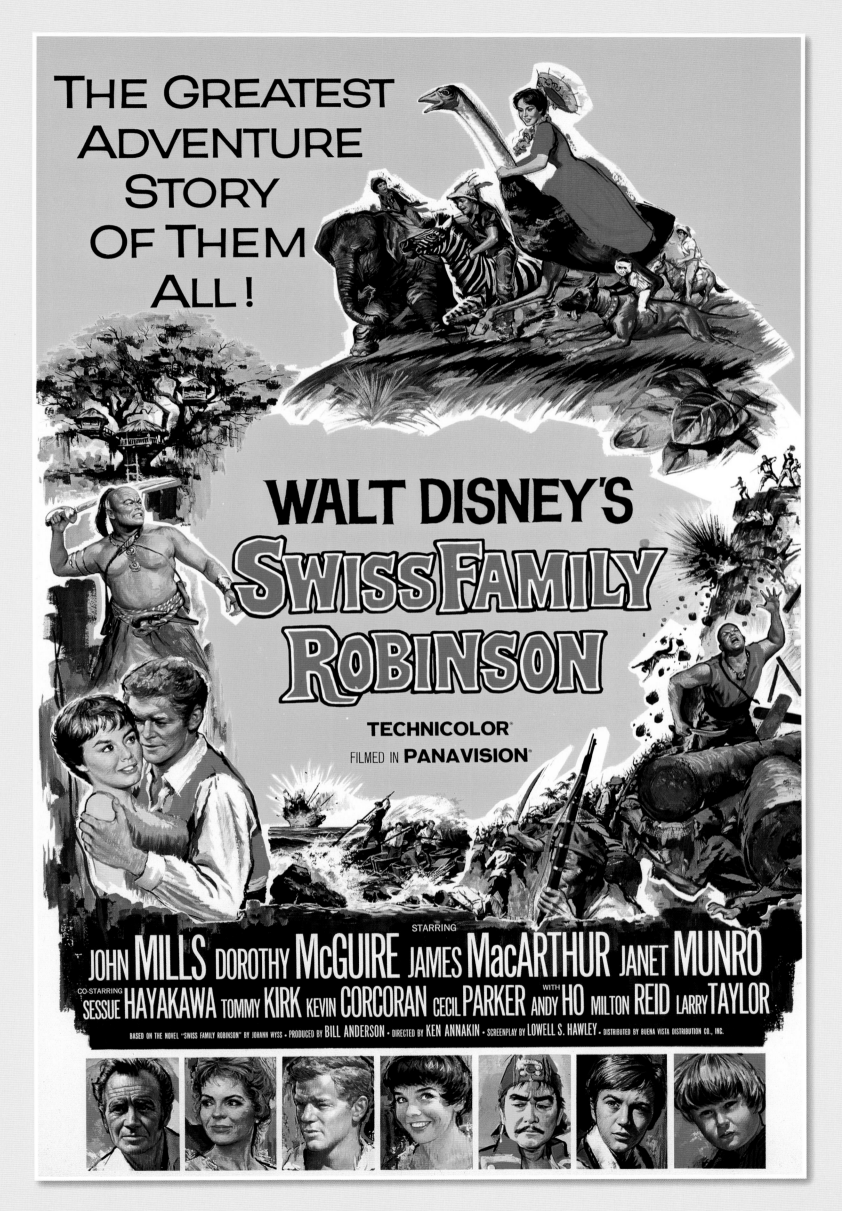

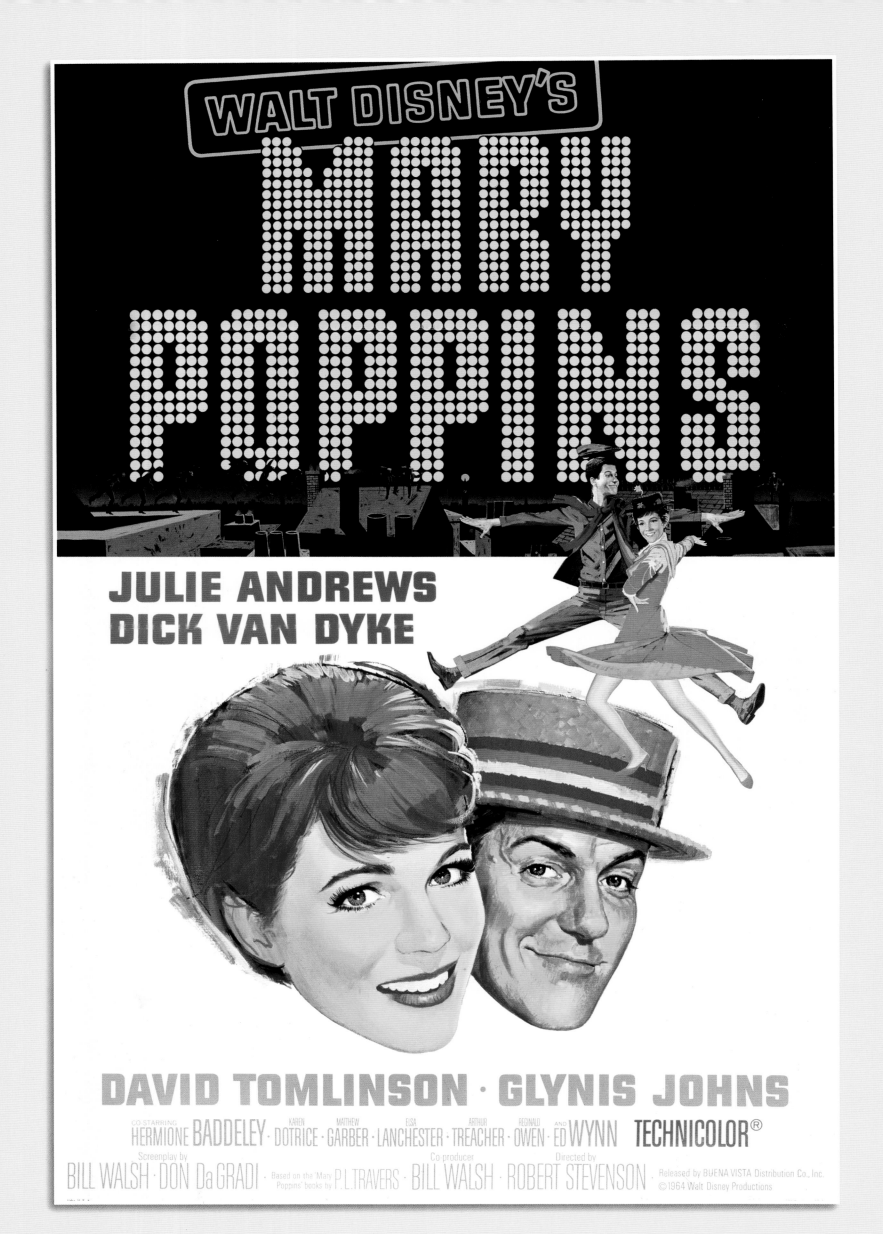

MARY POPPINS, 1964

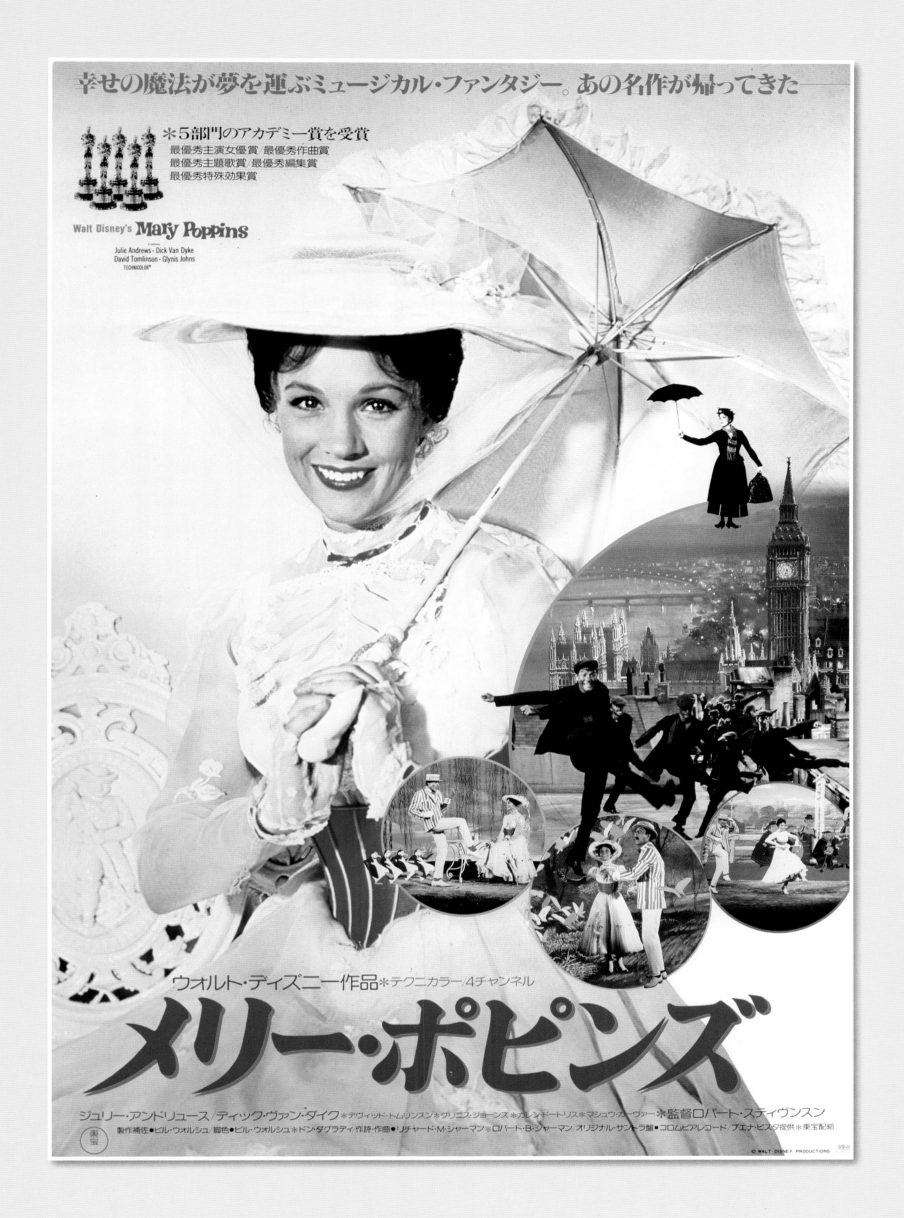

MARY POPPINS, 1965 (Japan)

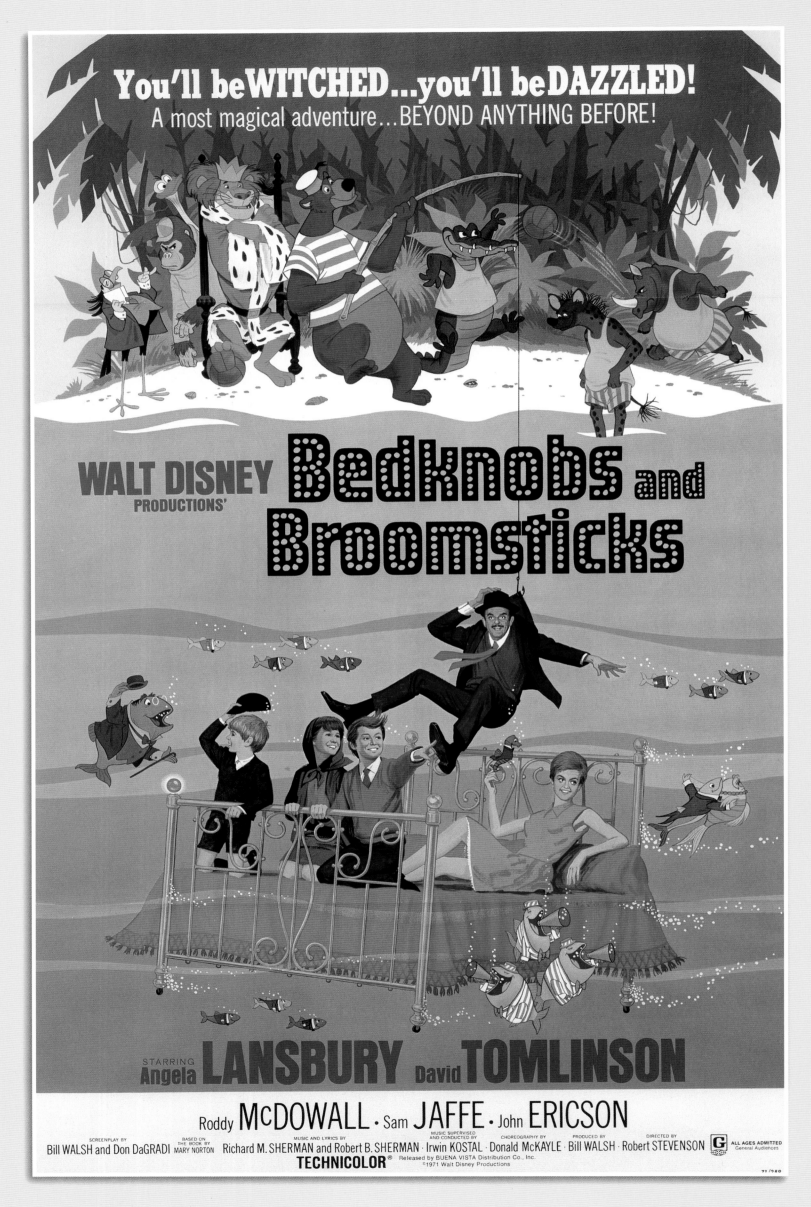

BEDKNOBS AND BROOMSTICKS, 1971

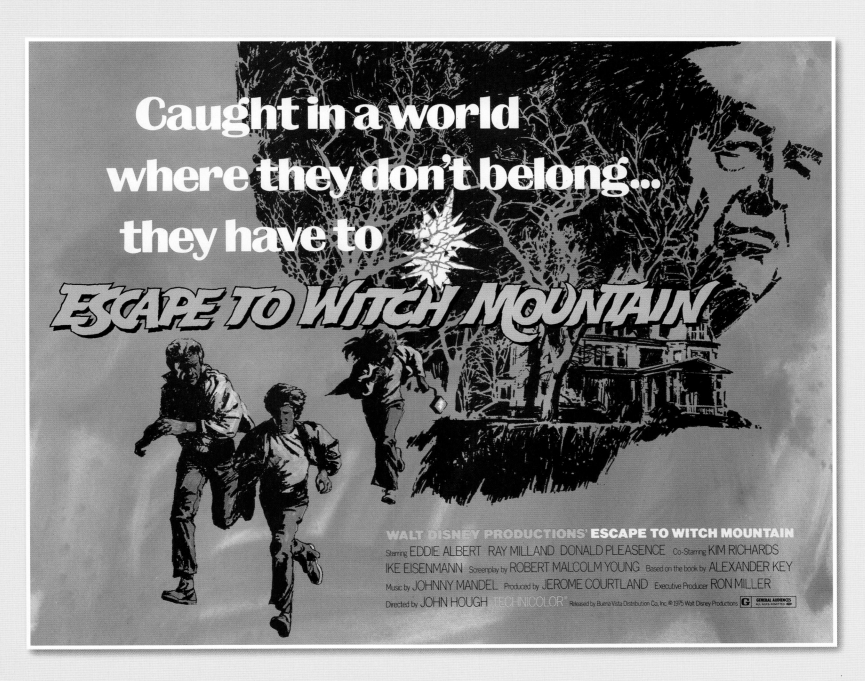

ESCAPE TO WITCH MOUNTAIN, 1975

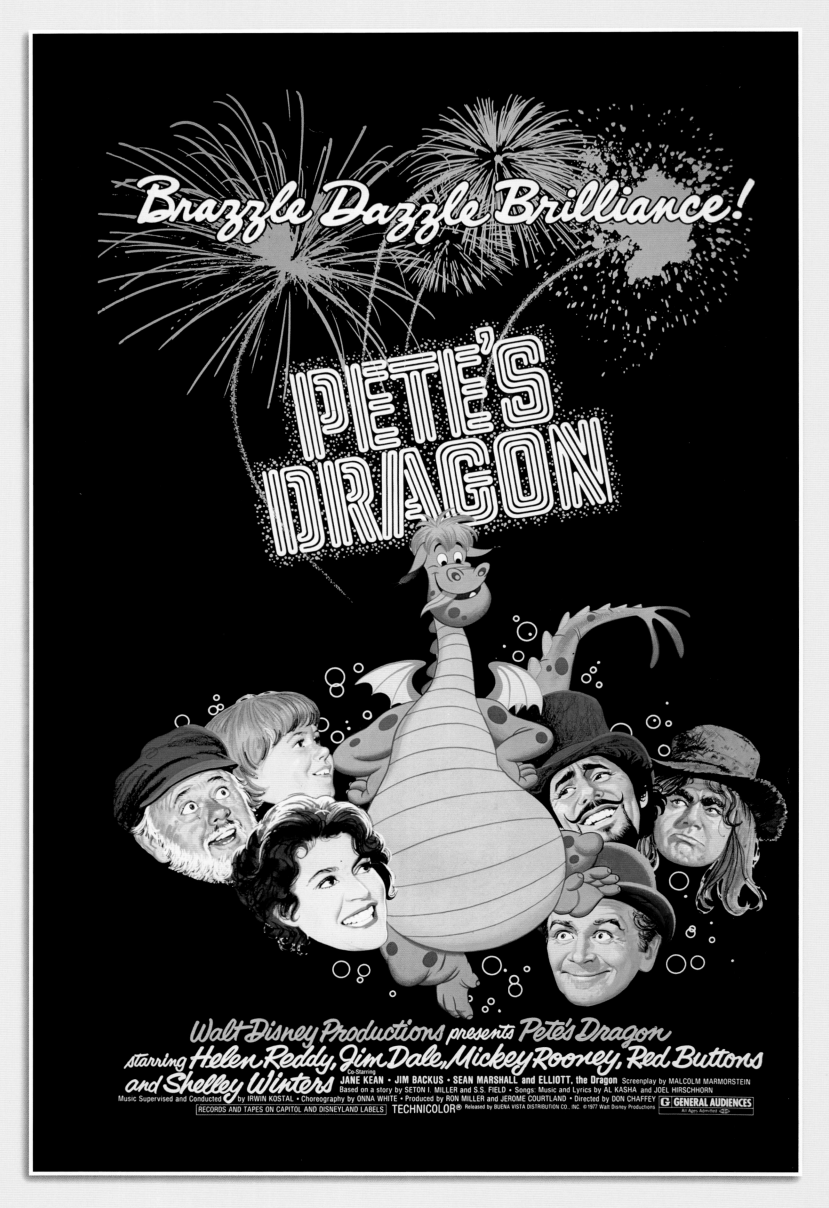

PETE'S DRAGON, 1977

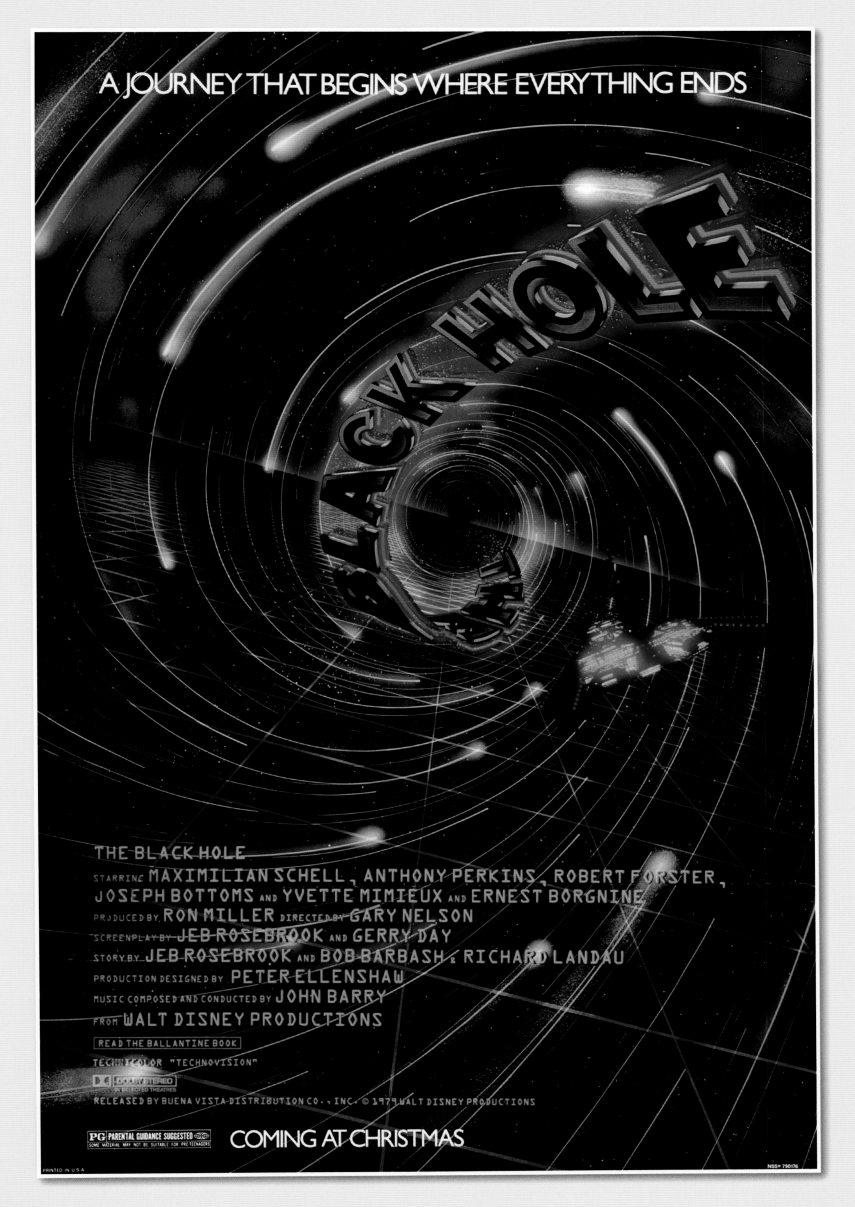

THE BLACK HOLE, 1979

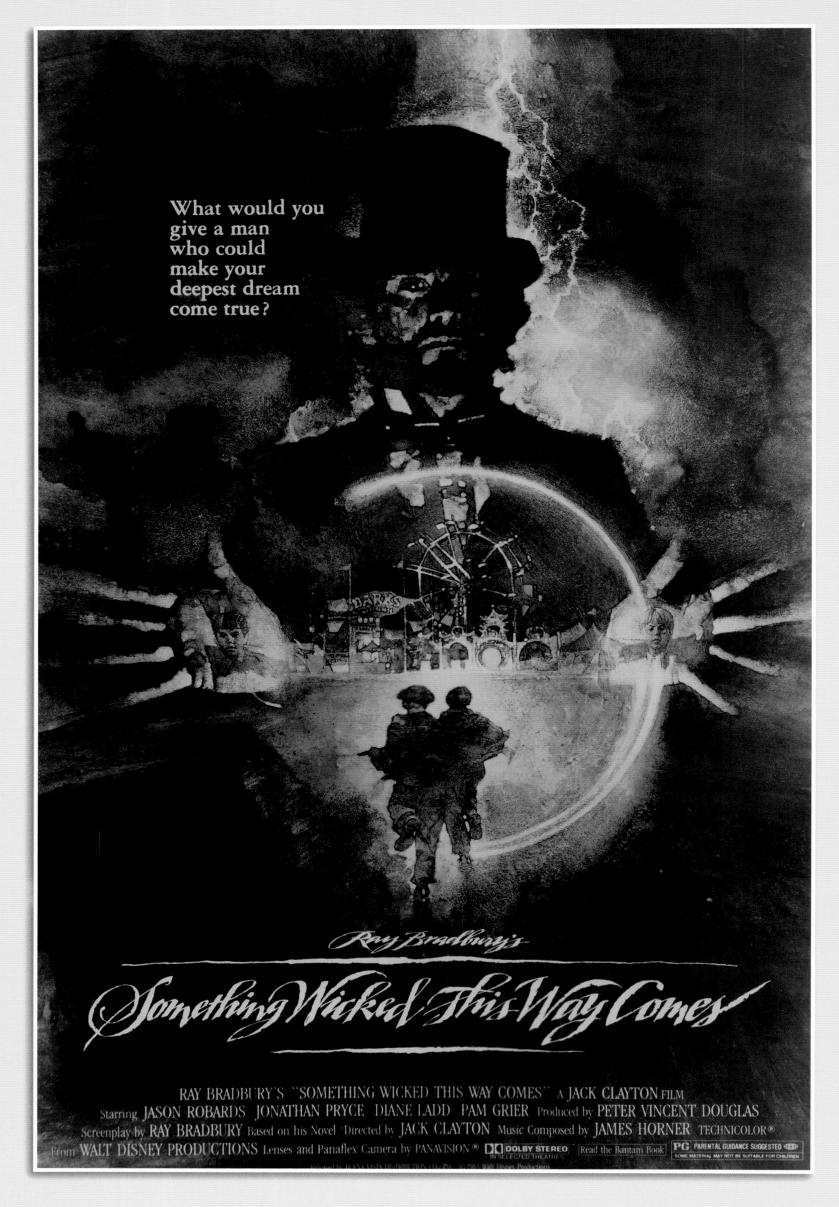

SOMETHING WICKED THIS WAY COMES, 1983

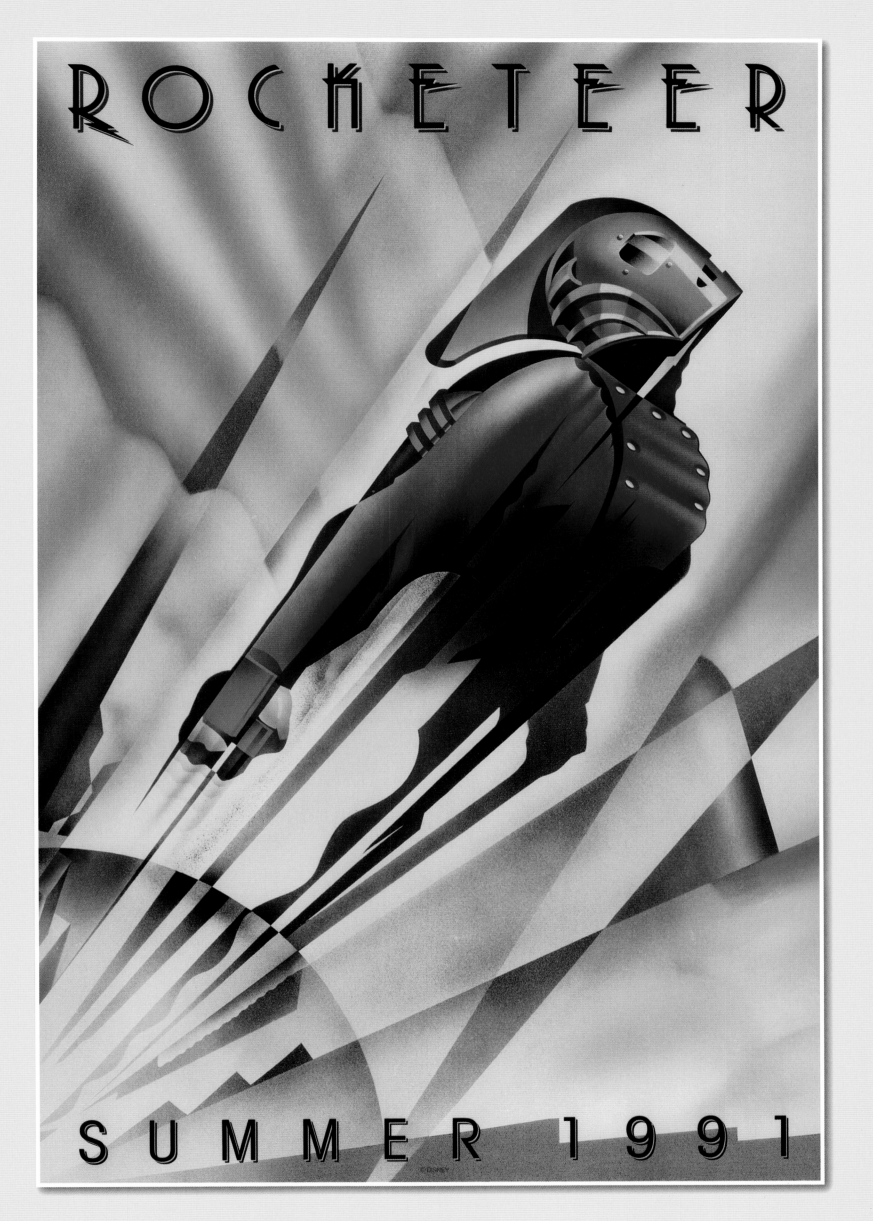

THE ROCKETEER, 1991

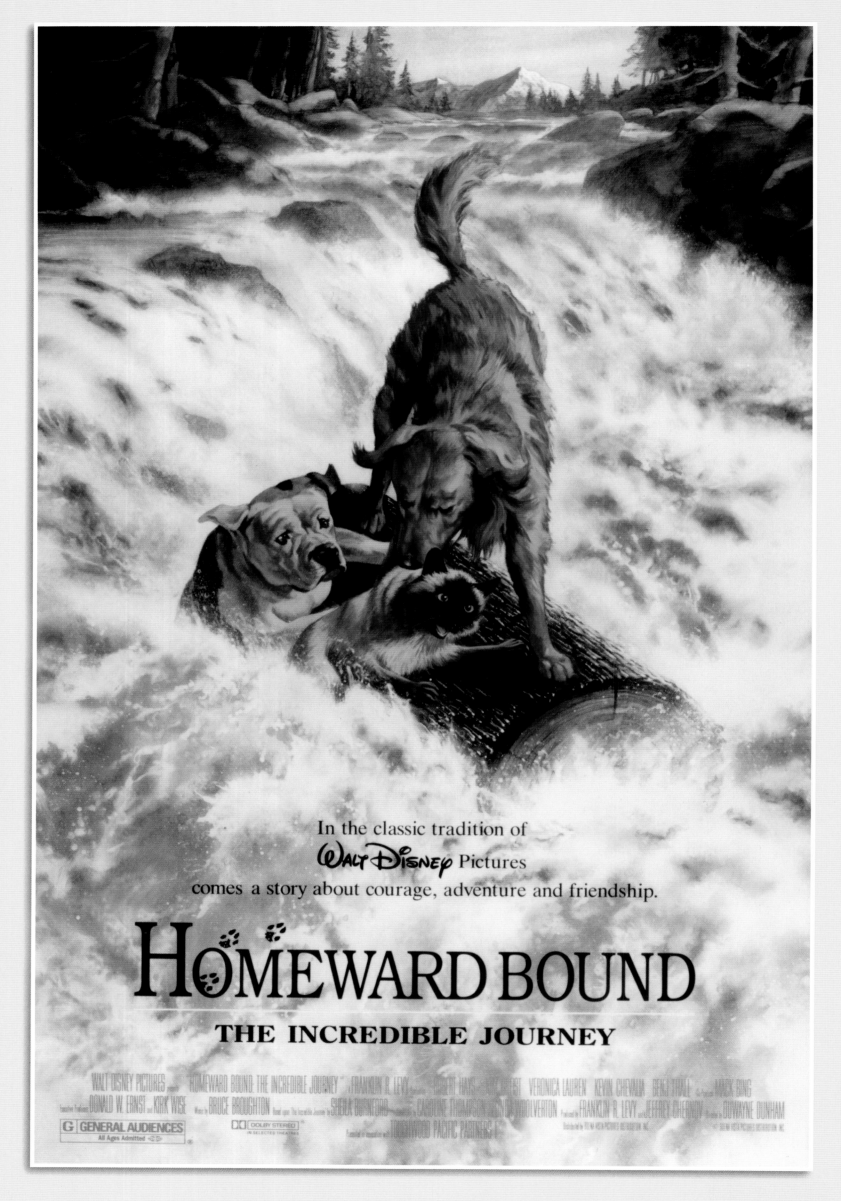

HOMEWARD BOUND: THE INCREDIBLE JOURNEY, 1993

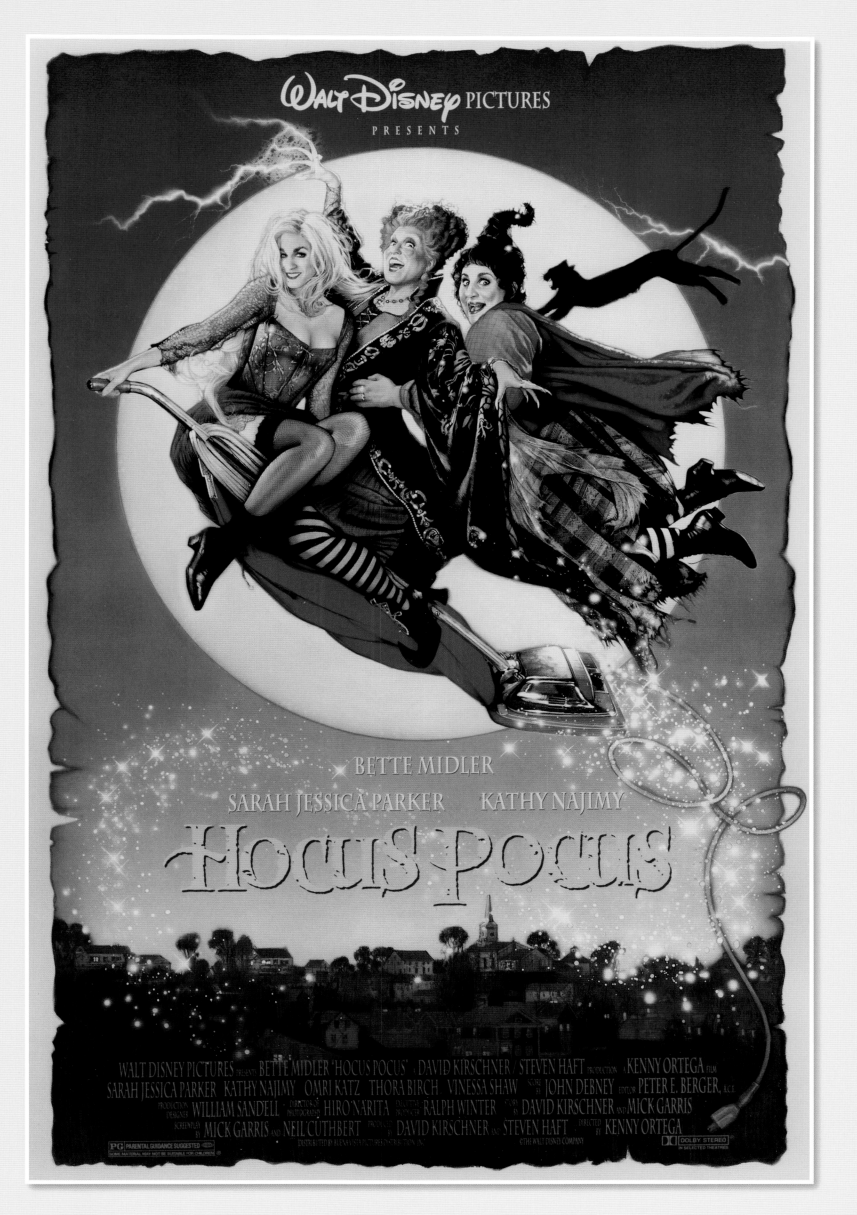

HOCUS POCUS, 1993

One dream.
Four Jamaicans.
Twenty below zero.

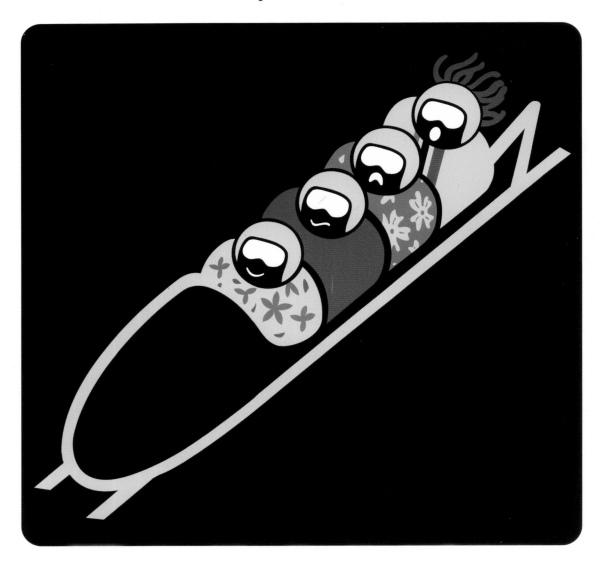

Inspired by the True Story of the First
Jamaican Olympic Bobsled Team.

Walt Disney PICTURES presents

WALT DISNEY PICTURES presents "COOL RUNNINGS" a DAWN STEEL Production a JON TURTELTAUB Film LEON · DOUG E. DOUG · RAWLE D. LEWIS · MALIK YOBA and JOHN CANDY
Score by HANS ZIMMER · Editor BRUCE GREEN, A.C.E. · Production Designer STEPHEN MARSH · Director of Photography PHEDON PAPAMICHAEL · Executive Producers CHRISTOPHER MELEDANDRI · SUSAN B. LANDAU
Story by LYNN SIEFERT & MICHAEL RITCHIE · Screenplay by LYNN SIEFERT and TOMMY SWERDLOW & MICHAEL GOLDBERG · Produced by DAWN STEEL · Directed by JON TURTELTAUB

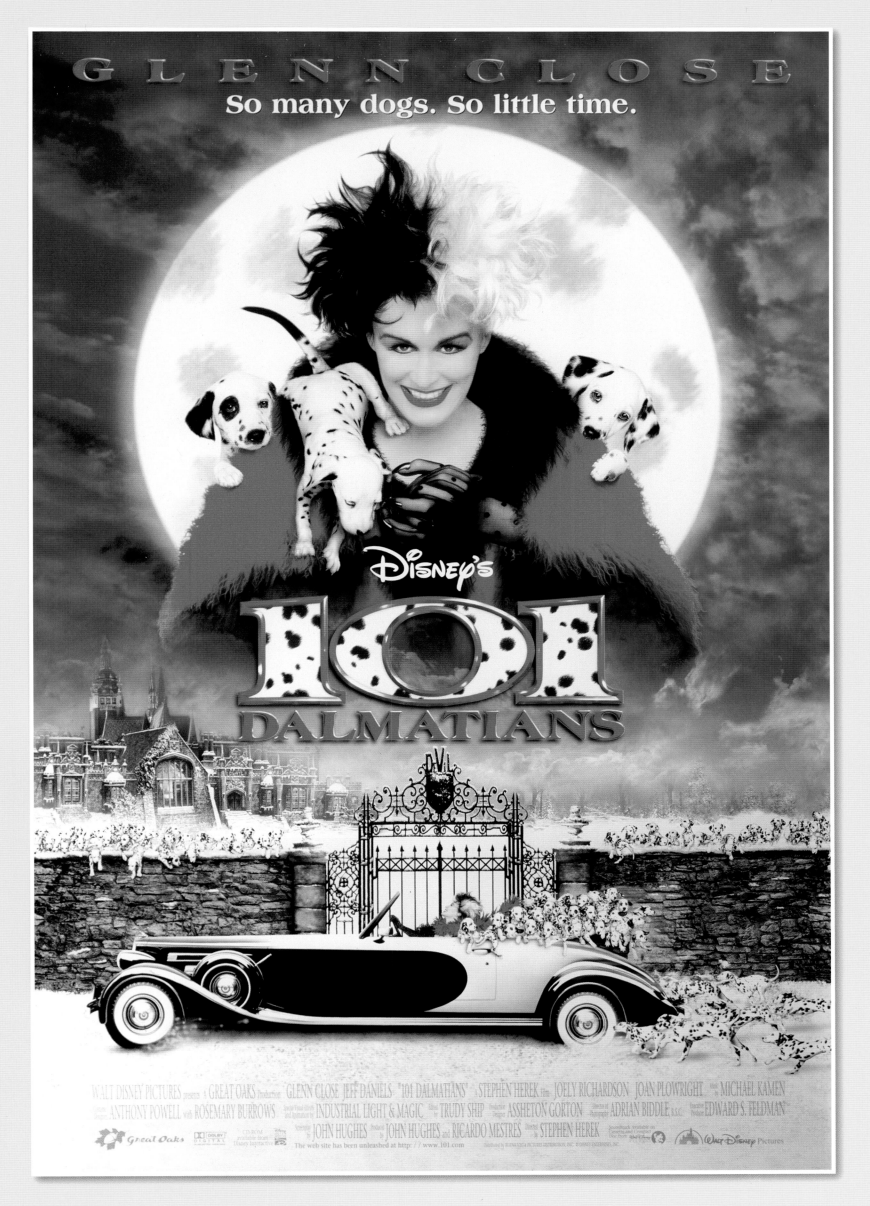

101 DALMATIANS, 1996

THE ROOKIE, 2002

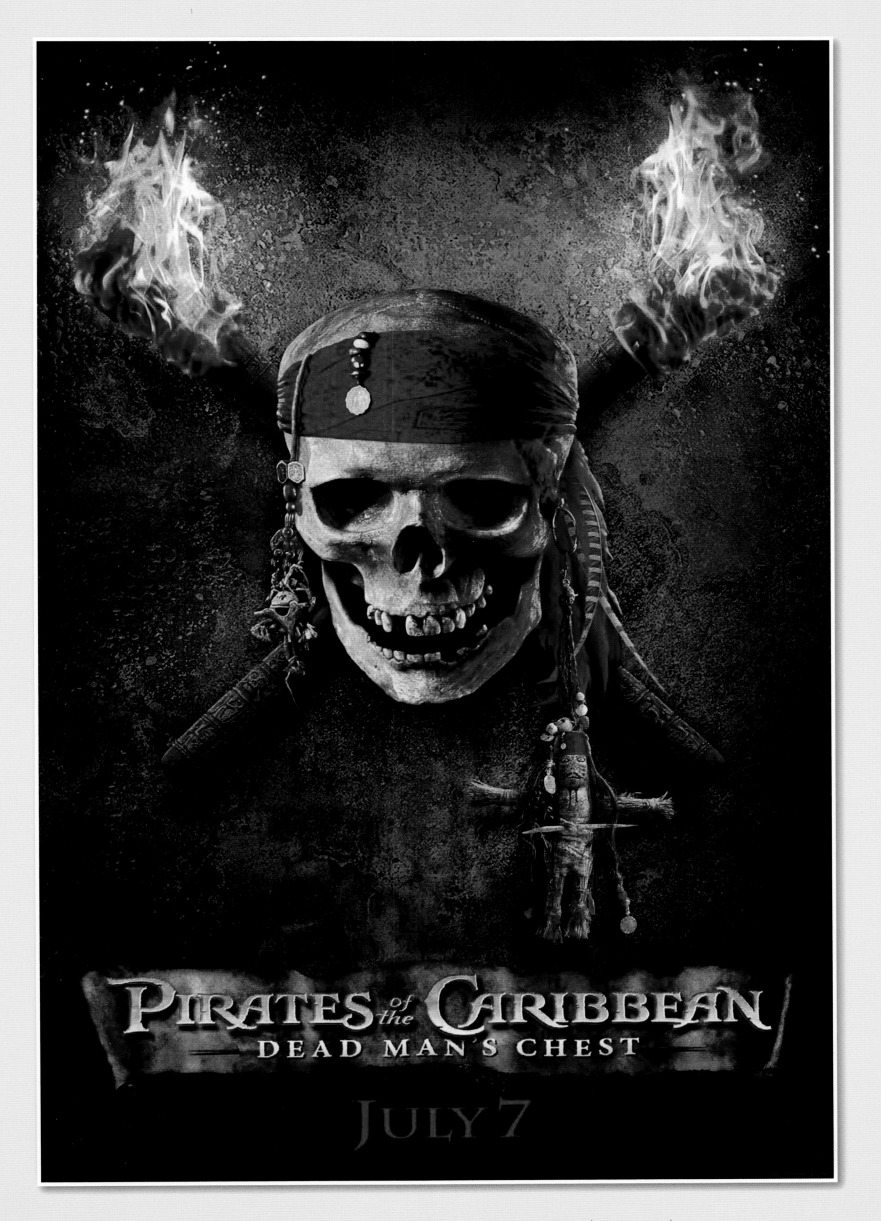

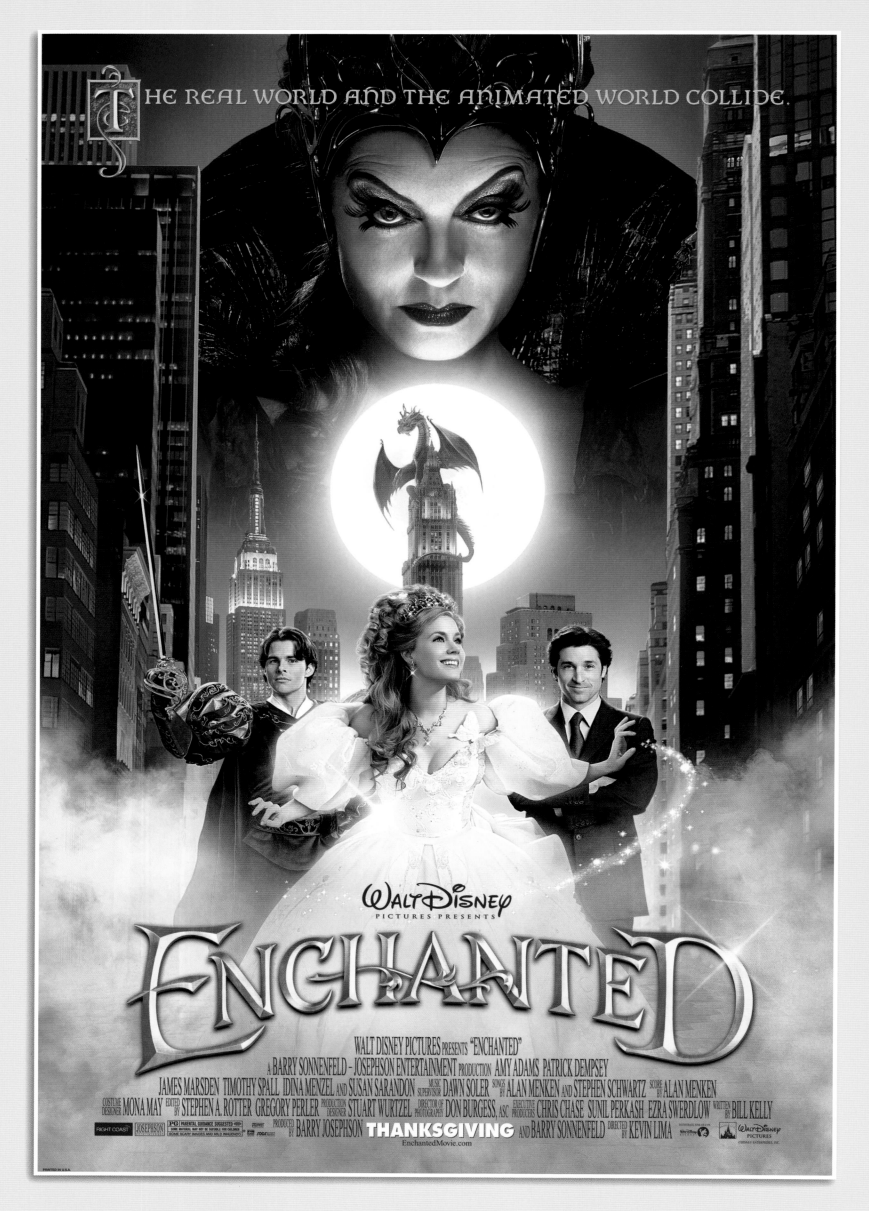

ENCHANTED, 2007

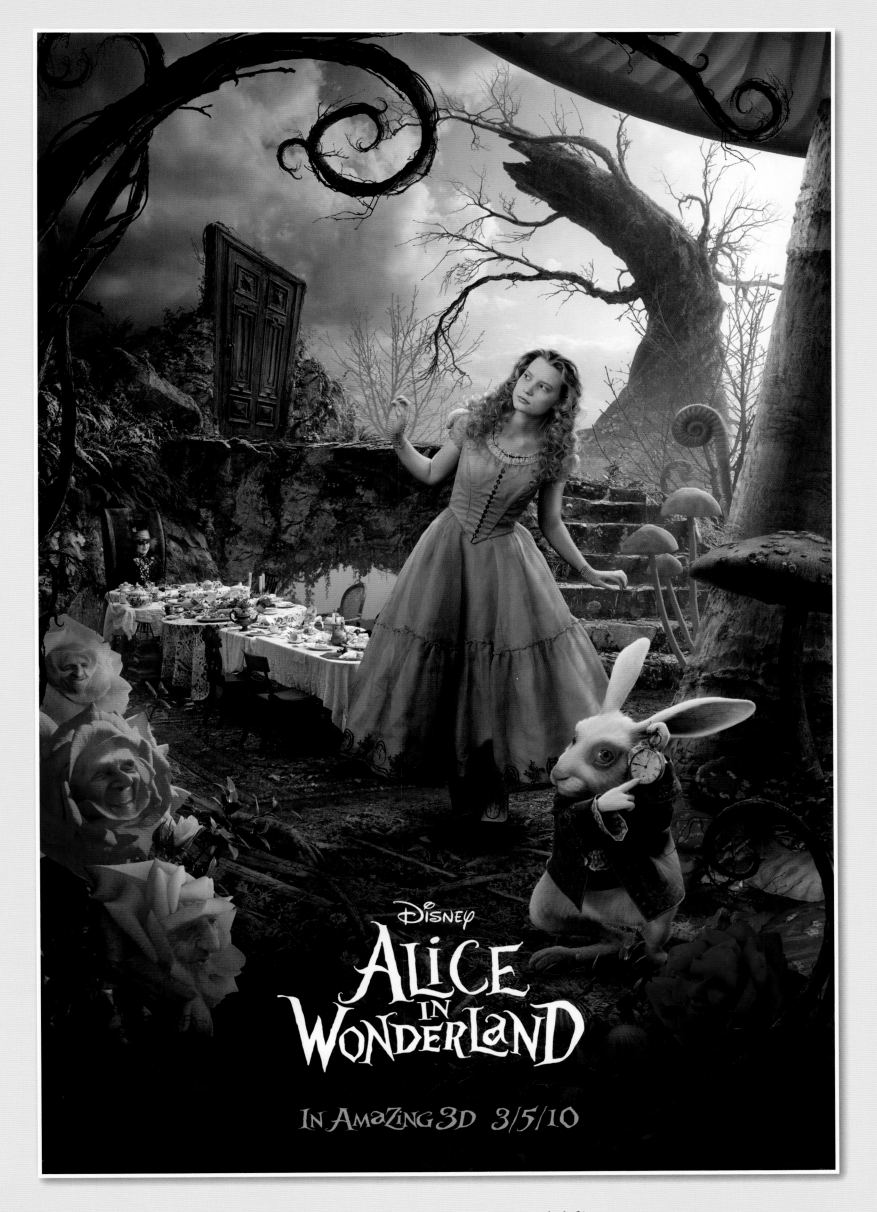

ALICE IN WONDERLAND, 2010 (triptych, left)

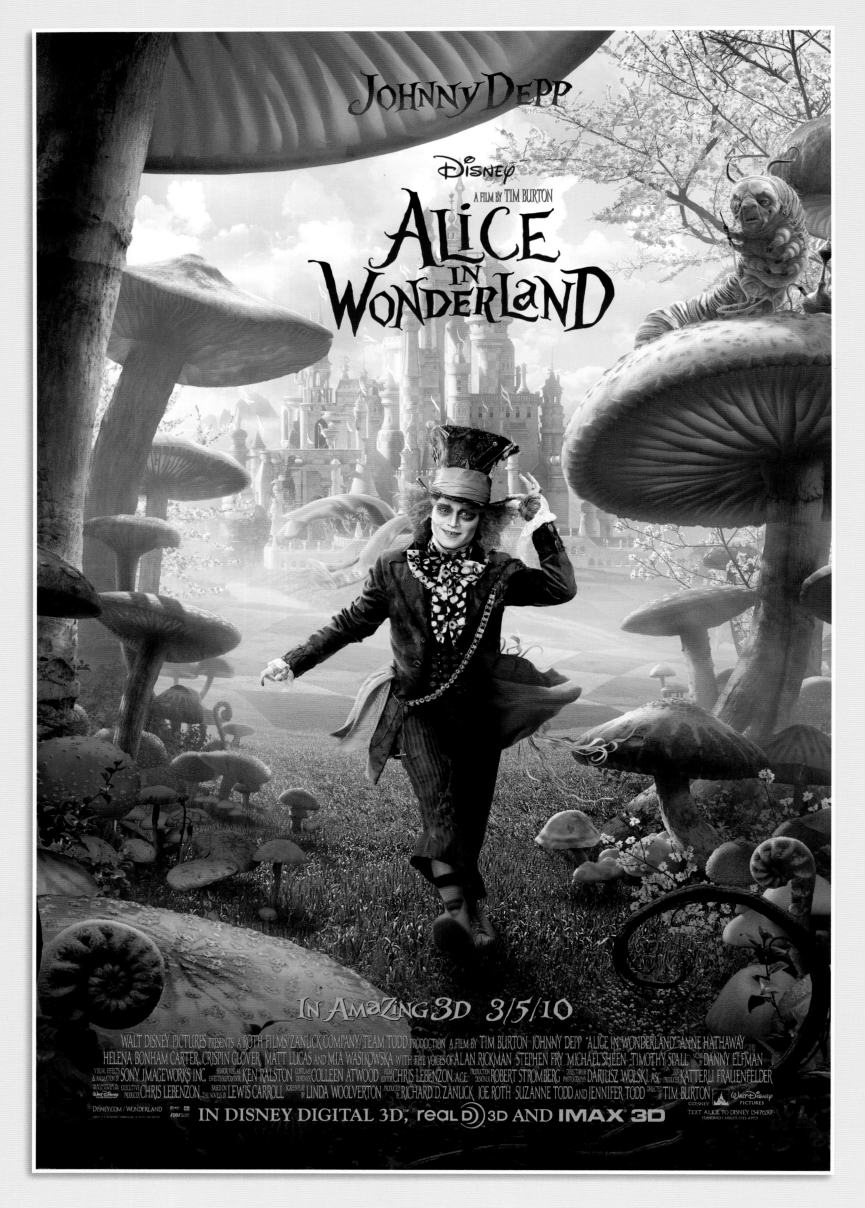

ALICE IN WONDERLAND, 2010 (triptych, center)

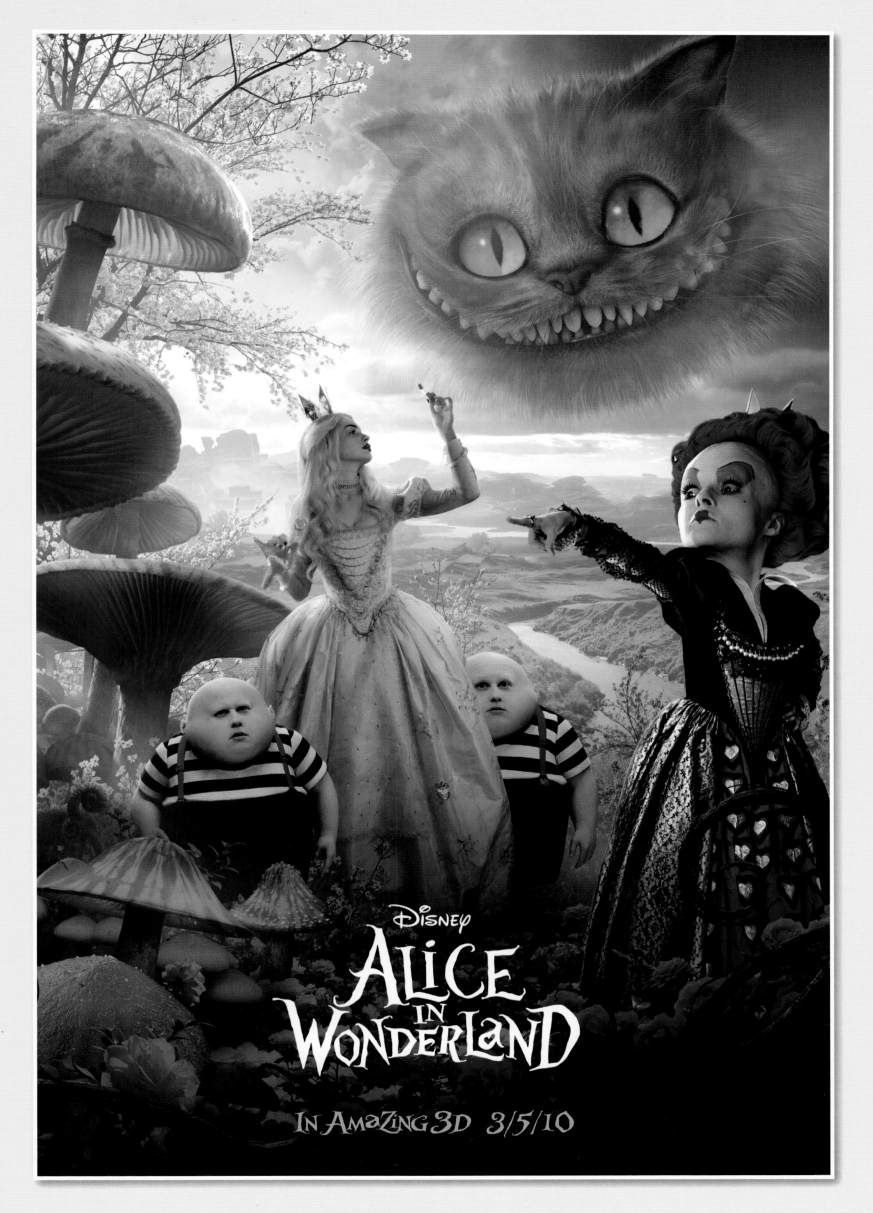

ALICE IN WONDERLAND, 2010 (triptych, right)

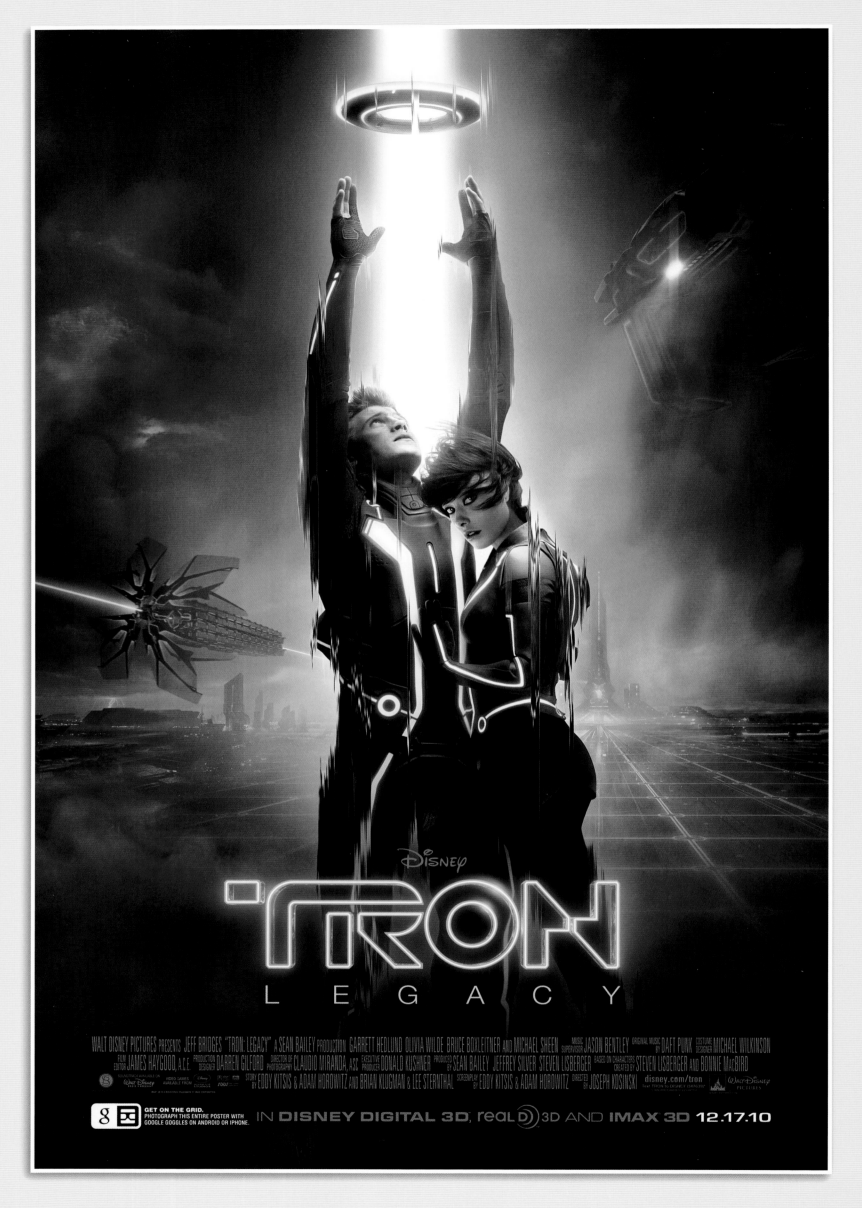

TRON: LEGACY, 2010

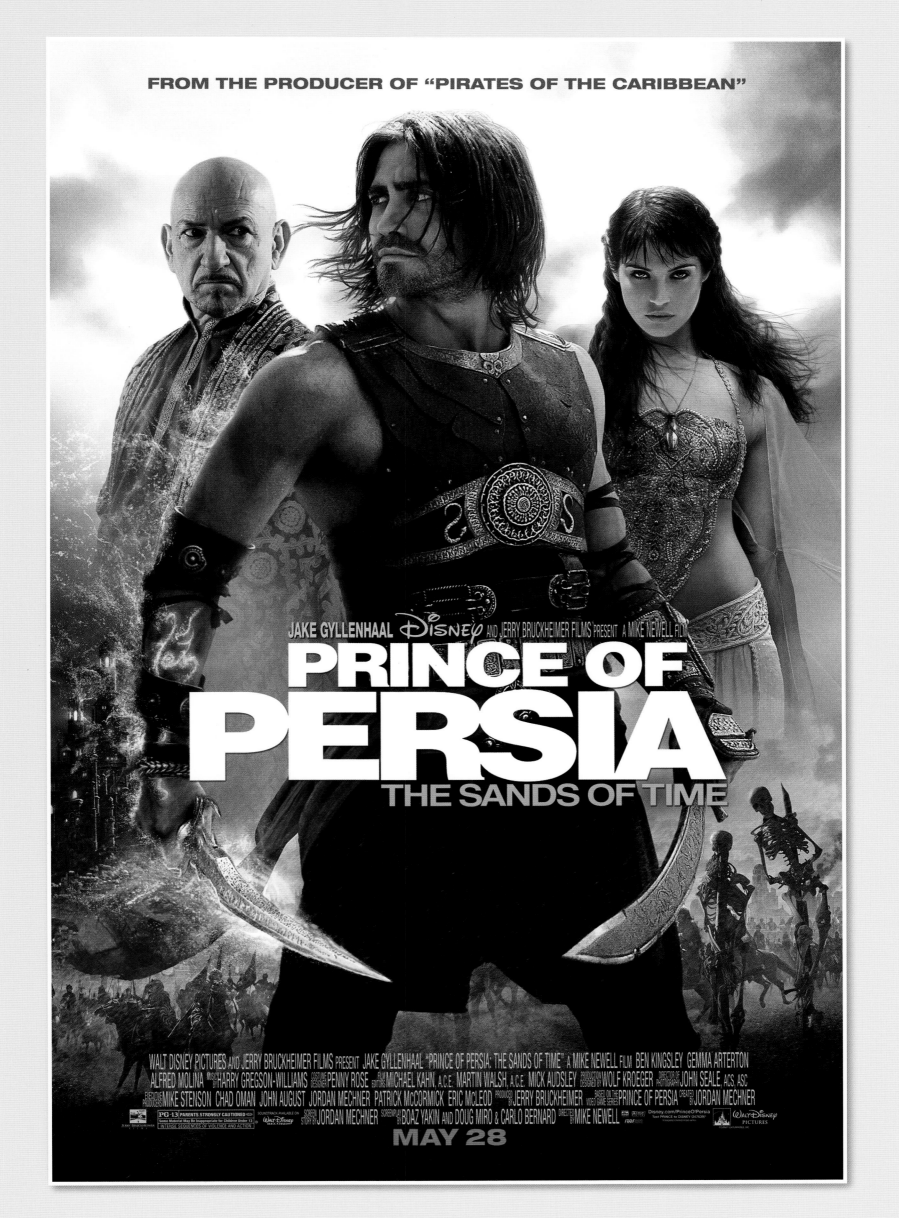

PRINCE OF PERSIA, 2010

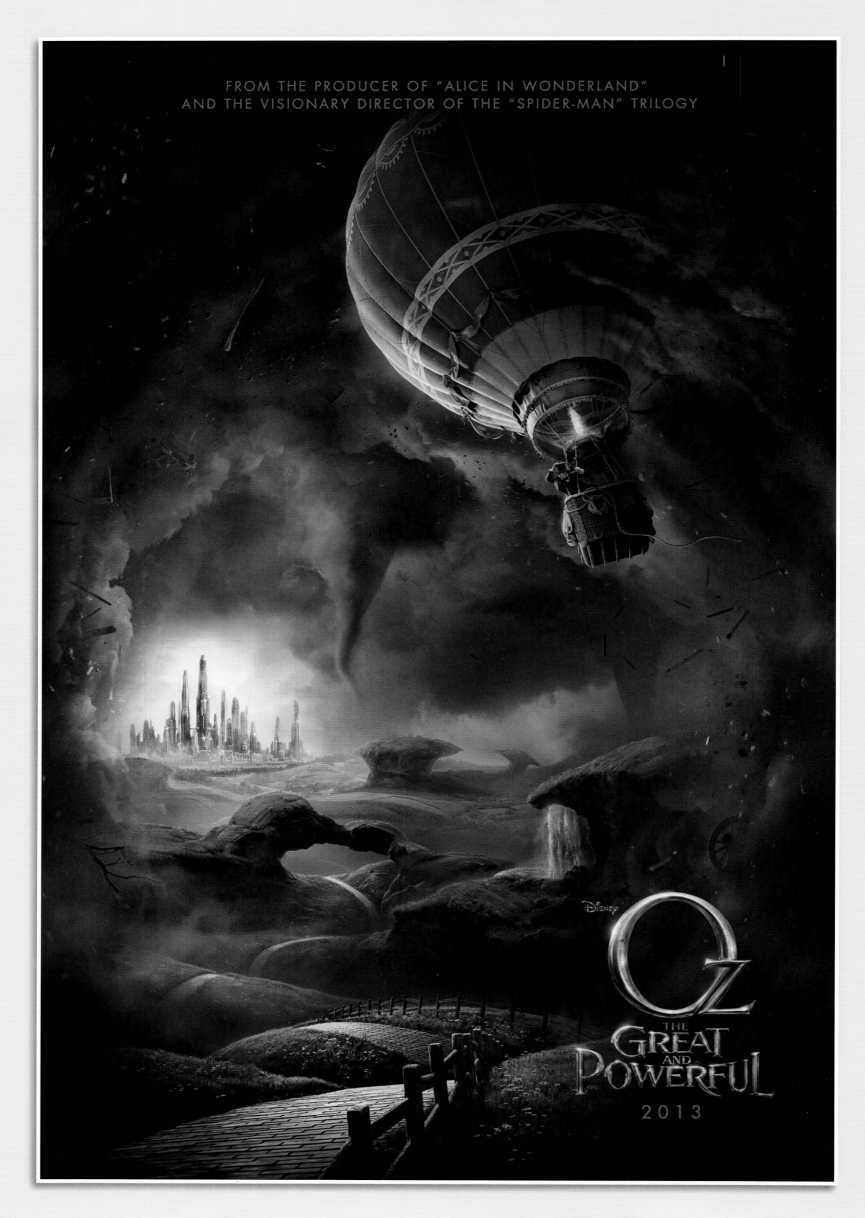

OZ THE GREAT AND POWERFUL, 2013 (teaser poster)

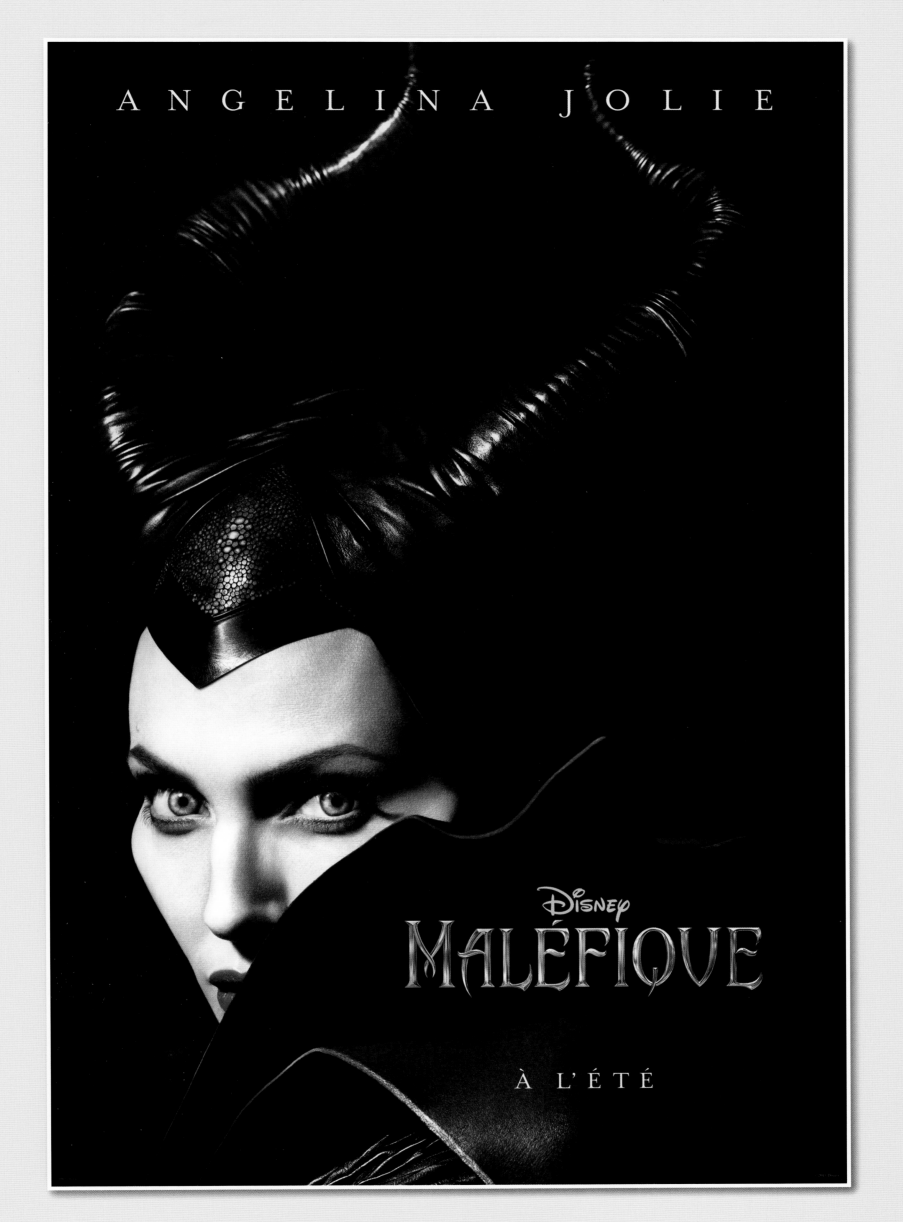

MALEFICENT, 2014 (French-Canadian teaser poster)

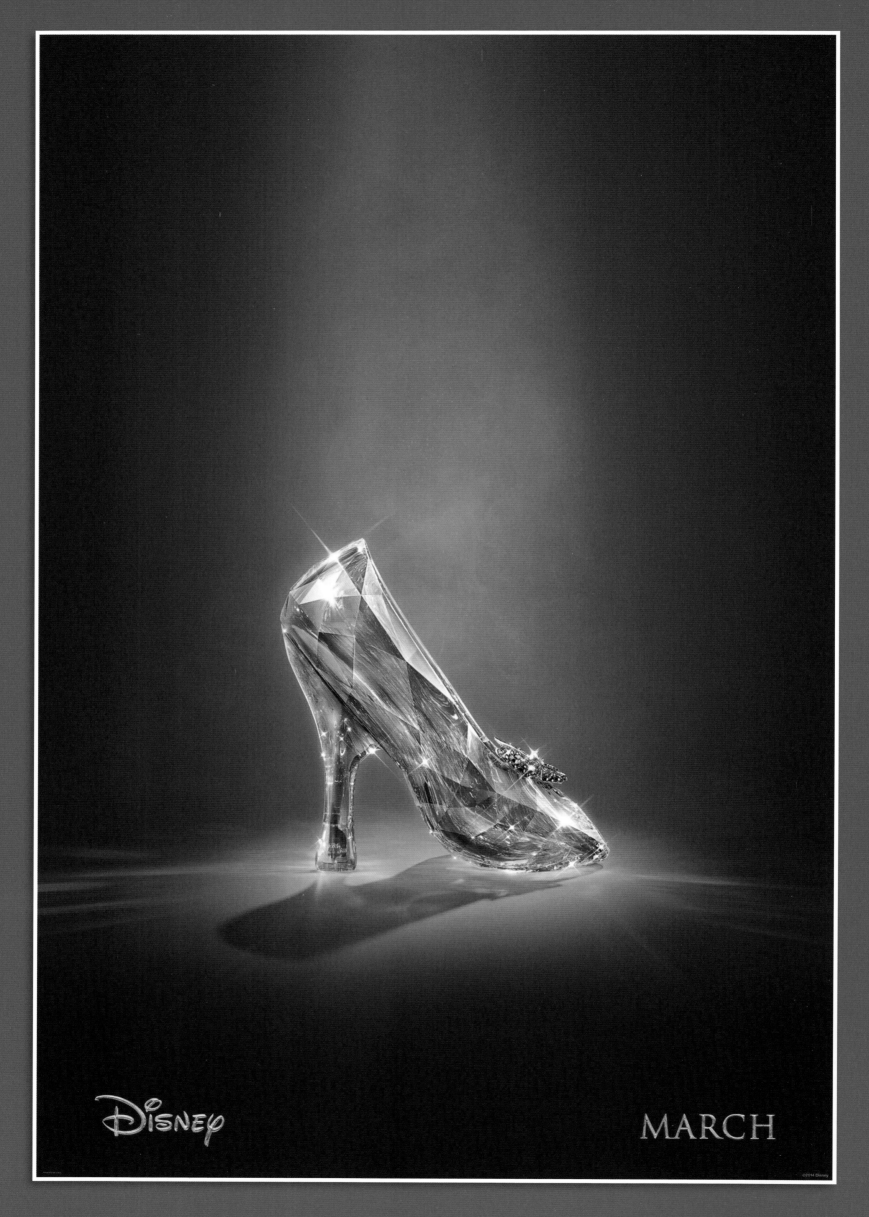

CINDERELLA, 2015 (teaser poster)

ACKNOWLEDGMENTS

THANK YOU, first and foremost, to the folks at Disney Publishing Worldwide, especially my editor, Laura Hopper, for all her hard work and support, and Jessica Ward, for her encyclopedic knowledge of all things Disney.

Several people were instrumental in the research stage of this book, in particular Shelly Graham, who was unfailingly patient with my frequent requests to add "just one more" poster to the online photo archive, and Justin Arthur and Lisa Bigelow, both absolutely essential in tracking down information for the international posters.

John Sabel, Steve Nuchols, and Jonny Kwan all took time away from creating the next batch of amazing Disney movie posters to answer my questions and talk about the art, for which I am quite grateful. Thanks also to Steve Czarnecki for coordinating those conversations.

And finally, thank you to Rebecca Cline, Kevin Kern, and Alesha Reyes at the Disney Archives and archivist Michael Buckhoff and Holly Brobst for their help with this project.

SELECTED BIBLIOGRAPHY

Briner, Lisa. 2009. "Walt Disney Goes to War." www.army.mil/article/19340/Walt_Disney_Goes_to_War/

Canemaker, John. *Before the Animation Begins: The Life and Times of Disney Inspirational Sketch Artists*. New York: Hyperion, 1999.

Clements, Ron, Alan Menken, and John Musker. Audio commentary, *The Little Mermaid*, Platinum Edition DVD. Walt Disney Studios Home Entertainment, 2006.

Gabler, Neal. *Walt Disney: The Triumph of the American Imagination*. New York: Random House, 2006.

Kwan, Jonny. Personal interview with author. June 19, 2014.

Maltin, Leonard. "Coming Attractions." In *The Disney Poster Book*, pg. 7. New York: Disney Editions, 2002.

Nuchols, Steve. Personal interview with author. June 19, 2014.

"Pixar Feature Films." www.pixar.com/features_films

Sabel, John. Personal interview with author. June 12, 2014.

Steamboat Willie (1928). Walt Disney Animation Studios via www.youtube.com

The Walt Disney Family Museum Web site: www.waltdisney.org

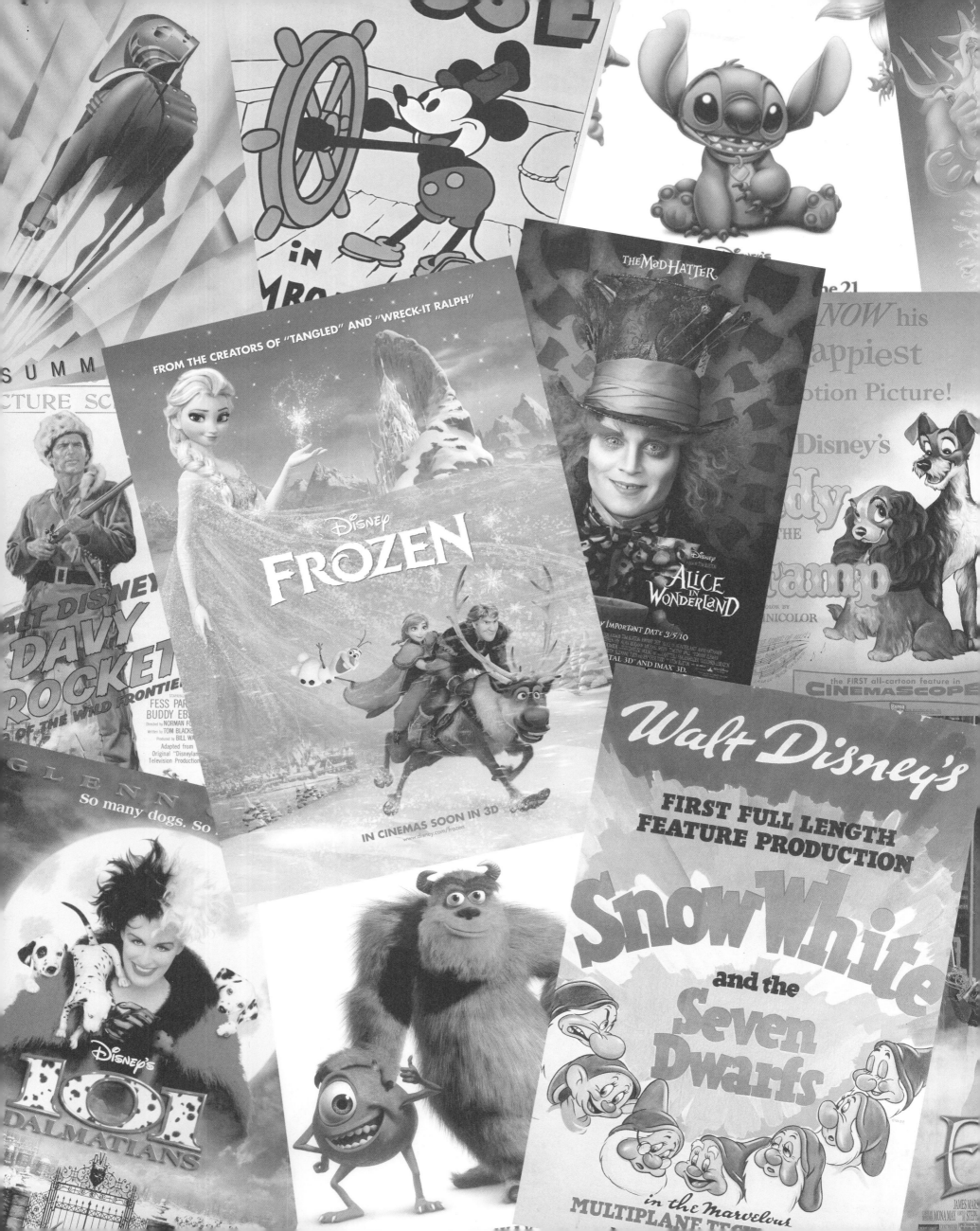